The Pottery of Acatlán

The Pottery of Acatlán
A Changing Mexican Tradition

By Louana M. Lackey

UNIVERSITY OF OKLAHOMA PRESS : *Norman*

Library of Congress Cataloging in Publication Data

Lackey, Louana M., 1926–
 The pottery of Acatlán.

 Revision of thesis (Ph.D.)—American University, 1978
 Bibliography: p. 157
 Includes index.
 1. Indians of Mexico—Acatlán de Osorio, Puebla—Pot-
tery. 2. Acatlán de Osorio, Puebla, Mexico—Antiq-
uities. 3. Mexico—Antiquities. I. Title.
F1219.1.P9L25 1981 783.3'0972'48 81-40280
 AACR2

Contents

Color Plates

Black-and-White Illustrations

Maps

Preface

This book is about a potter, Mario Martínez Espinosa, and his family and how they make and market the wares they produce. The Martínez family is typical of the potters who live and work in Acatlán, a mountain village in the south of the state of Puebla, Mexico. Acatlán is about halfway between Mexico City and the city of Oaxaca, on the Panamerican Highway, a route that traces an ancient pre-Columbian Indian trail. It is likely that Acatlán and its ceramic industry are just as ancient, but until much-needed "dirt" archaeology is done both in and near Acatlán, that statement can be no more than a guess. This book, nevertheless, is an archaeological report concerned with the ceramic tradition of Acatlán. Archaeologists have always been interested in pottery, for they find probably more potsherds than any other single kind of artifact; yet they have been more concerned with the appearance of the wares and their use than with the methods used to make them.

I selected Acatlán for a research site because it appeared that all the New World pre-Columbian pottery-making techniques could be observed there still in use. Modeling, coiling, and molds are used, either alone or in some combination technique. Finished pieces are fired in an open cylindrical kiln covered with pieces of broken wares, a kiln that is very similar to those in use in Late Classic Monte Albán. Potters are traditionally conservative craftsmen. They will change the wares they produce to accommodate changing market demand, but they are very slow to change the methods and the materials used to produce those wares. In Acatlán, as in other Mexican pottery centers, many traditional wares are no longer being produced, and much of the output is intended for the tourist market. Some of the tourist wares take strange new forms, and yet they are still produced by the traditional methods. Acatecan potters still use a clay body identical to that used in a group of Late Postclassic sherds found in the area and very similar to that used to manufacture Thin Orange, a fa-

mous Classic trade ware of as yet unknown origin. I believe that Thin Orange wares, if not actually made in Acatlán, were made in the Acatecan way.

Neither this book nor the dissertation from which it was developed would be possible without the help and encouragement of many persons both in the United States and in Mexico. Although I can never adequately express my thanks or repay my debts, I must begin the list where *I* began—with the Department of Anthropology of the American University in Washington, D.C., where I received undergraduate and graduate degrees. Harvey Moore, my first teacher in the department, introduced me to the discipline of anthropology and encouraged my reentry into academic life after an absence of more than twenty years. Other members of the department, both faculty and fellow students, were equally supportive. Probably the longest-suffering member of the department was Charlie McNett, my adviser since my admission as an undergraduate and more recently chairman of my dissertation committee. My debts to him can never be repaid.

I am almost as deeply obligated to the other two members of my committee. Frederick R. Matson, of the Department of Anthropology of Pennsylvania State University, answered my queries, provided citations, read my papers, looked at my slides, and made me feel as welcome on his campus as if I had been one of his resident students. Matthew Norton, a geologist who was chairman of the Department of Chemistry of American University, guided me through the mysteries of the polarizing microscope and X-ray crystallography to the final analysis of the materials used in the Acatecan clay body. His premature death in a Chesapeake Bay boating accident has been an unmeasurable loss to the academic community.

I am in debt to three other anthropologists for their help with the research that went into this book. Norberto González Crespo, now the State Archaeologist of Yucatán, was the first to encourage me to visit Acatlán, excusing me for several days from work on excavations at Las Pilas, Morelos, in the summer of 1973. A discussion of this visit with George M. Foster crystallized my intentions and set the research in motion. The way was smoothed by Fernando Cámara Barbachano, of the Instituto Nacional de Antropología e Historia, who issued the necessary permits, wrote letters of introduction to the authorities in Acatlán, and generally expedited my work.

In Acatlán my research was aided by civil and school authorities, potters, and pottery traders, but most particularly by Mario Martínez Espinosa and his family. My archival research in Mexico City was assisted both by the wonderfully helpful librarians at the Museum of Anthropology and by Clinton and Anna Lou Rich, who provided me with a home away from home.

Preparation of the manuscript was expedited by Frederick A. Ritter, Chairman of the Department of Geography in Morgan

State University, Baltimore, Maryland, who prepared the maps. Adam Koons, a graduate student in the Department of Anthropology in the American University, did the photographic laboratory work, and Shirley Hicks, a long-term friend, typed the final copy.

The research was made possible by a University Dissertation Fellowship from the American University, as well as by financial help from my parents, an expression of confidence that was equally helpful. My own nuclear family was equally supportive. My daughters took over for their absent mother, learning to wash, iron, clean, and cook. My incredible husband lived not only through these experiments but also through the years after I reentered academic life. He typed and retyped my research papers, editing, picking up dangling participles, and frowning at poor sentence structure and misspelled words. He stood by through phonemes, edge angles, comprehensives, and field research. Without his help I would have become a second-time dropout. To him I dedicate this book, with love.

Washington, D.C. LOUANA M. LACKEY

The Pottery of Acatlán

Introduction

Ceramics are probably the most numerous of the artifacts with which an archaeologist has to deal. Frequently, indeed, they have been so numerous that so experienced a researcher as Gordon R. Willey has complained of the problem of "literally tons of potsherds" (1961:230). There are two reasons for the survival of these sherds. The first is, of course, the remarkable permanence of the substance; the second is the countless uses to which man has put fired clay. Terming his list incomplete, Matson (1965:212) mentioned some of these uses. Included in the list are such diverse forms as beehives, slingstones, coffins, lamps, sickles, and hoes, as well as "pottery in endless variety." The broken remains of these objects are the tons of potsherds that engage the attention of the archaeologist.

The researchers have used the potsherds to answer an impressive number of questions. In the effort to reconstruct man's activities in the past, the archaeologist has asked the classic questions put by the newsman: Who? What? Where? When? and Why? Only very recently—and as yet too infrequently—has the archaeologist added, How? to the list of questions. When this last question is asked, the answer often can tell us only how the archaeologist thinks that the artifact or the structure had been used. Far less often are we told how the artifact or structure may have been made. That is particularly true of pottery, for many an archaeologist, either "old" or "new," has been guilty of forgetting the "Indian behind the artifact."

The "old" archaeologist was interested in historical reconstruction; his emphasis in ceramic studies was on their form and decoration. Webb (1972:125) coined the rubric "Carnegie-Peabody Co-Tradition" to describe this school. Many Mayan site reports, for example, belong to this category, with long lists of sherd types and varieties included either as an appendix or as a separate volume. Pages are filled with sherd descriptions, sorted into groups according to surface finish and decoration. The "paste" is de-

scribed, including the temper; the shape is reconstructed; and the vessel is named. *Probable* functions of these wares are sometimes described, but manufacturing techniques, excluding an occasional handle said to be mold-made, are not discussed. "Poorly fired," a term found in one site report, was not further explained.

The "new" archaeologist continues to base much of his work on ceramic typology. Computer techniques eliminate much of the tedious work involved, as wares, types, subtypes, and varieties are used to answer new kinds of inquiries put to them. Typical of this type of research are such studies as Freeman and Brown (1964: 126–54), Deetz (1965), and Longacre (1970). They ask whether the pottery types found can be correlated with house type or room use, and if changes in residence and social organization can be correlated with changes in design attributes. The increase in research of this nature can itself be correlated with the increased use of the computer as a tool of archaeological research.

Even in site reports that discuss manufacturing methods in greater detail, the analysis is not much more insightful. Often, the technique ascribed is inconsistent with the vessel described. In 1968, Shepard (1968:391) outlined suggestions for classifying vessel-forming techniques. She stressed the importance of defining primary forming techniques rather than giving undue emphasis to secondary features, an error that is likely to lead to inconsistent terminology. Yet, more recent site reports not only continue to reflect a misunderstanding of the differences between primary and secondary pottery-forming techniques, but arrive at a no more consistent vocabulary for doing so. Indeed, despite Shepard's efforts, there has been little advance in description and little better understanding of pottery-making methods since Richter (1923:xi), a classic archaeologist, complained that ignorance of what is possible and what is not possible in clay working has led to "some surprising theories regarding the technique of Greek vases; and these theories have been repeated over and over again in our books on vases, for the simple reason that, not having any first-hand knowledge, we have copied these statements from one another."

To avoid both Shepard's "inconsistent terminology and Richter's "surprising theories," the archaeologist must improve his understanding of pottery-making methods, primary and secondary forming techniques, firing techniques, and material winning—in short, the entire process. When he does this, he will better understand the role of "the potter as the active and controlling agent in these procedures" and will be better able to determine which "methods of manufacture are characteristic of individuals or groups of people." To achieve these objectives, the archaeologist has access to two extremely powerful interpretive tools. One is ethnographic analogy, which is, as Ascher (1961a:317) stated, one of the most widely used tools of archaeological interpretation. Frequently, however, the archaeologist will be unable to find ana-

logs that serve his needs. Despite Ascher's (1961a:324) later state-

ment that "the store of information on pottery manufacture and

its associated behavior" is "copious," the useful literature in this

field is, in fact, rather sparse. Matson (1960:44) explained the rea-

son for this. "The ethnographic literature abounds with refer-

ences to phases of pottery manufacture, although seldom are the

accounts complete because of a lack of adequate experience on

the part of the observer." Contributing to the scarcity of useful

ethnographic analogs is the fact that the study of material culture,

as Leone (1972:26) explained, "has been so long neglected by eth-

nographers that archeologists have seen themselves forced to

build their own analogues."

Frequently, it has proven too late for the archaeologist to find a

suitable area to do such a field study. The once "primitive people"

have become "folk"; the once "folk" end of the continuum has be-

come "urban." The archaeologist has found that the best way to

answer his questions of function and process, method and tech-

nique, has been by trial-and-error attempts to duplicate the ar-

chaeological evidence. Replication, or as Ascher (1961b:795)

named it, the "imitative experiment," can be used to "transform a

belief about what happened in the past into an inference. The ex-

ecution of an imitative experiment involves simulating in the

present time that which is believed to have happened in the past

in order to test the reasonableness of that belief." The imitative

experiment is increasingly used to answer the question of how

the primitive potter made his wares.

Replication in ceramics studies can be grouped into three types

of experiment: pottery making, decorating, and firing. This last,

firing experiments, occupies a midpoint between physico-chemi-

cal analysis and attempted manufacture and decoration of the

vessel itself. Under scrutiny are methods of firing, periods of fir-

ing, types of fuels employed, methods of fueling, temperatures

reached, and firing atmosphere (oxidization, reduction, or some

combination of the two). Investigation has generally taken one of

two forms: the carefully controlled laboratory experiment or, in-

sofar as possible, duplication of the firing methods of the society

being studied.

Laboratory firing experiments have been conducted by Fred-

erick R. Matson. One study (Matson 1971:65–79) treats ancient

Mesopotamian firing. This research involved the use of clay, from

Seleucia-on-the-Tigris, shaped into briquettes and fired at various

temperatures and kiln atmospheres. The changes in the color of

the briquettes under these varied conditions established a basis

for estimating the firing temperatures of Seleucia pottery, lamps,

and figurines (Matson 1971:70). Petrographic thin-section analy-

sis of both sample briquettes, and Seleucia figurines and vessel

sherds, confirmed the temperature indications provided by the

color of the fired products (Matson 1971:72).

In her experimental firings, Shepard (1968:78–80) attempted to

duplicate the methods of primitive potters. Both open and pit firing were studied in order to discover the differences in rate of temperature increase and length of burning of dung, wood, and coal. The length of firing and method of fueling, as well as the temperature, affects the color of the finished product and the vitrification of the body. Open-firing temperatures peaked between 900°C and 970°C, and reached a maximum of 1175°C in the pit firing (Shepard 1968:78).

Ceramic decoration techniques have not played as important a role in archaeological experiment as has firing. One important study in the field of Classic studies deserves mention. The black "glaze" paint on Greek vases, long a subject of some of the "surprising theories," was finally solved in 1942 by Dr. Theodor Schumann, a German, although the results of his experiments were not available outside Europe until after 1945. His work, summarized by Noble (1960:308), demonstrated that the black paint is not a glaze at all, but a slip prepared from the same clay as the vessel. Noble confirmed Schumann's work with spectrographic analysis, a method now used to differentiate between genuine Attic vases and modern imitations that have been painted with more conventional ceramic glazes.

Gisela Richter, writing earlier on the subject of Greek pottery, admittedly could not duplicate the glaze decoration (1923:49), although she did prove conclusively that they were fired only once. The enduring importance of Richter's work, however, lies in her successful attempts to duplicate the forming techniques of ancient Greek potters. Griffin and Angell (1935) were also interested in replicating forming techniques, although their interests lay in Eastern Woodlands pottery. In their attempts to duplicate these wares, they performed all the steps, from gathering the raw materials and preparing them, through forming the vessels, to firing them. Griffin and Angell were particularly interested in the coiling methods used and the technique of obliterating the coil marks with a cord-wrapped paddle. They concluded that "the determination of the method of constructing a vessel by the fracture lines is liable to be inaccurate unless, for instance, the lines of coiling have not been obliterated" (Griffin and Angell 1935:5).

Frequently, when archaeologists have found no evidence of coiling, they have used the term "lump-modeled" to describe the manufacturing method. "Lump-modeled" is becoming a handy catch-all term used to describe vessels of every shape, size, and description. According to the results of one replicative experiment, the shape and size of some of these vessels would seem to preclude this method of manufacture. As Hodges (1965:115, 116) in his experiments at the University of London Institute of Archaeology demonstrated, once a "pinch-pot" or "lump-modeled" vessel exceeds 6 or 7 inches, the bottom is no longer rounded, but becomes subconoidal.

After coiling and "lump-modeling" have been eliminated as

possibilities, a third manufacturing method is suggested: convex-molding. This widespread and probably ancient system seems not to have been described in the literature of anthropology until Foster's (1948, 1955) work on modern Mexican pottery-making methods. Since then, MacNeish, Peterson, and Flannery (1970: 237), working in the Valley of Tehuacán in the state of Puebla, Mexico, not only have recognized molds and mold-made wares but have elevated them to the status of a horizon marker of the Late Postclassic. Further archaeological work will most certainly extend the use of this method back in time and widen its spatial distribution.

Convex-molding methods apparently have not attracted the replicative experimenter, and there is little ethnographic description of the method aside from that of Foster. In addition to the two studies previously cited (1948, 1955), Foster wrote a brief paper on pottery making in Acatlán, Puebla (1960:205–14), and one article (1967a), both of which discuss convex-molding. Ascher (1961:324) to the contrary, ethnographic work in the field of Mexican pottery making is not "copious." Other studies include those of Thompson (1958) and Reina (1963:18–30), both for the Maya area; Van de Velde and Van de Velde (1939) on San Bartolo de Coyotepec and Hendry (1957) on Atzompa, both in the state of Oaxaca; and Diaz (1966) on Tonalá, Jalisco. Diaz (1966:143, 144) discusses convex-molding briefly, but the other studies cited either concentrate on other aspects of pottery manufacture or, as in the case of Reina (1963:18–30), other aspects of pottery production. A more complete list would further emphasize the need for more work both in pottery-making methods and in regional studies as well. Western Mexico, for example, including Colima and Nayarit, has been neglected both by ceramic ethnographers and, until recently, by archaeologists. Some of the most skillfully done forgeries of archaeological ceramics are reputed to be made in this area, presumably by the same methods used for the originals.

Acatlán, an important pottery-making center in the southern part of the state of Puebla, has been almost as neglected as western Mexico. With the exception of the brief paper by Foster (1960) mentioned earlier, little has been written, either about the town or the area, and although there is reason to believe that this industry is of considerable antiquity, little archaeological investigation has been done in the vicinity. The need for this type of research is urgent, though sites that have been buried for centuries can, presumably, remain so for a few years longer. More threatened are opportunities to study still extant traditional pottery-making methods. For a number of reasons, the traditional arts and crafts of Mexico are disappearing. Those that remain are undergoing rapid changes due to fading regional distinctions and the cheapening of products made for sale to an evergrowing tourist market. Because of better educational and employment opportunities, fewer young men are learning and following their fa-

thers' trades. Some older artisans are also taking advantage of this improved job market to abandon their crafts in order to earn more money. There still remain, however, some enclaves where pre-Columbian craft techniques are still being followed. Acatlán is one such enclave.

I first visited Acatlán in the summer of 1973. Although I was there for only three days, it was during this visit that I became acquainted with Mario Martínez Espinosa, a master potter, and with his family, and observed his work and that of his wife and sons. A discussion of this visit and of my observations with Dr. George M. Foster at the American Anthropological Association meetings in New Orleans in November, 1973, reinforced my conviction that Acatlán, both because of its importance as a pottery manufacturing center and because of its earlier neglect by anthropologists, would be a suitable site for a study.

When I returned to Acatlán in June, 1974, I was accorded a warm welcome by the Martínez family. I spent the summers of 1974 and 1975 working with them daily in the pottery. My ready acceptance by the Martínez family and by the other potters of Acatlán lay, not in my role of anthropologist, but in the fact that I, too, am a professional potter. Instead of the classic status of anthropologist as participant observer, I spent both summers working with Mario Martínez as a journeyman potter, a role to their advantage as well as mine. With the exception of the first two or three pieces of work I produced, which were not up to standard (neither my own or that of Mario and his pottery merchant), and a few small pieces brought back to Washington, all of my work belonged to Mario and was sold along with his own and that produced by the rest of the family.

While my pottery added a little to the family income, there were other, less tangible, contributions. My presence in the pottery served to relieve the monotony of the work in several ways. I provided a new ear to listen to stories long familiar to friends and relatives and, in return, I provided tales not heard before. Most of the family's relief from the boredom of the work was provided by watching my inept bungling in the early stages of learning the completely new set of motor habits needed for a completely new and unfamiliar method of pottery making. My early questions, which showed complete ignorance of things that everyone in the world was thought to know, also caused amusement, although this was politely suppressed. Mario, however, in his achieved role as master potter and his ascribed role as my teacher was extremely patient in his demonstrations as to how things should be done and with answers to my questions.

As I became more competent in Acatecan pottery-making methods, our discussions became more technical. The relationship between master and journeyman is a traditional one and, without exception, my questions were answered with clarity and

frankness. I was allowed to participate in every part of the process, from mining the raw materials, to loading and firing the kiln, to carrying the finished work downhill to the trader. The trader, Alfonso López Martínez, was also extremely frank and helpful, both in relating the many recent changes that have taken place in Acatecan ceramics and in explaining present-day merchandising practices.

During the summers of 1974 and 1975, I shared the family's social and religious life and was introduced to some two dozen of their potter friends, who also permitted me to watch them work and answered questions. I was freely allowed to photograph every aspect of the pottery-making process, as well as the everyday lives of the potters and their families. I was asked, along with my camera, to parties, weddings, graduations, and other social events, and I returned to Washington with about 2,500 photographs. During the summer of 1975, I was able to record temperatures of several firings with a portable kiln pyrometer and built an experimental kiln fired with kerosene in Mario's patio. I returned in the spring of 1977 to visit the junior high school ceramics classes and to confirm some of my earlier observations.

Traditional pottery making may come to an end in Acatlán within another generation, although as yet there seems to be little recent change in manufacturing methods and techniques. Of particular interest to archaeologists is the study of surviving pre-Columbian manufacturing methods and techniques and the separation of indigenous from intrusive techniques, tools, and materials. The enculturation of children and adolescents as they learn to make pottery is also of interest, as there has been little research into this aspect of pottery making. While these problems are being investigated, some of the questions raised by Foster (1965:43) might be answered as well. He noted that little attention has been paid to the social, cultural, and economic settings in which the manufacture of pottery is done. Most studies, he states,

> reveal little about such things as the status of the potter in his or her society, how potters look upon their work artistically and economically, standards of workmanship and the range of variation within a community, and above all the processes that contribute to stability in a tradition, which make for change and which may be involved in the dying out of a style.

I feel that assuming the role of journeyman potter (rather than anthropologist) enabled me to obtain information that I could have obtained in no other way. Although intended primarily as a contribution to the archaeology of southern Puebla, this study, as a descriptive account of pottery making by a potter, should be of use to ethnographers who are interested in the area. Chang (1967:228) asked two questions:

(1) Is it possible and fruiful to reconstruct culture and history by

classifying artifacts without recognizing or satisfactorily demonstrating cultural behavior?

(2) Is there a recognizable logical and causal relationship between the physical properties and contexts of the artifacts and their relevance to the behavioral and cognitive systems of the makers and users?

Neither of these questions, he states, can be answered without rigorous ethnographic research. Yet many ethnographic descriptions of pottery manufacturing techniques are incomplete or inaccurate due to the researchers' incomplete grasp of the processes involved. Richter (1923:xi) complained of the failure of archaeologists to understand how the wares were made. She believed that

> many archaeologists have, of course, seen potters at work in different places, or perhaps consulted potters on specific points but that is a different thing from getting a thorough knowledge of the craft oneself and learning once for all what is possible and what is not possible in clayworking.

Richter was a curator of Greek and Roman art in the Metropolitan Museum of Art. She returned to school to study pottery making in order to "gain new insight" into how the wares she worked with were made. Richter was fifty years ahead of her time; other archaeologists are now, at last, interesting themselves in such studies. The increasing popularity of the imitative experiment in ceramics research reflects both a growing concern among archaeologists as to how the vessels under study were formed and fired, and the scarcity of ethnographies that describe these practices. In many parts of the world, it is too late for these latter studies; indigenous potters and their pots are long gone. In Mexico, although pottery is still, in many places, being made by pre-Columbian methods, its existence is so threatened that a case could be made for calling such a study one in salvage archaeology. The present study, of pottery-making methods in Acatlán, Puebla, could be so described, although it could, at the same time, be termed both an ethnography and an imitative experiment.

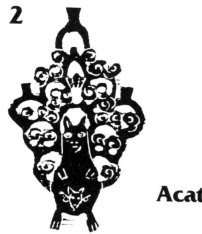

Acatlán

Acatlán is in the southern part of the state of Puebla, Mexico (map 1). It is 153 kilometers south of Puebla, the state capital, and 62 kilometers north of the Puebla-Oaxaca border, at 18°12′6″ north latitude and 98°3′ west longitude. In 1960, its population was reported as 7,086 (Tamayo 1962:417). At an altitude of 1,213 meters above sea level, the town itself lies roughly in the center of the Acatlán Valley, between the Sierra Acatlán and the Mixteca Baja, two of the meridional ranges that transverse the Central Plateau, connecting the Sierra Madre Oriental and the Sierra Madre Occidental. One of the sharp hairpin turns taken by Highway 190, the Pan American Highway, in its route through these mountains passes through the center of the town (map 2).

Acatlán's location, west of the Sierra Madre Oriental, is set apart from the humid winds of the Gulf Coast, and the climate is semiarid and warm. Fuentes Aguilar (1972:79), using the Köppen classification, types it as BSh'wg—that of dry steppes, with the little rain falling predominantly in summer. Both the mean annual temperature and the monthly mean for all of the months is higher than 18°C. Mean temperature for January, the coldest month, is 22°C; April and May, the two warmest months, are both 27°C. During the rainy season, May through August, rain will fall, usually late in the day or early evening, not exceeding 250 to 500 millimeters annually.

The Acatlán Valley is drained both by the Acatlán River, known locally as the Río Tizaá, and by the Mixteco River, into which it flows just south of Tecomatlán. The Mixteco is, in turn, a tributary of the Atoyac, the principal watershed system of the state of Puebla. The Atoyac rises in the north of the state, high in the Sierra Nevada near the Puebla-México border, flows generally from the northwest to the southeast until it reaches Molcaxac, where it turns sharply toward the southwest, crossing the valleys of Matamoros and Chiautla before entering the state of Guerrero. Known here first as the Mezcala, later after passing the town of Balsas,

Map 1. Mexico, showing area of study.

Map 2. Southern Puebla.

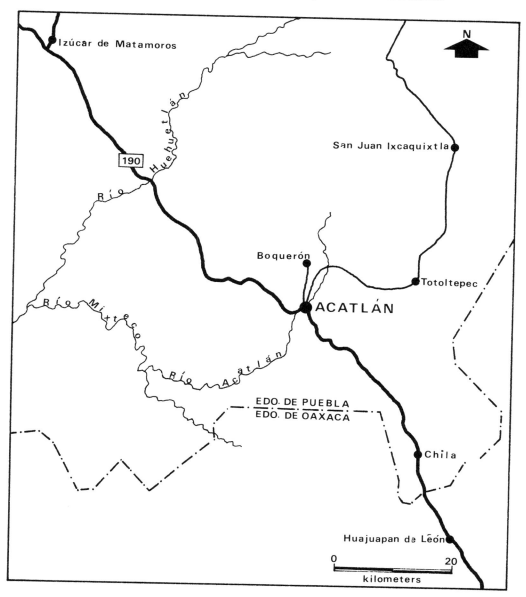

Guerrero assumes its best known name, that of the Balsas River. Its lower course forms the border between Guerrero and Michoacán before emptying into the Pacific Ocean at Petalco Bay.

By whatever name, the Balsas is one of Mexico's major rivers. It drains an area of approximately 112,320 square kilometers in the region bounded by the Transversal Volcanic System, the Sierra Madre Oriental, and the Sierra Madre del Sur. Major public works under way in the Balsas River drainage include, among others, a hydroelectric plant in the lower valley and a storage dam at the confluence of the Mixteco and the Atoyac (Fuentes Aguilar 1972: 46). Acatlán has been a beneficiary of the Río Balsas Proyecto Agua Potable, which has brought pure drinking water to it and other towns and villages on the Balsas and its tributaries.

Both the Sierra Acatlán and the northeastern slopes of the Mixteca Baja are covered with sierozem, or gray desert, soils. Here, according to Fuentes Aguilar (1972:99), the layer of humus is only a few centimeters thick, where it exists at all. Calcium carbonate is very close to the surface, uncovered to varying degrees by erosion. The only vegetation sustained is low thorny forest with succulent plants predominating. Cultivation is possible only under irrigation, and the principal use of these lands is for pasturing goats.

The valley, on the other hand, is composed of prairie soils considered semipodzolic. These have, as Fuentes Aguilar (1972:95) states, very different characteristics:

> Horizon A is generally deep, dark gray to dark red with a varied and active microrganic flora. The surface structure of this horizon is generally granular due to the influence of vegetation. The interchangeable calcium content is high in spite of the manifest acidity, and there is little descending movement of iron and aluminum.
>
> Horizon B generally shows some accumulation of clay and, at times, has a lumpy structure that impedes the drainage. The color of this horizon is dark gray with a gradual transition to the mother rock and is generally rich in lime. [My translation]

Natural vegetation in the Acatlán Valley is a low deciduous, seasonal forest that attains a height of between 8 and 15 meters. Characteristic trees mentioned by Fuentes Aguilar (1972:105) include several species of *Bursera*, *Ceiba*, and *Juliana*. In association with these are found groups of thick-stemmed and fleshy-stemmed succulents. Examples of these are organ and columnar cacti and prickly pear. With increasing altitude and aridity, the vegetation changes to that of spiny legumes and low thorny shrubs between 4 and 8 meters high. Frequently, owing to earlier land-clearing activities, the vegetation consists of second-growth acacia and mesquite.

Such secondary associations are widespread throughout the Balsas region according to Wagner (1964:251–53), and the original cover may have been very different from that of the present. As Wagner (1964:253) explains:

Most of the basin lands of the Balsas and Papaloapan have long held dense settlements, and the present state of their vegetation reflects very profound alterations through human agency. Undoubtedly the pronounced aridity in this area makes the survival of vegetation all the more precarious and the mark of man more permanent.

Historical Background

Mexican Route 190, the Pan American Highway, on its route through Acatlán, retraces an ancient pre-Hispanic trail, which went from Itzocán (now Izúcar de Matamoros) through Tehuitzingo, Acatlán, Petalcingo, and Chila to Huajuapan de León (Jiménez Moreno 1966:14). Acatlán's location on this road is seemingly recent, dating only from about the middle of the sixteenth century. In their history of the town, Tapia y Márquez Herrera (n.d.:9) trace its origins:

> The town of Tizaá was founded in the twelfth century by a Mixtecan tribe that had left its original home under the leadership of its chief Tizaá ("man of spirit"). The place they chose to settle was at the confluence of three small rivers, now called Nopala, Chazumba, and Ramales.
> In 1445, Moctezuma I (Ilhuicamina) conquered the Mixtec nation and named the town of Tizaá (a Mixtecan name) Acatlán, a Náhuatl name that can be translated "place of the reeds" (since sugarcane was not known before the arrival of the Spaniards).
> About the middle of the fifteenth-century Acatlán was repopulated by another Mixtecan tribe that had come from Tecomaxtlahuaca, in the direction of Tenochtitlán, to see the king, Moctezuma I. They wanted him to arbitrate in their dispute with the people of Juxtlahuaca over possession of the lands they had settled. In passing Acatlán, the Tecomaxtlahuenses were invited by the original founders to take up residence in the town and were offered free plots on which to live and land to sow. Many accepted the offer and the others continued their march. [My translation]

Unlike the Zapotecs, who had early allied themselves with the Spanish invaders, the Mixtecs resisted. They built fortifications and undertook a desperate and prolonged struggle. Not until 1533, when their last leader, King Umiyuchi, was captured by Francisco de Orozco, did the Mixtec nation finally fall. In the division of Mixtecan lands following this defeat, two *cacicazgos* were created in the vicinity of Acatlán, both granted to women. One of these went to a Doña Rosa de Mendoza, of Chazumba, now in the state of Oaxaca, and the other to a Doña Alejandra Villagómez, of unknown origin. Upon taking possession of her new lands, this latter cacique had the people of Acatlán expelled from their original settlement. They then moved farther south and refounded their town close to the Tizaá River on land belonging to the cacique Rosa de Mendoza (Tapia y Márquez Herrera, n.d.:10).

When de Vera visited the town in 1581, he found a primarily agricultural economy. He described the principal crops as corn, beans, chilis, and lime-leafed sage. Other cultigens included avocado, onions, radishes, lettuce, cabbage, colewort, mustard, mint, and parsley. Other fruits and vegetables were found growing wild, including pepino and pitahaya, both of which are still used (de Vera, 1907:104).

Dominican friars founded a monastery in Chila some time before 1571. Here, 38 kilometers southeast of Acatlán, they established schools for arts and trades, introduced sediculture and wheat, and installed a mill. Among their other activities, the friars also maintained the general headquarters for the Spanish conquerors. Before the end of the sixteenth century, two of these Dominican monks, Francisco Martín and Pedro Fernández, arrived in Acatlán as missionaries. Setting out to convert the Mixtecans to Catholicism and to build the first church in Acatlán, the pair seem to have accomplished both aims; Acatlán was raised to the status of a parish in 1630 (Tapia y Márquez Herrera n.d.:11). The church they built was destroyed by an earthquake in 1711, and in the following year, the present structure was started. This church, San Juan Bautista, was finished in 1724, a baroque basilican edifice typical of its time. In plan cruciform with nave and side aisles, it has, as well as two cupolas and a bell tower, a large dome covered with turquoise-glazed ceramic tile, which can be seen throughout the valley.

A second church, El Calvario, was built in 1824 on an elevated site overlooking the town, some 800 meters to the south of San Juan Bautista. Mejic (1977:6) describes this structure as colonial in style, built of stuccoed brick. Also cruciform in plan, it has two towers, one over the crossing and the other over the sacristy. Its chief interest lay in its image of "Christ of the Precious Blood," which hung over the altar until destroyed by fire on February 24, 1977. It was this crucifix that, carried in procession from barrio to barrio, was given credit for curing a cholera epidemic that took more than 300 lives in the autumn of 1833. Its loss is deeply felt by the people of those same barrios, most particularly San Rafael, La Palma, and Las Nieves. As yet, no decision (or agreement) has been reached as to a replacement.

For six months in 1862, according to Mejic (1977:6), El Calvario, both hill and church, were turned into a fortress due to the "French intervention." Acatecans are proud of having fought under Morelos in the War of Independence and in every war since, including the Yankee invasion. Battles have raged up and down the valley and in the town itself. Fields have been laid waste, dwellings have been pillaged and burned, and the people have been forced to flee to the hills. During the Revolution, a single day, April 7, 1911, saw the destruction of the post office, the bank, and the tax-collector's office, while the town archives were put to the torch (Tapia y Márquez Herrera, n.d.:45). The route

through Acatlán has been a convenient one for bandits, as well as guerrillas and armies. As recently as 1950, according to Simpson (1971:342), southern Puebla was terrorized by gangs of *pistoleros*. Sixty murders were committed in Acatlán alone, and "when the distracted mayor called on the military for help, he was shot for his meddling."

Present-Day Acatlán

Intermittent earthquake activity, as well as wars and civil strife, have taken their toll, and, as a consequence, modern Acatlán presents only negative evidence of its historic past. With the exception of San Juan Bautista, little remains of the colonial period, although it was probably under the influence of the Dominicans that the new settlement was laid out according to the Hippodamian grid plan common to much of Latin America. At the center of town is the zócalo, Parque Central, bordered on two of its sides by the Pan American Highway. Across from the zócalo on the southern and western sides are stores; to the east is the church. Buildings on the north include those of the Red Cross, the police station and jail, and the Palacio Municipal. This last structure houses not only city offices, but those of the *municipio* and the *distrito* of Acatlán. As political entities, a *municipio* is approximately equivalent to a township in the United States, and a *distrito* is similar to a county (map 3).

As much a consequence of its position as a political, religious, and marketing center as of its geographic location, Acatlán is a busy and prosperous city. In driving time, it is almost exactly halfway between Mexico City and the city of Oaxaca and is, therefore, a convenient meal stop for tourists, truck drivers, and the many buses that use the Pan American Highway. It is also the starting point of the newly paved road to San Juan Ixcaquixtla in the mountains to the northeast. The great numbers of restaurants, food stands, and snack vendors, far out of proportion to the population of Acatlán, reflect the brevity of most of these people's visits. Feeding transients is not a new thing with Acatecans. De Vera (1907:105) found as long ago as 1581 that this was the principal method used by the townspeople to earn enough to pay their tribute. In contrast, there are only two hotels in Acatlán, although a new posada, under construction for several years, is now partially occupied.

At first glance, Acatlán does not exude an air of prosperity. With the exception of the Pan American Highway and the road to San Juan Ixcaquixtla, none of the rutted, hilly streets is paved. These alternate between a state of gumbo during the rainy season and blowing dust the rest of the year. There are few sidewalks, as these are built and maintained by individuals in front of their own properties. As an outward indicator of success, sidewalks seem to run a poor third to the television antenna and the *pila*. A *pila*, or

Map 3. Acatlán today.

1 San Juan Bautista
2 Zócalo
3 Plaza des Armas
4 Market
5 El Calvario
6 Martínez household
7 Locería Juárez
8 Casa López
9 Site of *arena*
10 Site of *tinta*
11 Site of *tierra colorada*
12 Site of *barro negro*

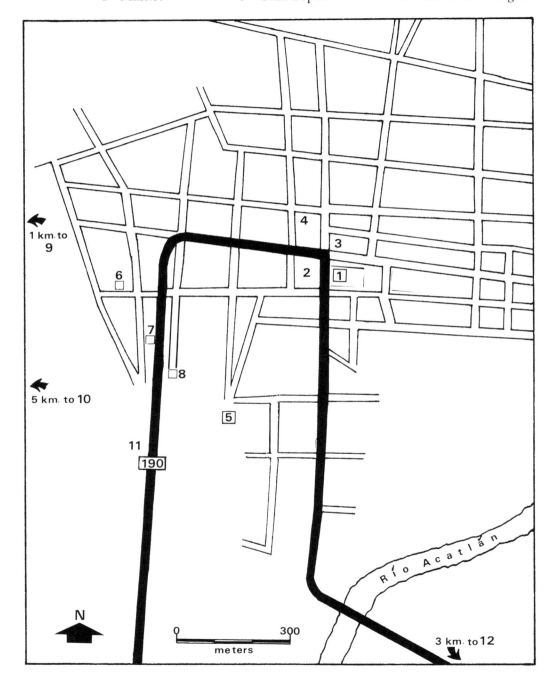

water storage tank, on the roof of a house indicates the presence of an electric pump and indoor plumbing. Many of the newer dwellings in the city proper are built of concrete blocks, although some adobe construction is faced with stucco on the side facing the street and presents a similar appearance. Houses are often painted with a quickly peeling, rather impermanent paint; pink, blue, green, and bright yellow seem preferred, although purple and red are also seen. City dwellings are inward facing, with few windows on the street. Many are compounds, with one- or two-room, single-family dwellings surrounding a central communal patio or yard. Often, these compounds are shared by extended families, although some are occupied as rental units by unrelated tenants. Houses in outlying areas are similar, flat-roofed and rectangular. Here adobe is more common than concrete block as a building material, and fences of growing cactus, rather than walls, demark the property lines.

The rapidly changing culture of Acatlán is more visible in the zócalo and its surrounding streets than in the architecture of the town. Burros and bicycles, motorcycles and campers, compete for parking space. Jukeboxes play norteamericano rock music alternately with the popular ballads of the Acapulco Tropical. The paseo is still practiced in the early evening in the park, but now teen-aged girls, unchaperoned, are wearing miniskirts or pants, along with rhinestone-studded T-shirts, their long hair left unbraided in the gringa style. Teen-aged boys are letting their hair grow, and the really *jip* are sporting blue jeans. Traditional dress for most married women of any age still includes the rebozo, worn even with double-knit pants suits. Few men are seen wearing the traditional homemade white campesino shirt and trousers; factory-made ready-to-wear is the rule, rather than the exception. For men who have achieved some measure of success, the Yucatecan *guayabera* shirt has become a status symbol, signifying an escape from manual labor.

The acquisition of city clothing and other material culture of a rapidly industrializing nation is equated with success, prosperity, and progress in Acatlán. In general, Acatecans favor progress and change, and they take great pride in the steps that their community is taking toward modernity. They stress its many schools, the modern hospital with its seven doctors, and the planned 27 million peso clinic to be built by the Instituto Mexicano de Seguro Social. A permanent indoor market has just been completed, and land has been purchased for a 90,000 peso sports arena. Plans are also being formulated to build a library and museum, and although the library is now open 3 afternoons a week, the museum is still in the committee stage. Another committee petitioned President Echeverría to establish a regional technical institute in Acatlán, renewing its request after the change of administration.

Acatlán's past is as much a source of pride as its present and future. Acatlán's survival through four and a half centuries of earthquake, epidemics, crop failures, and internal and external

wars is frequently mentioned. Acatecans attribute their ability to "stand the strain" both to the help of God and the saints, and to the fact that they are Mixtecan. "Mixtecs don't give up like the Zapotecs." Although the town is now primarily mestizo, the first Spanish families did not move in until the end of the eighteenth century (Tapia y Márquez Herrera n.d.:15), and the Mixtecan heritage is still very strongly felt. Graduation ceremonies at the local schools will often feature native dances. The Normal School graduation in July, 1975, presented an elaborately costumed display, featuring a light and sound show that incorporated Mixtecan music, poetry, and dancing, along with burning copal, which filled the auditorium with heavy smoke. This spirit of *indigenismo* is both fostered by, and reflected in, the monthly newspaper, *La Mixteca: Voz del Tesáha*. A monthly column, *Significado de*, traces the origins of local place names to their indigenous roots. Mixtépec, for example, is derived from the Nahuatl *mix(tli)* ("cloud") and *tepec* ("population"); together they mean "people of the clouds" (Ortíz de Montellano 1975:4).

La Mixteca is eagerly awaited each month by the townspeople as, like most small-town newspapers, it carries news of weddings, graduations, announcements, and advertisements. It also seeks to improve both its readers and their city. It is serializing Miguel Y. Tapia and Simitrio Márquez Herrera's (n.d.) history of Acatlán, publishes brief histories of neighboring villages, and uses as fillers quotations from the world's great thinkers—Aristotle, Goethe, and Martin Luther King, to name but three. Its editorial policy is strongly in favor of progress through public improvements, and it decries the dirty unpaved streets, the "unhygienic" *liquado* stands, and public buildings in need of repair. In one lead article, the editor, Senén Mejic (1974:1), pointedly praised the recent improvements, either completed or under way, in neighboring Huajuapan de León, Oaxaca, an hour south on the Pan American Highway. Particularly cited were the newly paved streets and the spacious new market. *La Mixteca* had long condemned the slowness of construction and the dirt, smells, garbage, flies, and crowded condition of its ancient outdoor market.

The new market, built of cement blocks, is located just behind, and slightly uphill from, the Palacio Municipal. It is bounded on the east by the Plaza de Armas, an open unpaved space on the north side of the zócalo. During the week, the new market building is adequate to house the vendors since only a small percentage is present to sell produce, notions, and a few odds and ends of clothing, although most of the *liquado* stands and cooked-food stalls are open. In Acatlán, as in many parish centers, the big market day is Sunday, and, to take advantage of the crowds, all of the stores are open, including furniture and appliance stores that offer credit on "big ticket" merchandise. Buyers and sellers are attracted from the entire valley and surrounding mountains, as are entrepreneurs from Izúcar and Puebla. Some of these latter bring

in merchandise by the truckload: clothing, dry goods, grocery staples, hardware, and other commodities not available during the week. On Sunday, the market overflows the new building, the Plaza de Armas, its traditional site, and extends for several blocks in every direction.

Products offered for sale in the Sunday market reflect the primarily agricultural base of Acatecan economy. Sugar and corn are the principal cash crops, followed by produce from truck gardening. Produce stands offer a wide array of locally grown vegetables and fruits, such as corn, beans, squash, chili peppers, tomatoes, onions, potatoes, plums, avocados, apples, figs, mangos, peanuts, and lemons. Also to be found are exotic imports from the tierra caliente, including bananas, pineapples, and chocolate. Pitahaya, pepino, and other wild fruits and vegetables collected from the surrounding countryside are also offered, usually by country women, who also, often, bring in their homemade baked goods, candy, preserved fruits, and goat's milk cheeses. Although a few cattle are raised, goats are more important, both for meat and for dairying. Pigs are numerous, and most people in the outlying areas will raise one or more along with a few chickens, a turkey or two, and, if the family can afford one, a burro.

Livestock is sold on Sunday on Ricardo Reyes Márquez, the street bordering the zócalo to the south. Also sold here are corn and other seed, burro saddles, machetes, and all of the other items necessary to the farmer. The fields to the south of Acatlán are principally devoted to sugarcane. Most of this crop is trucked north to refineries and distilleries closer to Puebla. An unknown quantity is reserved to be distilled locally into untaxed aguardiente varying in quality, proof, and price. Many of the town's tiendas sell it, under the counter, for about 2 pesos for 100 milliliters. Sunday afternoon finds many men intoxicated as they stay too long in conversation at their favorite tienda while waiting for their women to conclude their business at the market.

Compared to larger market centers that enjoy a tourist clientele, such as Oaxaca and Cuernavaca, handcrafted offerings are few. For the most part, these few are functional rather than decorative, and are locally made for local consumption. Each year, these face more competition from factory-made functional equivalents of metal, plastic, glass, and other materials. Petates are still sold (fig. 1), as are market baskets and hampers woven in Amatitlán, a neighboring village. Mixtecan hat weavers from Yucunduchi, a tiny settlement in the hills east of town, bring in their week's work and continue to weave while waiting for customers. Carpenters offer unpainted furniture, including large and small chairs, tables, and hanging cradles, as well as burro saddles. A number of huarache makers offer handwoven sandals of raw, untanned gray leather strips woven together and stapled onto soles cut from discarded automobile tires. It is uncertain how much longer any of these items will survive as market goods. Petates and small handmade chairs are giving way to "real" beds and

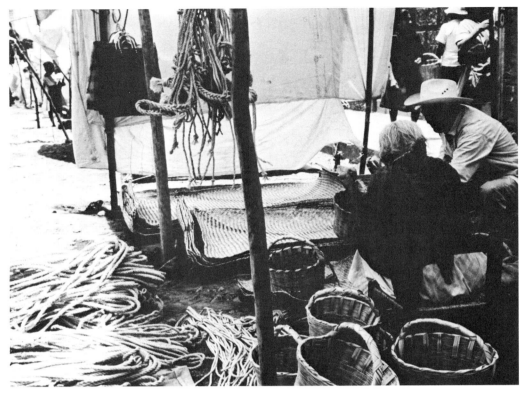

Fig. 1. Petates, baskets, and cordage in the Sunday market.

Fig. 2. Domestic wares in the Sunday market.

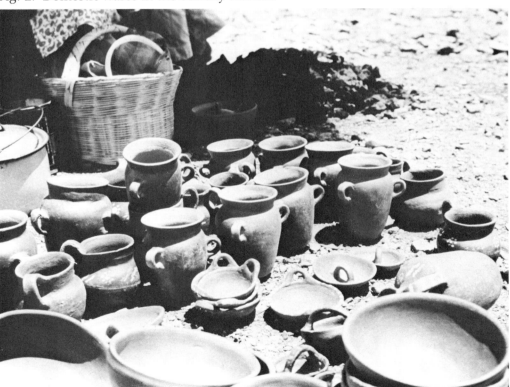

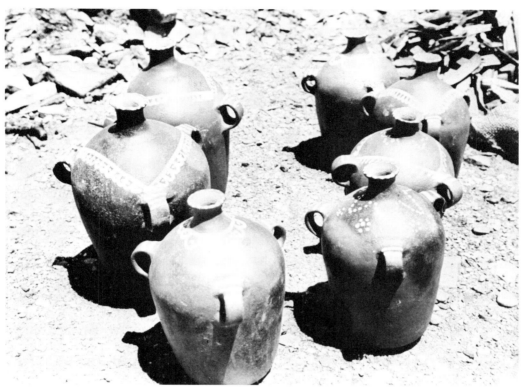

Fig. 3. *Cántaros* with traditional painted decoration.

Fig. 4. Glazed *ollas* and *cazuelas* from Puebla.

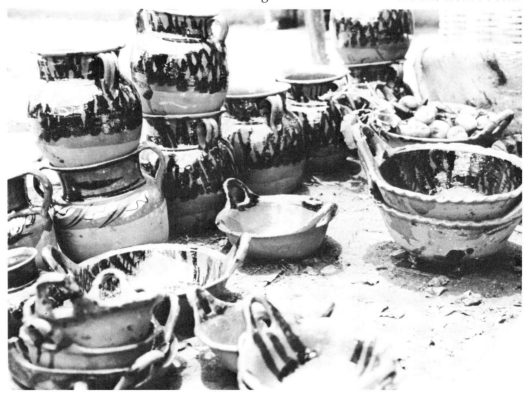

chairs, as stamped metal, chrome, and plastic furniture is offered on "easy credit." Handwoven baskets, hats, and sandals are also being replaced. Plastic shopping bags and other containers are offered in the market at half the price of baskets of similar size. Hats and huaraches, however, are being replaced by more expensive, status substitutes. Sombreros from the factories of Sahuayo, Michoacán, and shoes from those of León, Guanajuato, are no longer seen only on the very rich.

Potters who sell their wares at the market usually fire their week's work on Saturday and bring it into the market early Sunday morning. With the exception of a very few miniature and decorative items, or of special pieces made for the Day of the Dead or Christmas, the majority of the pottery is utilitarian and functional. Domestic ware predominates, such as *molcajetes*, ollas, *cazuelas*, *cántaros*, *platos*, and *tazas* (fig. 2). Any decoration is simple, limited to a few strokes of white paint (fig. 3), or a stamped or incised design. Next to these local black or redwares, and often sold by the same vendor, are glostwares, both green and *chorreada* from Oaxaca and black on red from Puebla (fig. 4), as well as factory-made, cheap, glazed earthenware and milk-glass dishes with painted designs. Also sold here are metal and plastic water bottles (plate 1) and aluminum pots and pans of the thinnest gauge.

Increasingly, Mexico's new wealth is changing both living patterns and household inventories, and, of course, the supply of goods for sale in the market reflects the demand. The mano and metate are falling into disuse as corn is now ground into masa at the neighborhood *molina nixtamel*. The *molcajete* is joining the metate as an artifactual relic. Fodor (1972:286) explains the rapidity with which the electric blender has replaced the *molcajete*. Its ability to make the intricate sauces of fresh or dried chilis ground together with herbs, spices, nuts, vegetables, fruits, and sometimes chocolate, in moments rather than hours, has made the blender more popular in Mexico than in any other country in the world.

As yet, not all Acatecan women can afford the luxuries of chrome and plastic dinette sets, innerspring mattresses and box springs, blenders and television, and other more costly status symbols. Even a complete set of matching factory dishes or glassware is out of the reach of most. Little by little, however, the cheaper pots and pans and dinnerware, as well as plastic pails and storage containers, are being substituted for more traditional ceramic wares. As a consequence, many potters have adapted to this dwindling demand by either changing their market or leaving the trade.

3

Pottery and Potters

Only a small percentage of the gross Acatecan ceramic output is sold in the Sunday market. As demand for domestic wares has dwindled, potters who have not abandoned the craft have turned increasingly to the manufacture of artwares and novelties intended for sale to tourists. These are not taken to the market, but are sold instead to middlemen who have established a number of shops along the Pan American Highway where it enters the town from the north. Other pottery merchants come to town periodically to load their trucks with these novelty wares, which they buy directly from the potter. Most of these itinerant buyers are from Mexico City or Oaxaca; others come from as far away as Ciudad Juárez.

Acatecan domestic wares sold in the Sunday market reflect a ceramic tradition of hundreds of years. Moser (1969:480–83), for example, pictures some Late Postclassic *molcajetes* that are almost identical to those still sold—only the shape of the feet has changed. The same cannot be said for the tourist wares, however. These not only reflect the rapid changes that have been taking place in the last twenty years, but serve to confirm Foster's (1960:212) contention that diffusion is wiping out many regional distinctions in ceramics. This phenomenon can readily be seen in a visit to one of the modern pottery shops along the highway. Not as yet found here are wheel-thrown shapes, glostwares, and high-fired stonewares. With these exceptions, the work on display, all made in Acatlán, reflects a cross section of ancient, as well as modern, wares from all over Mexico.

Archaeologically influenced wares include Colima-like fat little dogs, Teotihuacanoid wall masks, the ubiquitous Aztec "calendar stone," and more directly influenced *grecas*, volutes, and other minor decorative touches. These last, as well as the now common highly polished red finish, were copied by Herón Martínez from some sherds found by Instituto Nacional de Antropología e Historia archaeologists in a surface survey in the area (Espejel 1975:

77). The preconquest stepped-fret design was a symbol that appeared very frequently on Cholula Polychrome. Its first postconquest appearance was, according to Kubler (1971:222), south of Mexico City in the murals painted between 1570 and 1580 in the Augustinian cloister at Culhuacán. Kubler feels that

> bits of empty decoration like the Culhuacán borders are important, however, as early dated examples of the most abundant category of "survival" art in existence, the category of tourist souvenirs decorated with archaeological themes. Enormous amounts of textile, pottery, jewelry, and painting have been emblazoned with the Aztec calendar disc or with the Tiahuanaco "sun-gate" figure. These empty revivals, without meaning beyond the vague evocation of place, first appeared as an industrial phenomenon about 1875.

Sharing the shelves of the Acatecan pottery shops with these "empty revivals" is a bewildering diversity of wares of equally diverse design origins (plate 2). Other than such ordinary vessel shapes as bowls, cups, lamps, and other functional wares, shapes include architectural forms such as churches (fig. 5), boats, houses, streetcars, and even merry-go-rounds. Animal forms include frogs, toads, lizards (fig. 6), owls, bulls, cows, goats, chickens, fish, and such exotic imports as Mickey Mouse (fig. 7) and Donald Duck. Many of the wares are copies of Oaxacan styles, originally made by Teodora Blanco of Atzompa or Doña Rosa of Coyotepec. Other once-regional styles include trees of life typical of Izúcar de Matamoros, Puebla; suns from Metepec in the state of Mexico; and decorative painting techniques reminiscent of Tonalá, Jalisco, or Tzintzuntzan, Michoacán. Many of the architectural forms were originally conceived by Candelario Medrano of Santa Cruz de las Huertas, Jalisco.

Colors of these objects include not only those of the natural clay, a pinkish buff, but the highly polished redware mentioned earlier. Blackware (produced by firing in a reducing atmosphere) was, according to Foster (1960:211), introduced to Acatlán in 1955 by Cleotilde Schondube, a Oaxacan dealer. Postfiring decoration is limited to painting with acrylic colors on a background of dead white (plate 3). This medium is said by ceramics dealer Alfonso López Martínez to have been used only since 1973. The style originated in tempera-decorated wares intended for use on the Day of the Dead. With the introduction of a durable, washable, waterproof substitute for the impermanent tempera, the practice of painting became very common. A number of people who are not themselves potters are now engaged in decorating wares (plate 4). If they do not paint wares made by a member of their family, they will buy plain wares from the potter or a dealer, paint them, and resell them to a dealer. Painting is sometimes used to disguise badly fire-clouded ware that are thought not to be salable otherwise.

There is a third category of ceramic wares made in Acatlán,

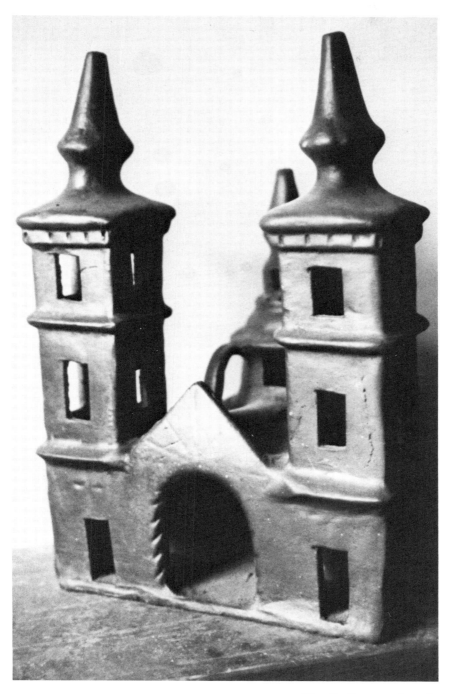

Fig. 5. Pottery church.

along with a third method of marketing. These are large, functional wares made for domestic use. They include large water storage *barriles* (fig. 8), rain spouts (fig. 9), and *chimeneas* (figs. 10, 11). These last, more than a meter in height, are functional equivalents of the cast-iron, potbellied stoves found in rural sections of the United States. They are more than adequate for their task of heating a one- or two-room adobe house. The *barriles* are used in almost every household that does not have indoor running water and a *pila*. The Río Balsas Agua Potable project has brought fresh water as far as most people's patios, but neither is this an unmixed blessing nor has it had much influence on the type of ceramic wares produced to carry and store water, as this source of supply is, as yet, somewhat undependable. The water is sometimes shut off for hours, either because of some problem at the waterworks or because of the town's electrical problems. To prevent being caught short of water, every well-run household has three or four *barriles*, kept filled with water from a hose when the water is running. Since these hold about 250 liters apiece, a considerable supply can be kept in reserve. In outlying areas where water is not being piped to individual households, central faucets are being installed to replace springs and other seasonal sources, and water is carried home from these, either by a child with a plastic or galvanized pail or by the family burro loaded with *cántaros* (fig. 12).

The tinaja, also used for water storage, is slightly wider at the widest part and much narrower at the neck. The largest in Mexico, a meter in height and 80 centimeters in width at the widest part, are made in Acatlán by Raimundo Martínez (Espejel 1975: 74). None of these oversized wares is usually seen in the Sunday market. Most often, they are made to order by the potter for the

Fig. 6. Lizard.

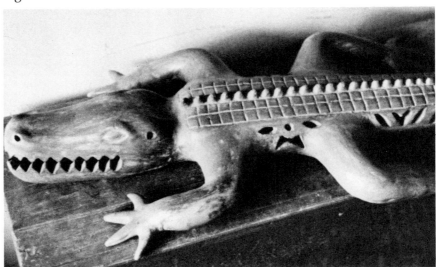

Fig. 7. "Mickey Mouse."

purchaser, although in the fall, dealers from Oaxaca and other cities will try to stock several dozen *chimeneas* for their local clienteles.

Almost all of the last kilometer of the Pan American Highway leading into Acatlán from the north is lined with places at which to buy pottery. Not all of these are the modern shops mentioned earlier. Some are private houses with a few vessels on the walls or set on boxes and with a homemade sign offering the wares for sale. Few of the residents of these houses are themselves potters, though some are related to the potters whose work they are attempting to sell. Several roadside restaurants and *refresquerías* along this stretch of the highway also attempt to take advantage of their location by offering a few wares for sale. Tourists interested in buying pottery tend to park their cars and visit several shops before making a final decision, often stopping for a *refresco* before doing so. The clustering together of the pottery shops, therefore, works to the advantage of both buyer and seller.

The number of stores that deal exclusively in pottery varies

Fig. 8. A *barril*.

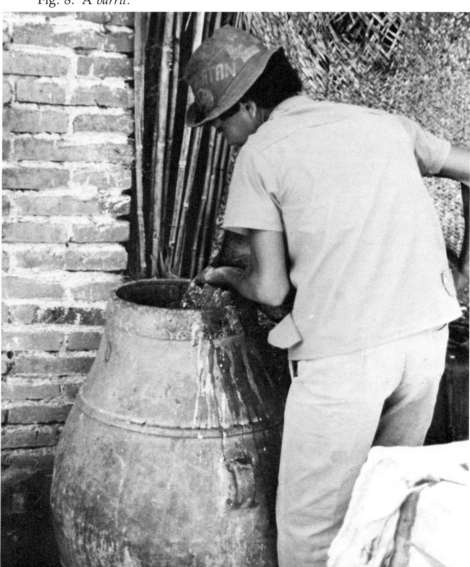

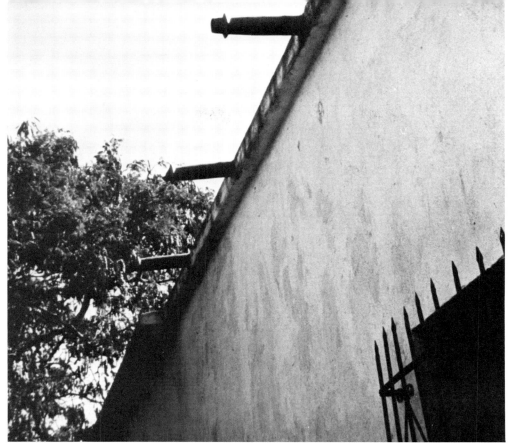

Fig. 9. Rainspouts.

from year to year, as it is a business that requires a considerable initial outlay of capital before any return is realized. Not only is this original investment tied up, but more money must be spent each week to maintain a coterie of potters in return for selling their work. As a consequence, there have been a number of failures in what has become a highly competitive business. Two of the most successful pottery shops are the Locería Juárez and the Casa López (plate 5). The first, the Locería Juárez, is one of the oldest, and is owned by Cirilo Juárez, a former potter who was mentioned by Foster (1960:211). The Casa López moved to its present location, a large, new, well-lighted store on the highway in 1975.

The Locería Juárez and the Casa López are the only pottery shops in Acatlán that advertise in *Artesanos y Proveedores* (*Craftsmen and Suppliers*), an annual publication devoted to the merchandising of arts and crafts. Possibly, this explains to some degree the success that both stores have enjoyed. *Artesanos y Proveedores* contains exhibition announcements, crafts news, articles, and advertisements, as well as a directory of subscribers. Although written in Spanish, the editorial content is summarized in both English and French. It is the only publication of its kind in Mexico, and it has a wide audience among those who purchase craft items for later resale. *Artesanos y Proveedores* is also used by tour guides. A

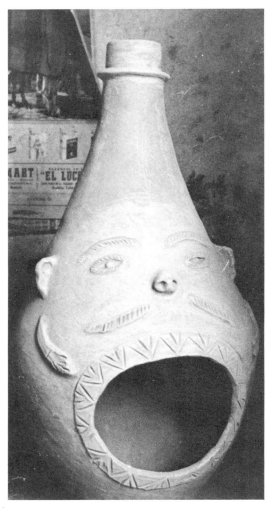

Fig. 10. A *chimenea.*

busload of tourists can spend hundreds of pesos in the 30 to 45
minutes allowed for a stop. Tour guides, as Norman and Schmidt
(1973:130) explain, "depend on tourists for a living. A part of that
living comes from steering you to their favorite shops, which pay
them a kickback of 10 to 20 percent of what you spend there."
When tour buses stop at Acatlán to buy pottery, it is usually at
either the Locería Juárez or the Casa López. None of the shops
has prices marked on the wares; these are "adjusted" to allow for
the particular situation—raised to cover a tour guide's kickback or
lowered by bargaining.

Whether or not their success can be attributed to their advertis-
ing, both Juárez and López are well-established traders, with
large and varied inventories of wares and a substantial invest-
ment in buildings and equipment. Alfonso López Martínez is a
much younger man than Juárez and has reached his present level
of affluence gradually. Many traders, he points out, have gone

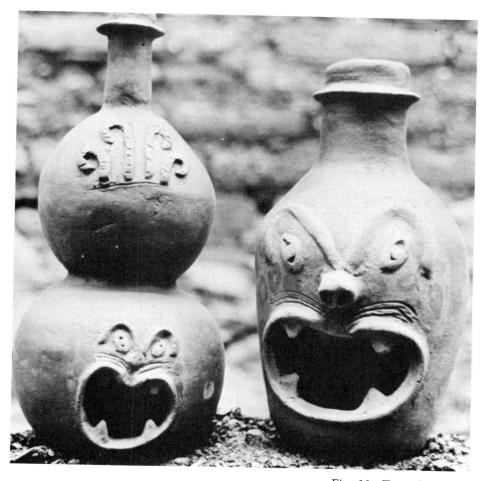

Fig. 11. Two *chimeneas*.

Fig. 12. Burro with four *cántaros*.

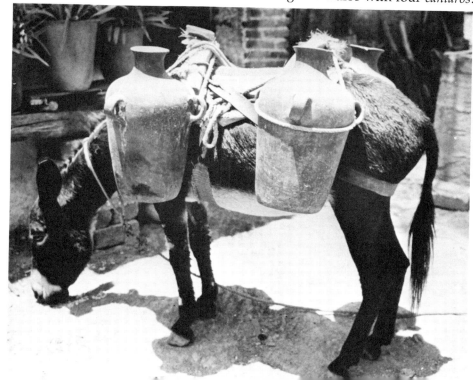

bankrupt by overextending themselves and by trying to do too much too fast. López owns a small warehouse on Carillo Puerto, around the corner from his house, as well as the new store on the highway. Many wares he stores there are overstocks of items already on display in the store, but most are destined for export to Mexico City and Oaxacan gift shops. López's wholesale business seems to be as thriving and successful as his retail business. In 1977, he was able to purchase a new, bright red, Dodge pickup truck and to increase his profits further by doing his own trucking (fig. 13).

López does not plow all of his profits back into his business; some are used to support the good life that is the hallmark of the successful businessman in Acatlán. These include, of course, the rooftop *pila* and television antenna and a sidewalk, which advertise his success for all to see. The house is filled with furniture in the latest style from a store in Puebla, including a plastic dinette table with matching chairs and an overstuffed living room suite with clear plastic covers. Among other accoutrements are a telephone, a television, and a *consola* (record player). The floor is tiled with glazed ceramic tile from Puebla and is covered in some places with rugs. A maid keeps the house in order, cooks, and takes care of the López children, freeing Señora López to help with the business.

Both the López life-style and their material possessions are typical of Mexico's emerging middle class. Their two preschool

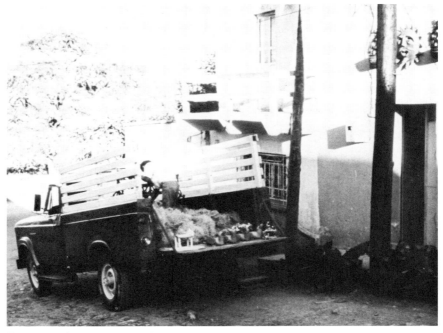

Fig. 13. The López truck.

daughters, for example, wear shoes and socks, in marked contrast to the other neighborhood children and to the adults, who wear only sandals when not barefoot. Señora López tries to dress like the modern Mexican career woman she feels herself to be. She wears a rebozo only to church and occasionally wears pants suits.

Actually, much of the López family's financial success is due to the active partnership of Señora López. She is responsible for the retail end of the business, freeing her husband to concentrate on the wholesale aspects. She manages the store, trains the help, and has a good "feel" for what will sell. It is she, usually, who conducts the day-to-day business dealings with the potters. She places an order weekly with most of the potters with whom the firm does business. This order will specify the type of wares wanted, the size and finish, as well as the number, which usually amounts to a kilnload. The price is agreed upon at the same time, often accompanied by an advance payment. This practice has apparently become quite common in pottery-making centers. Diaz (1966:180) mentions it, as does Novelo (1976:126). Novelo finds that the pottery traders in Capula, Michoacán, not only give the potters advance payments and loans but also supply them with glaze, paint, and fuel. The potters are then obligated to sell to the same trader all of the time, as their debts exceed the week's production. In Acatlán, at least, the traders do not supply materials to the potters; nevertheless, an advance is usual not only to seal the bargain, but because the potter, having spent all of his earnings from the week before, has been reduced to asking for one. He often must ask for another before the week is out, as Señora López is not overgenerous with her advanced payments. "We have to beg for every centavo," say the potters, "and then she is always dropping around to check up." In justice to Señora López, some of these potters are improvident alcoholics who drink until they are out of money and work at their trade only enough to get by.

Similar complaints are made about the other traders, but most of the potters appreciate the virtues of this relatively new system of marketing. Older potters point out that they are saved the trouble of carrying all of their wares to the market, "wasting" the entire day attempting to sell them, and carrying home again the wares that went unsold. Potters also feel that they now enjoy a little more security and that much of the guesswork has been removed from their trade. "We know what things to make and how much money we will get for them, so we know how much money we can spend." In times of personal or family financial crisis, potters know that they can borrow enough from their trader to see them through the difficulty. Bonds of compadrazgo, as well as of debt, usually tie a potter to a particular trader, further cementing the relationship. López cannot remember the number of times that he and his wife have been called upon to fulfill this role. They

have been godparents of baptism, graduation, *quinceaños*, and marriage, and are bound in one way or another, beyond a business relationship, to most of the potters whose work they offer for sale.

With his week's income ensured by the trader's weekly order, the prudent potter attempts to minimize the risk of not being able to fulfill his obligation. He overproduces the order by one or two examples of each of the items the trader has ordered. If all survive the manufacturing and firing processes, the potter gradually builds up a backlog of extra wares, which he can sell to the occasional itinerant trader for an unexpected windfall.

When Foster visited Acatlán in the spring of 1959, he found that pottery was being made by about 200 individuals, who were members of about 80 families (Foster 1960:207). These figures do not differ significantly from those given eighteen years later either by Alfonso López, or by Mario Martínez, a potter. These figures, however, include only those households that are engaged in the production of pottery as a full-time occupation. There are an unknown number of people, often women whose husbands are employed at other occupations, or widows, who engage in pottery making on a part-time basis. Most of the production of these latter, sometimes referred to rather scornfully as "amateurs" or "doodlers" by the full-time practitioners, is that of small domestic wares for the Sunday market or of some of the tourist wares (fig. 14).

Even full-time practitioners in Acatlán barely get by economically and still feel themselves, as Herón Martínez told Foster in 1959, "the lowest people in the social structure of the town" (Foster (1965:46). After a brief review of the literature, Foster (1965: 47) concluded that

> more intensive fieldwork will indicate that the position of potters in peasant society generally is not high, and that given reasonable alternatives, a majority of potters will try to abandon the profession. The explanation for low status probably is found in the combination of average low income and the feeling that the work is dirty.

Foster limited his investigation to peasant societies because in primitive societies one does not usually find craft specialists such as potters. A survey of complex societies, such as our own, would have produced similar findings. It is almost a cultural universal that potters throughout history have been poor, anonymous, and have enjoyed little status. There are exceptions, as Charleston (1968:9) explains:

> The potter has usually been a humble craftsman, providing the world with its utilitarian wares, and only occasionally rising to a higher plane of artistic pretension in the execution of some special commission, as when the 17th century English country potter made a slipware dish to commemorate a wedding or a birth. Such pieces survive when the plainer products which were the staple of his trade have long since been broken and discarded. Sometimes, however, the potter has aspired to the status of an artist.

Fig. 14. Attempting to sell a few wares at the Sunday market.

It is this latter phenomenon that is responsible for the excep-
tions. There are and have been among potters, artists who, since
Andocides and Euphronius, have lost their anonymity, becoming
rich and famous. Few, however, can be said to have gained much
status until the twentieth century. Two examples are Bernard
Leach, an Englishman, and Shoji Hamada, a Japanese, close
friends and working colleagues. Leach received an honorary doc-
torate from the University of South Wales in 1961 and in 1966 the
Order of the Sacred Treasure 2nd Class in Tokyo, the highest Jap-
anese honor ever given to a British commoner (Hodin 1967:15).
Until his death in January, 1978, Hamada was one of the most cel-
ebrated of Japanese contemporary artists in any medium and, ac-
cording to Munsterberg (1964:247), "in 1955 the Japanese govern-
ment, by designating him an Intangible Cultural Treasure of the
nation, bestowed on him the highest honor it can give to an artist
working in a traditional craft."

Although partially for the sake of tourism, as Graburn (1970:
203) suggests, Mexico is beginning to recognize the artists among
its potters. None has yet achieved the stature of a Leach or Ha-
mada, although many have gained international recognition, and
prices for their work reflect this fame. Some of these potters have
been previously mentioned; others are Aurelio Flores of Izúcar de
Matamoros, Puebla; both Armando and Simeón Galván, brothers
of Tonalá, Jalisco; and Jorge Wilmot of Tonalá. The last named,
one of Mexico's most copied potters, is responsible for revolu-
tionizing ceramic techniques in Tonalá. Gutiérrez y Gutiérrez

(1970–71:36) explain that Wilmot "in the past few years has developed a ceramic fired at high temperatures according to modern Japanese techniques but retaining the exquisite traditional decorative style of flowers, animals, and the sun."

Possibly not Wilmot's equal in terms of artistic merit, but certainly as influential, is Acatlán's "favorite son" Herón Martínez Mendoza, also one of Mexico's major contemporary artists. His work has been one of the major forces in effecting recent changes in the ceramics of Acatlán. He has, according to Espejel (1972:36),

> given new dimension to the craftsmanship of that village. Herón came from a family of traditional potters. He began to work with traditional forms: the olla and the *cántaro*, but later began to conceive new forms derived from the candlesticks traditionally used for November's festival of the Day of the Dead. A great variety of forms is owed to his imagination such as the hanging candelabra, the musical animals, and the other pieces that have little by little been increased in size, and that now characterize Acatlán. [My translation]

Since Foster's visit in 1959, Herón's work has grown progressively larger, freer, more ornate, and more carefully executed. As he has become more inventive, his pieces have become less repetitive, and unique. They have commanded higher and higher prices. As he has grown more successful, he has become liberated from the need to mass produce sixty to eighty nearly identical objects each week for 25 to 50 pesos apiece. He exhibited at a major show at the Museo Nacional de Artes e Industrias Populares in 1968, and has been represented by a Mexico City gallery since then. In 1975, at an exhibition of ceramics from the entire country selected by the Board of Tourism, one of his candelabra was offered for sale for 10,000 pesos—at that time worth 800 dollars in United States currency.

As Herón has grown increasingly wealthy, he has spent his money acquiring more land and making improvements to his house, adding a sidewalk, window glass and grilles, indoor plumbing, and tiled floors. Other material goods include furniture, a telephone, television, stereo, and two automobiles. His children are attending, or have attended, college. One son is attending art school, but none has, as yet, followed Herón into his trade.

Herón's affluent life-style has not passed unnoticed. Foster (1964:43) recounts several explanations used by villagers of Tzintzuntzan to explain the acquisition of wealth by one of their number. Of these, the "tapping of outside sources of wealth by supernatural or lucky means," is closest to the one used by Acatecans to account for Herón's success. Luck, rather than supernatural forces, is to blame; interestingly, the luck involved seems to have been Foster's 1959 visit to Acatlán and his selection of Herón as informant. The other potters feel that it was the ensuing publicity that was responsible for Herón's good fortune. "Why him?" they ask. "It could have been any one of us." Their envy of his success

has provided the impetus for ceramic experiments in their spare time as they attempt to perfect new forms and designs. Some of these prove to be successful enough to become part of Acatlán's new tradition.

4

Mario Martínez Espinosa
and His Family

Mario Martínez Espinosa is a more typical potter than Herón. Mario is, in fact, typical of not only the majority of Acatecan potters, but of potters in general. He is poor, yet not as poor as many in Acatlán. He is unknown to the outside world, yet he enjoys a great deal of prestige among his peers for his excellent craftsmanship. He is addressed as "maestro" by those who are not his intimate friends. Mario is 41; Teresa, his wife of 22 years, is 38. They live with eight of their nine surviving children across the street from Herón Martínez, a distant relative. Teresa is a good wife and an excellent mother; Mario is an excellent husband and a warm and affectionate father. They are a hardworking, close-knit family and, even among the children, quarrelling is kept to a minimum. Both verbal and physical affection are frequently exhibited among all members of the family. Laughter and joking are common, but the jokes are never at the expense of others. Even at the height of the rainy season, when no pottery has been fired for three weeks or a month and the family has gone deeply in debt simply for food, morale does not seem to suffer. In a discussion of the dynamics of poverty-stricken Mexican families, La Farge (1956:ix) finds an almost diametrically opposed situation, as

> among the striking things about these families are their general *malaise*, the rarity among them of happiness or contentment, the rarity of affection. Demonstrative affection or, except during a relatively brief courting and initial mating period, what we usually mean by "love" are rare among the poorer, simpler peoples of the world. Above all, where hunger and discomfort rule, there is little spare energy for the gentler, warmer, less utilitarian emotions and little chance for active happiness.

The Martínez family and their life together better illustrate Foster's thought (1967b:61)

> that in pottery-making families domestic relations run rather smoothly. Potting, more than any other occupation, requires the

intimate, smoothly integrated, continuing cooperation of husband and wife, and of the older children as well, if the family's economic needs are to be met. Potter spouses spend much more time in each other's company than do those in farming and fishing families, and continuing friction would seriously jeopardize the productive process. Moreover, the quiet, sedentary nature of much of the work encourages talk and an interchange of ideas and feelings not possible in the other occupations. If pottery-making does, in fact, encourage domestic bliss, it is an important compensation for the miserably low incomes that characterize most of these families.

Whether or not Foster is correct in assigning the responsibility for it to pottery making, Mario and Teresa, if not "blissful," are content with each other and their family. They are not, however, content with their lot in life, their "destiny," which is pottery making and poverty. Their income is certainly "miserably low." Even in Acatlán, Mario finds it difficult to support ten people on the equivalent of 40 to 50 dollars a week in American money. The family lives from day to day, almost from hour to hour, with any unexpected expense, such as illness or accident, wreaking financial havoc. Teresa then uses every avenue available to her, straining her account at the tienda as well as the bonds of friendship, kinship, and compadrazgo to their limits. At times, she has had to sell some precious family possession or use it as security for a loan she has no hope of being able to repay. Some of these crises are products of status maintenance—the purchase of a wedding or graduation present for a relative or neighbor or of flowers for a funeral. Failure to do so would result more in loss of face than in actual social ostracism. People would smile knowingly and clap their right hand to their left elbow in the gesture meaning *coda*, or "stingy." Continued failure to participate in these customary exchange gestures would seriously damage Mario's reputation in the community. Almost all of their friends and relatives are engaged in the same economic struggle, but everyone tries to "do what is proper."

From time to time two of the sons will earn a few extra pesos working for Señor López, or Mario will manage to sell a few extra wares to an itinerant trader, but the unexpected windfall seldom coincides with times of family financial crisis. These extra sums are not often used to repay debts, but are channeled instead into new clothes or shoes for whichever family members are the most in need. These are usually the oldest children; younger children, as in large families all over the world, having to suffer the indignity of hand-me-downs.

Keeping nine growing children in clothing, even with hand-me-downs, is a continuing struggle. Expensive, special-purpose clothing needed for baptisms, first communions, and graduations is not a problem; this is provided by the appropriate godparents. Providing the required school uniforms is more of a strain. These are passed around within the family from sister to sister and from cousin to cousin until they fall apart. The cost of these uniforms,

as well as of books and school supplies, has provided the family with enough of a financial problem that they have kept the children at home until they are seven or eight years old. Once in school, they are given every encouragement to do well. Both Mario and Teresa graduated from *primaria*, the equivalent of the United States six-year elementary school. Until recently, this was all the schooling that Mexican children were required to complete; now *segundaria*, junior high school, has been made mandatory. Both parents hope that their children will go farther in school than they did, and perhaps be able to escape the vicious circle of poverty.

Mario's father was a potter, as was his grandfather, and "on back for maybe a thousand years." Yet, of a family of five sons and seven daughters, only Mario and one brother have followed the family trade, and none of his sisters has married a potter. Teresa did not come of a pottery-making family. Her grandfather was a farmer until his death, and her grandmother, with the help of two of her sons, still farms the family land. After her husband died, Teresa's mother supported her family with a food stand in the market. One of Teresa's sisters followed their mother into this trade and owns one of the restaurants that also sells pottery on the highway, some of it Mario's. Teresa's family helps in a number of other ways—her grandmother with fresh fruit and vegetables from the farm, her mother and sister with leftover food from their restaurants, her aunt, a physician, with medical attention and drugs. In return, Mario provides them with some of their pottery needs, particularly with some of the larger items, such as *barriles*.

Yet, as poverty-stricken as the Martínez family is, there are others even poorer, several of whom look to Mario and Teresa for help. Mario, for example, supplies prepared clay body and *tinta* to two or three old women, potters' widows. Mario charges them only 2 or 3 pesos for enough material to supply them for a week or more because "they would not be happy if they didn't pay, they would feel they were robbing me of my livelihood and they wouldn't come back, then I would be robbing them of theirs." These old women are among the part-time potters who produce some of the smaller domestic wares such as cups, plates, and *molcajetes*, as well as a few of the smaller tourist wares. Frequently, Mario will fire some of their wares along with his own—they take up no room in the kiln since most are small enough to fit inside objects of the size he usually produces.

Typically, in Acatlán as elsewhere, the nuclear family constitutes a pottery-making work group. Teresa knew nothing about the craft until she married Mario and, learning from him, has become his skilled partner. Oscar, their oldest son, wanted no part of this work. He found pottery making "dirty and boring," further stating, "besides, it doesn't pay." When he was sixteen, he took the first step toward realizing his ambition of becoming a physician when he left home to live with his mother's aunt, Doctor Altagracia De La Paz. He works after school in her pharmacy,

trying to earn enough money needed for his tuition both to the University of Puebla and to the medical school. Both Oscar and his brother, Salvador, 18, are still in *preparatoria*, the Mexican equivalent of the United States high school. Salvador and Juan, 15, also have higher ambitions than pottery making; Salvador wants to become a teacher, Juan an engineer. Both, however, work with their parents after school, on Saturdays, and during summer vacations from school, and are already extremely competent potters. The next four children are girls: María Luisa, 12; Teresa, 10; Alejandra, 8; and Veronica, 7. They help their mother with the cooking and cleaning, run errands, and take care of the youngest children, Martín, almost 4, and María Cecilia, less than a year old.

The family lives in a one-room adobe house, previously used only as a workshop and storage area—a fairly recent living arrangement. They formerly lived next door in a two-room house separated from the workshop by a narrow passage from the street to the patio. Financial reverses forced them to first rent one of the rooms and finally, in 1976, to sell the house and move completely into the workshop. The interior of this structure, roughly 5 by 7 meters, is lighted by a single 40-watt light bulb that hangs from the middle of the ceiling. A door open to the patio admits the only daylight now, as the single window has been boarded up for privacy.

All family indoor activity, sleeping, cooking and eating, as well as pottery making, is confined to this relatively constricted area. Much of the preparation of the raw materials takes place here and, during the rainy season, storage of the greenware as well. There is little in the way of household furnishings to interfere. The largest item is the parents' double bed, of metal painted to resemble wood. The "bookcase headboard" holds medicines and lotions, a few schoolbooks, and a picture of the Madonna and Child. The footboard is also a storage area and under the hinged top are kept precious family photographs and documents. In one corner hangs a wooden cradle, used by one infant until displaced by the next. The other children sleep on the earthen floor on petates; these are rolled up and stored in a corner during the day. The switch to the overhead light, with the only electrical outlet in the house, is to the right of the door to the patio. Under this stands a small table, once the stand of a treadle sewing machine. This serves sometimes as an ironing board, sometimes as a desk, but is for most of the time a radio table.

The other table, made of wood, is used for meals by the parents and the two oldest children present at the time. Only four can eat at once, sitting on the small handmade wooden chairs bought from a carpenter at the market. The other children are faced with the choice of waiting for a chair or sitting on the floor. Usually too hungry to wait, they opt for the latter. Cooking is done sometimes inside on a two-burner kerosene stove that rests on cement

blocks, sometimes outside. Outside cooking is done over an open fire, with an olla or a comal resting on three stones over a small fire, or sitting on an *anafre*, or brasero. The former is a purchased metal charcoal burner, the latter a ceramic made by Mario. The choice of cooking methods depends, to a large degree, more on what find of fuel is available at the moment than on what is being cooked. Other kitchen paraphernalia include the ubiquitous mano and metate; two aluminum saucepans; a few blue and white enameled metal cups, bowls, and spoons; and some assorted drinking glasses. The metate leans on the wall near the stove with the mano resting on it; the other items are stored in a wooden box that is hung on the wall as a shelf. Other wooden boxes are hung both on the wall behind the bed and near the light switch next to the door. The former holds school books and papers, the latter a screwdriver and other household tools, miscellaneous parts, and the iron and radio when not in use. As these last are the family's only electric appliances, it is convenient to store them near the outlet, although of course only one can be used at a time.

Another shelf hangs over the eating table. This one is carpenter made and serves as a family altar or shrine. On it are votive candles, bits of last year's palm, often a few flowers, and pictures of San Rafael, the barrio saint, Saint Francis of Assisi, and the Virgin of Guadalupe. Other wall decoration includes maps and pictures made by the children in school, some American baseball cards in a plastic cover, a three-year-old calendar kept for its picture, and a small mirror, with a few picture postcards and snapshots thrust into the frame.

A makeshift closet takes up one corner of the room, with a few "good" clothes hung on hangers from a line that is stretched diagonally from wall to wall for a distance of about 2 meters. The rest of the clothes are stored in boxes under and behind the bed and must be ironed before being worn.

Outside of the iron and the radio, the family's most expensive possessions are a bicycle and a Remington portable typewriter. They owned a burro, almost a necessity for a potter, but he died at the age of 15 in the spring of 1977, and the family cannot afford to replace him; between 40 and 50 dollars in American money, the equivalent of a week's income, is the price of a burro.

Of necessity, due to the size of the house, much of the housekeeping takes place on the patio. Here, under the shade of several trees, are a number of ceramic vessels made in various shapes reflecting their intended functions by Mario. These are filled with a hose from the faucet in the passage on the side of the house and are used for water storage, bathing, and dish and clothes washing. Other sanitary facilities are lacking, and the family uses any convenient area at the back of the lot near to the kiln to relieve themselves.

Pottery making in Acatlán is not a 9:00 to 5:00, Monday through Friday occupation. Although there is a somewhat recurrent pat-

tern from one week to the next, work schedules, if the term can be used, show a great deal of flexibility. A sample week in the Martínez household is fairly typical of that of many other potters' families.

A typical week begins early Sunday with the unloading of the kiln, with everyone in the family old enough to do so helping to deliver the finished wares to the trader. Once payment for these has been received, the family goes its separate ways. Teresa goes to the Sunday market, taking with her one of the older girls to help her carry the purchases home. The other older daughter remains at home with the younger children. Mario and his older sons might go to a sporting event, such as a bullfight or basketball, football, or baseball game. When he was younger, Mario was an excellent baseball player; now Salvador is the shortstop and Juan the batboy for the San Rafael team and Mario an active fan. If the San Rafael team is playing at home, Teresa will fix a picnic lunch on her return from the market and take it, and the younger children, out to the playing field. The family does not then regroup, however; Salvador and Juan remain with their teammates and Mario stays to drink beer with his cronies. Teresa joins the other women and children to sit and watch, and from time to time serves one of her family a taco or contributes a few pesos for *refrescos* or popsicles.

Sporting events are not the only recreational events that exhibit this separation by age and sex. The same phenomenon can be observed at most social events in Acatlán, such as christenings, birthday parties, *quinceaños*, weddings, or saints' days. These are held, whenever possible, on Sunday afternoon or evening to ensure a larger male attendance, as the later in the week they are held, the fewer the number of men that will be able to attend. Men contribute little to these events, however; they are first to be served, and they then gather into little groups to talk and drink while the women and children eat.

Whether or not there is a sporting or social event to provide the excuse, Sunday, and often Monday as well, is seldom a working day for Mario and some of the other Acatecan potters of his acquaintance. The time is instead devoted to socializing, errand running, and any repairs necessary to tools or equipment. Mario tries to arrange his time so that he can work uninterruptedly on pottery making once he gets started. By this time, however, the family is usually out of money, and either Mario or Teresa must go down and strike a bargain with Señora López in order to receive an advance. Once this has been done, Mario can plan his week. Usually, he will discover that some necessary component of the clay body is missing, and he or one of his sons must go to obtain it. Ideally, the materials will be obtained and prepared so that work can begin early in the morning on the following day. The ideal working day begins with plenty of prepared clay body; everything that is needed can be found; Mario, Salvador, and Juan are all ready to work; and Teresa or an older daughter is at home

to fetch and carry. In practice, this ideal is seldom achieved. One material or another is lacking, Mario is distracted from work, Salvador and Juan have to go to school, no one is at home to help out, a particular tool is lost or broken, or a needed *molde* loaned to a neighbor has not yet been returned. Somehow a solution is found to the problem, or a compromise is reached. When the inevitable can be postponed no longer, work is finally begun.

It takes Mario a great deal longer to get started when he is working alone. It is not only the greater length of time that it takes one person to prepare the materials and to collect everything necessary, but the fact that he must also overcome his reluctance to get back to work. With other people working, there is, at least, someone to talk to. Alone, he faces a long empty day of boredom. Boredom, a major irritation among production potters, is not one that is faced by those few potters who have achieved the status of artists. Herón Martínez is an example. Each of his pieces is different from the last, and Herón can find his work both interesting and creative. The luxury of creativity is one that is seldom shared by Mario and most of the other potters of Acatlán. For this reason, Mario is pleased when he receives an order for *macetas*, braseros, or *chimeneas*. These wares are decorated with faces and he can let his imagination run wild. Usually, however, he must reproduce the same item over and over again, "like a machine." Boredom is a reason frequently cited by young men who do not want to follow the potter's trade of their fathers.

The problem of boredom has been somewhat relieved by modern communications. For example, Richard Culbertson, a Frederick, Maryland, potter, watches television as he throws repetitive shapes upon the wheel. Acatecan potters, instead, listen to the radio, as does Mario. A favorite station is turned to in the morning and left on, sometimes through great explosions of static to avoid smearing clay on the dial and knobs while adjusting it. Sports in season are a prime favorite, and baseball, football, and basketball are followed. The continuing problems of *Una Mujer se Llamada Cristina* and other serial soap operas are found almost as interesting. Along with these are other programs devoted to news, news analysis, commentary, political debate, weather and general information. It is probably the radio rather than the schools that should receive the credit for the fact that Acatecan potters, including Mario, are not only extremely well informed, but speak a more standard Spanish than the average Acatecan nonpotter who does not spend so much time listening to the radio. Potters no longer consider radios luxuries, and many, including Mario, try to maintain a portable radio also, both to use on the occasions when the electricity is "decomposed," as well as to take out to the mine.

Other welcome diversions include guests who drop by or Teresa's return from church, the market, or a social affair with the latest gossip. Children, on their return from school, will report in some detail on "what I learned in school today" before starting in

on their homework or doing their chores. Neither the radio or conversations with guests or family members is allowed to interrupt the manufacturing process once it is finally started; any diversion makes the time seem shorter. Since working has been put off until it can be deferred no longer for fear of actually starving, only some major event is now permitted to interfere—the funeral of some close relative, compadre, or friend is one example. Mario worked through his nephew's wedding and the fiesta following it, as well as Oscar and Salvador's graduation from *segundaria*, or junior high school. He did, however, take an entire Saturday afternoon when Juan celebrated his first communion. Usually, Teresa, with all of her preschool-aged children in tow, attends weekday social affairs without Mario and reports to him everything that took place.

Working days begin with someone, usually María Luisa or another of the older daughters, rolling up the sleeping petates and storing them in a corner. Each member of the family who is going to work that day then lays out an old petate and on it assembles those tools, materials, and pieces of equipment that he will need (fig. 15). Included will be those molds that he will be using in his first hour or two of work. Once someone is settled down and working, it is only with great reluctance that he gets up for any purpose other than to eat or to relieve himself. Ideally, there is a child to carry work and molds to and from the drying yard, refill the water can, find a lost or forgotten tool, and bring drinks of water. With his sons working beside him, and his wife and younger children around to help, working days are both easier and more interesting for Mario. Between conversation and pottery making, the time goes quickly.

Fig. 15. A workspace.

5

The Materials of Pottery Making

The Clay Body

The one basic requirement of any pottery-making activity is a suitable clay or clay body. That these two terms are not synonymous is emphasized by Hamer (1975:30), who defines a body as

> a clay for a special purpose. It is created by blending different clays or by adding to clays other minerals, such as feldspar and flint, in order to produce a desired workability or finished result. A body is the result of man's technology. A clay is the natural product, though possibly simply processed to make it homogenous.

Among modern Western potters, there are probably more formulas for clay bodies than there are potters. Each potter uses a different body for different purposes, such as throwing, casting, or handbuilding. Considerable space in *Ceramics Monthly* is devoted to discussion of various body formulas, along with their advantages and disadvantages. According to William O. Payne (1970:5), this interest was apparently not the case in pre-Columbian Mesoamerican ceramics. His microscopic analysis of Valley of Oaxaca pottery samples, dating as early as 1400 B.C. and as late as A.D. 1500, indicated that "potters used their materials virtually as found." Additives appear only after these natural deposits have been depleted, and potters were forced into an attempt to duplicate the natural bodies that they were accustomed to using. Payne finds this the case at the end of the Sung dynasty in China, and that "generally similar changes may be observed in the Southwest of the U.S. and in parts of Mexico just before and since the Conquest. With the diminution of natural deposits, the potters were forced to duplicate the qualities of the originals by using additives, such as river sand or crushed potsherds."

Unlike either pre-Columbian Oaxacan potters, who used an unaltered natural clay or modern western potters with their individual formulas, Acatecan potters share a common fabric. The

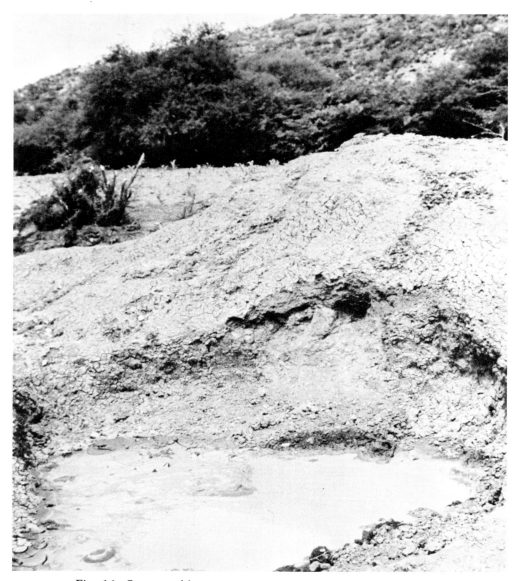

Fig. 16. Source of *barro negro*.

paste formula in common use among them differs little from pot-
ter to potter and is identical, according to Mario Martínez, to that
of a surface collection of Late Postclassic sherds made on the
Loma Flor (map 3), a hill southwest of town, in August 1974.
Three ingredients, plus water, make up this body: *tierra colorada*,
50 percent; *arena*, 25 percent; and *barro negro*, 25 percent. (For an
analysis of these materials, as well as *tinta*, the material used as a
paint, see the Appendix.)

There have "always" been potters in Acatlán because "every-
thing was right for us." Among factors cited by Acatecan potters
contributing to Acatlán's fame as a ceramics center were both its

location on heavily traveled main roads and its popular weekly market. The once-abundant supplies of fuel and suitable clays were of equal importance. Now, increased population pressures, along with an increase in land fenced and cleared for farming, has resulted in longer trips into the mountains and desert outside of town for materials, as well as a shortage of fuel for firing. *Barro negro*, for example, is no longer available for the taking, but must be purchased from the owner of the land on which it is found (figs. 16, 17). Although the owner is a potter, and lives and works around the corner from the Martínez family, his farm is southeast of town at Km. 255 on the Pan American Highway (map 3). The *barro negro* must be brought by truck from this location. Half a truckload costs 90 pesos, and constitutes a supply sufficient for three or four weeks. After it is delivered, it is broken up into small pieces with a flail, dried in the sun, and stored in large ollas, under plastic, to keep it dry until needed.

Barro negro is the only material that is stockpiled since half a truckload of it must be purchased at one time. Because storage space for other materials is lacking, trips to obtain them become almost a daily occurrence. Fortunately, both of the other materials used in the clay body are closely located and easily obtained. *Arena* is dug from a *mina* in the first range of hills west of town (map 3). Each family uses its own *mina* until the supply is exhausted or until the tunnel is too deep to work safely. No one does any timbering of the tunnels, and the hills are pockmarked with abandoned *minas*, none more than 2 or 3 meters deep (fig. 18). *Arena*, a soft grayish-white material, is easily picked loose, then loaded into two 20-liter oil cans with a shovel. These cans are tied to either side of the burro's wooden saddle (fig. 19); an additional amount can be carried on top of the saddle in a canvas bag. The pick and shovel are tied on last, or are left in the *mina* to await a second trip.

Fig. 17. Source of *barro negro*.

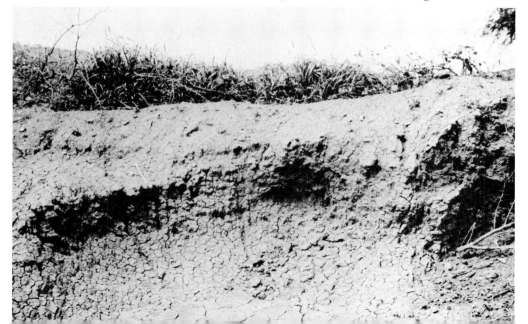

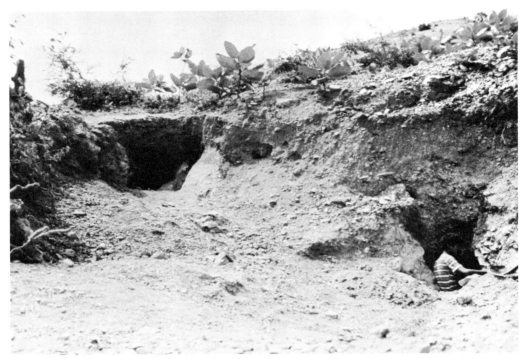

Fig. 18. Mining *arena*.

Fig. 19. Loading the burro with *arena*.

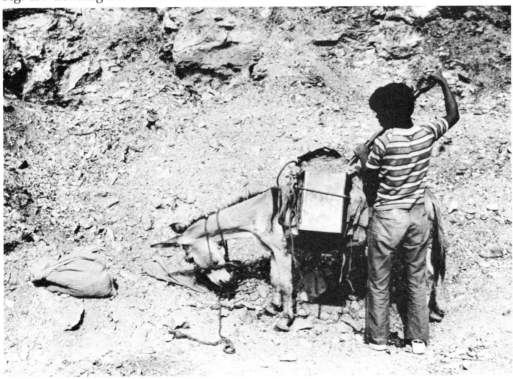

Tierra colorada, used not only for half of the clay body but for a mold release, is also, fortunately, the easiest of the materials to obtain. It is easily dug from one of a number of pits behind the Panteón, less than a kilometer south of the Martínez household (map 3). It is seldom compacted enough to require picking and can be shoveled directly into the oil cans (plate 6).

Water is essential to every stage of pottery making, including firing. In the archaeological past, potters have had to locate near streams or other reliable water sources. Present-day Acatecan potters are fortunate to have running water brought at least to their patios by the Río Balsas Agua Potable project. In common with other Acatecans, the Martínez family keeps three or four *barriles* filled with water from the hose that is always attached to the faucet. The water is used from these *barriles* for everything: drinking, cooking, dish-washing, bathing, laundry, and the baby-bottle, as well as for pottery making. On the occasions when the city water has been off for some time and the stored water is used up, someone, usually Juan, must take the burro for more. It takes three or four trips to the well behind the Panteón, with the burro loaded with four *cántaros*, to fill the *barriles*. This chore must be repeated two or three times a day for as long as the water supply is turned off. During these periods, water is used only for essentials; cooking and pottery take priority over dishwashing and laundry. The necessity for this is viewed with disgust, but not surprise, as problems with the water and electricity are common occurrences.

When all of the materials have been obtained, initial preparation begins. There is no set location for this procedure; sometimes it is done inside the house, at other times in the yard or even in the street. Many potters find it more efficient to prepare both *tierra colorada* and *arena* at the mines, as both materials must be reduced to a fine powder and sieved before they are used. An old petate or a piece of canvas is spread out on the floor or ground, and the material is emptied out on it. It is then beaten into a fine powder by flailing it with a heavy stick. Often, two of Mario's sons will take part in this chore, rhythmically beating in turn until the job is done (fig. 20). *Tierra colorada* is more quickly pulverized than *arena*, and it reduces to a finer powder. Any foreign matter or large particles are separated by sifting the material through window screening onto a sheet of canvas or plastic (fig. 21). The fine material is then easily poured into one of the 20-liter cans, or some other container, until time to mix the clay body.

The Acatecan formula, as stated by Mario, consists of 50 kilograms of *tierra colorada*, 25 kilograms of *arena*, 25 kilograms of *barro negro*, and 20 liters of water. Since no one weighs or measures any of the ingredients before mixing the clay body, this represents the ideal. An old petate is laid out on the floor and the pulverized *tierra colorada* and *arena* are emptied out onto it, with about twice the amount of *tierra colorada* used as *arena* (fig. 22).

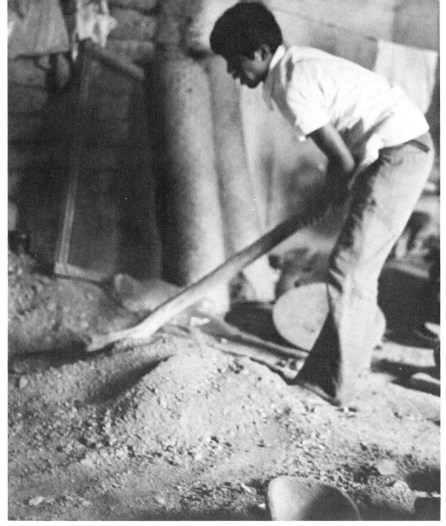

Fig. 20. Flailing *arena*.
Fig. 21. Sifting *arena*.

These two materials are mixed together thoroughly by hand. If the color is not judged to be exactly right by Mario, the blend is corrected by adding more of one or the other ingredient. The dry mix is then heaped into a mound and a large depression is made in the center for the *barro negro*. This rather intractable material is also prepared by crushing with a flail, but it is not sieved until after it has been mixed with water. It is added, little by little, to the water in an *urna* or a 20-liter oil can and mixed into a thick soup. Mario himself does this by hand. With both arms immersed up to the elbows, he pinches out any lumps. One of his sons or his wife helps by pouring in more water or *barro negro* as called for.

The final steps in the preparation of the clay fabric are performed when the "soup" is ready. The screen is placed on the dry mix and the *barro negro* is poured through, a little at a time, into the dry material. Everyone present then works rapidly to mix the two together before the liquid material has a chance to run off onto the floor. This process is repeated several times until all of the wet mixture has been added to the dry. On occasion, too much has been added, making for a very gummy body; more *arena* is mixed in to correct this. Anything that will not go through the screen is discarded, and the screen is put out to dry in the sun. When all of the clay material has been mixed together, it is taken in small amounts of about 5 kilos at a time, wedged, and then stacked on a sheet of plastic. When all of the clay body has been wedged, usually into about twenty-five loaf-shaped pieces, the pieces are sprinkled with water and covered with another sheet of plastic until needed. They are taken one at a time and wedged again just before use.

No matter what clay or clay body is being used, all potters wedge their clay, for a number of reasons. Lawrence (1972:108) explains that wedging serves to randomize the arrangement of

Fig. 22. Mixing the dry ingredients.

particles and to distribute the moisture more uniformly through-out the mass. Air bubbles and excess water are removed at the same time. Another important point emphasized by Nelson (1971: 143) is the considerable effect that wedging has in increasing the plasticity of the body, particularly beneficial in a coarse clay due to the realigning of the particles.

For several reasons, wedging clay seems to be a universal prac-tice among potters, although methods may differ from culture to culture. Most western potters stand to do this work at a wedging board or table. The lump of clay is cut with a wire; the two halves are then reversed and slapped together with great force. This cy-cle is repeated two to three dozen times until all of the air bubbles are gone and the ball of clay is completely homogeneous. Mario and his sons use a method of wedging called the Oriental, or Jap-anese, method. This is described by Bernard Leach (1973:51):

> The Japanese knead their clay by a two-handed rotary movement with the weight of the shoulders coming down rhythmically on the right wrist. Fifteen to thirty pounds of clay are handled at a time; the clay is turned slowly clock-wise mainly by the left hand, the right hand taking a fresh hold after each pressure and release. The effect is to move the clay on the outside towards the centre of the mass whence it works out slowly to the circumference again.

Leach (1973:52) pictures this process being done at a table. Mario and his sons, in common with other Acatecan potters, kneel on the floor, keeping their work on the petate.

Although methods of wedging differ, potters seem to be in uni-versal agreement that it is a necessary step in the preparation of a clay or clay body. This is not the case when it comes to aging the clay. In Acatlán, pottery making often comes to a stop for lack of materials, and time must be taken to prepare more. Indeed, be-fore this can be done, someone usually must take the burro and go for more *arena* or *tierra colorada*. Mario seldom does this now that his sons are old enough for the task, preferring to stay work-ing and using up the previous batch of paste. This is in sharp con-trast to the practice of many other traditions wherein the clay is felt to improve with storage. Even at Coyotepec, Oaxaca, Van de Velde and Van de Velde (1939:29) report that the clay after beating "is then put in the *pila* (a small cemented tank), covered with water, and left to stand until saturated, a period of twenty-four hours."

Among modern potters, there is much folklore and little under-standing regarding aging. Rhodes (1973:71) refutes one of the most common myths: "It is said that Chinese potters put down clay for their grandchildren and use that which was prepared by their grandfathers. But in all probability even the Chinese are not so well organized as that, and their pottery shops are probably chronically short of aged clay, just as ours are."

Bernard Leach (1973:48), who worked in Japan for many years and is regarded as a primary authority by modern potters, insists

that "clay is improved by long storage; it gains in plasticity, its decomposition continues, it changes colour, and may even begin to stink. I have been told of old potters who speak of such matured, or soured, clay with the quiet impressiveness of epicures discussing vintage wine."

Hamer (1975:2) differentiates between aging and souring. Aging, he states, is physical action involving

> the slow penetration of water between clay particles giving a net result of more particles of smaller size. This means a higher plasticity. . . . Souring is slightly different: it involves organic action. Bacteria in the clay break down the organic matter and multiply. In so doing they create a colloidal gel through the water which is between the clay particles. This gel has the property of plasticity which adds to that of the clay.

Potters have known empirically for thousands of years what aging does to clay. Science has put this knowledge on a firmer basis, as Michaels (1958:29) says:

> Recent experimental evidence suggests rather convincingly that aqueous suspensions of monovalent cation forms (lithium or sodium) of Kaolinite, when allowed to age for extended periods of time, gradually convert to aluminum forms of the mineral. This apparently results from a gradual sloughing off of aluminum (as aluminum hydroxide) from the crystal edges, which then replaces the monovalent ions on the crystal faces. The conversion process, as might be expected, appears to result in flocculation of the clay. In all probability, the characteristic stiffening of clay pastes on aging under moist conditions, or on mechanical blending, is due, at least in part, to this conversion process.

Mexican potters, in general, do not seem to age their clay. Foster does not mention the practice (1948, 1955, 1960), nor do Espejel (1972, 1975) or Hopkins (1974). Diaz (1966:143) finds in Tonalá, Jalisco, that "the regular pattern is for the clay to be made into paste in the morning, often before early morning Mass, and then it is allowed to 'rest' until after breakfast when the next step in the process is begun."

Van de Velde and Van de Velde (1939:30) find the potters of Coyotepec well aware of the practice of aging, sometimes taking the trouble to store and "ripen" some clay when contemplating the manufacture of some especially fine pieces. This assertion is doubtful: Foster does not mention aging in his discussion of Coyotepec, and Shepard (1968:52) feels that in the few ethnographic cases reported of prewheel potters storing clay, the habit was learned from Europeans.

Mario, in common with the rest of Acatecan potters, does not prepare his clay fabric until needed. If there is no place to store even a small supply of raw materials in the small houses in which most of them live, there is certainly no room for several months' supply of aging clay. The clay body does not seem to suffer from lack of aging. Possibly the large percentage of *barro negro* in the

body formula is the reason. *Barro negro* is a montmorillonitic clay, very plastic, with a high shrinkage rate, and a tendency to crack in drying. Montmorillonites are very gummy and must be added to water, rather than having water added to them. Western potters use as little as 1 to 3 percent in their clay bodies when improved plasticity is needed.

In a discussion of the theory of aging, Mario stated that the clay in other parts of the world was not as good as that in Acatlán and that anything people could do to make it better would, of course, be tried. He also felt that people will continue doing things the way they have always done them, even if there no longer exists any good reason for doing so.

Paints

Acrylic paints used by some Acatecans are sold in a number of places in the town. They are available, as are brushes, in the paint store on Miguel Hidalgo, a block east of the Plaza de Armas, as well as at the Sunday market. Many of the people who use acrylics buy them at one of the variety stores, or at the closest tienda, where they can charge them. Sold in bottles, rather than tubes, 20 milliliters cost 3 pesos.

Both redware and blackware produced for the tourist market owe their highly polished finish to a substance called by the potters *tinta* (see Appendix). *Tinta* cannot be called a slip, as it contains very little clay; it is closer in form to the coloring oxides used by western potters. It is prepared by soaking iron-bearing rocks in water until a thick paint results. This is started about an hour before the paint is actually needed. When first made, this paint is used for the second, or final, coat. It then "passes" to being "old" and is used for the initial or first coat of the next lot of wares, before being discarded.

The *tinta* is obtained from a small *mina* in the mountains 5 kilometers southwest of town (map 3). It is a difficult trip with the burro, up and down hill and along a narrow track close to a mountain stream. The round trip, the mining, and loading the burro take about four hours. The *mina* is about 5 meters below the crest of a steep hill, and there is only a narrow ledge from which to work. An inside sheltered source is sought because rain washes all the "good color" from the stones, rendering them useless. The burro is tethered in a safe place to browse until enough material is picked loose. It is then led carefully down the steep slope and loaded for the difficult trip home. Fortunately, enough *tinta* is obtained in one trip to last almost a year. The burro can carry somewhat more than 100 kilograms, and only 2 kilograms or so are used in preparing a week's supply. Despite the arduous and somewhat dangerous trip, the entire family goes along. They make a holiday out of the occasion, taking a picnic lunch, picking desert fruits such as pitahaya along the way, splashing in pools of water if the stream is not dry, and generally enjoying the day.

A problem Acatecans share not only other Mexican potters, but with the rest of the world, is the increasing shortage of fuel. Older people say that sixty years ago forests grew to the very outskirts of the town and that they were filled with wild animals, such as bears, coyotes, wolves, wildcats, rabbits, and deer. The predators killed livestock, and the rabbits and deer ruined gardens and corn crops. Since the Revolution, the government has allowed these animals to be hunted and has granted permission to clear the forests for more farms and fenced fields.

As a consequence, there is little wood now for potters' kilns, though when it is found it is used. Currently, the most commonly used fuel is cactus, but even this must be sought farther and farther from town as competition increases for the scarce supply. Jiotilla (*Escontria chiltilla*) and pitayaha (*Cereus pachycereus*) are the species most favored. Two larger species, known popularly as *órgano* (*Cereus marginatus* and *Cereus gemmatus*), are not suitable for the average potter's kiln. They grow to a height of 8 to 10 meters, with branches a meter in diameter. They are difficult to cut down and too large to fit into the kiln openings. They are used, however, by brickmakers to fire *ladrillos*.

Few potters take the time to hunt their fuel, yet the price, when one can find a vendor, has been climbing steadily. In 1974, the cost for four *cargitas*, or burroloads, of cactus was 80 pesos (fig. 23). By the following year, only two *cargitas* could be bought for that price, not quite enough to fire the kiln once. By 1977, the price for two somewhat smaller *cargitas* had jumped to 150 pesos, but this was after the peso had been devalued. Fuel has to be

Fig. 23. The fuel vendor.

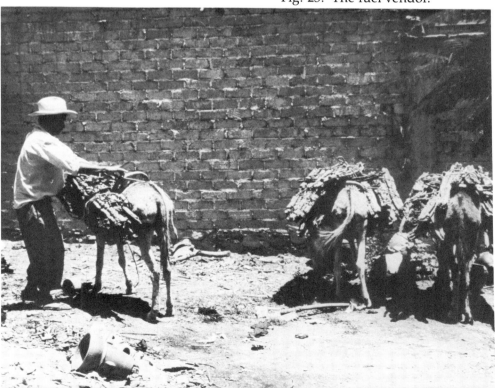

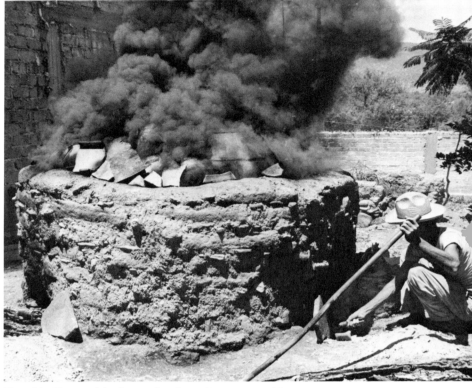

Fig. 24. Dense black smoke from burning rubber.

brought increasingly greater distances. In 1977, it was brought from Boquerón, 9 kilometers north. Boquerón is only about a fifteen-minute trip by car, but a loaded burro will take two hours or more. It is said that there is very little more cactus to be had in the vicinity of Boquerón, and there is talk of trucking it from Petlalcingo, 23 kilometers south on the Pan American Highway.

Potters have tried a number of substitutes: rubbish, sugarcane, and cornstalks, among others. In 1975, potters discovered that the addition of a bag or two of cut-up tires added to two or three *cargitas* of cactus would suffice for a firing. Two bags of these cost then 10 pesos and the price, unlike many, has increased only slightly (reaching 12 pesos).

There is competition even for tires, not only with other potters, but with sandal makers, who use them for soles (plate 7). There is fear that increasing scarcity will force up the price of these out of reach. Tires are not a satisfactory fuel and cannot be used alone, as they burn too quickly and with too hot a flame. Even in combination with cactus, the results are uneven, and fire clouding often occurs in an oxidizing atmosphere. No one likes the eye-stinging acrid smoke of the burning rubber (fig. 24), and Mario worries that with every potter burning tires, the air pollution of Acatlán will equal that of Mexico City.

6

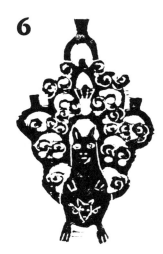

The Implements of Pottery Making

Tools

In contrast to some craftsmen, potters as a class do not require a great many tools. Many of these would be difficult to recognize as such by an archaeologist inasmuch as potters have a tendency to use any object at hand, discarding it immediately after use. Many tools are not only perishable, as are small sticks or pieces of gourd, but have not been altered enough to be recognizable as tools. Hopkins (1974:68) comments on the inventive nature of the Mexican potter:

> He picks the seemingly useless out of his surroundings and converts it to his special needs. This bent for invention may show in the arrangements for firing, or in the little items used daily in the shaping and finishing of articles: stones for flattening the clay tortillas or slabs, bits of sheet metal for shaping and scraping, corncobs for shaping and smoothing, rags or scraps of leather for wetting and smoothing, cactus thorns for striating or outlining, a horsehair or maguey fiber for deftly cutting a piece from its base after turning on the wheel, a crumpled nucleus or "soul" (*alma*) of newspaper around which to mold a rain spout, brushes of domestic animal hair for painting. But he is not above utilizing what mechanization has produced, so he smooths some pieces with a plastic sponge and substitutes nylon thread for the horsehair.

Of those tools listed by Hopkins, only the stones might survive to be discovered in an archaeological context. While in the southwest of the United States some pottery polishing stones have been recognized as such, the flattening stones mentioned by Hopkins would probably not be. It is more likely due to the nature of pottery-making tools rather than a lack of interest on the part of archaeologists, but little is found in the literature on the subject. Exceptions are Quimby (1949) and Houston and Wainer (1971). Usually, any discussion of pottery-making tools is incidental; Shepard does not go into the matter, Richter (1923:84–86) only briefly.

In general, potters' tools, both in Acatlán and elsewhere, can be divided into two major classes: those needed for winning and preparing the clay body, and those used during forming and finishing the wares. A third class could be added—those tools used in decorating the wares.

Few tools are needed for obtaining the materials. A *pica* is used to loosen the clays from the mine. This is more like an American crowbar than a pickaxe. It is a straight shaft of steel about 2 meters long and is wedge-shaped at one end. Mario has had his for about ten years and remembers that "it cost about 12 pesos." It is used like a wooden digging stick, for which it is probably a modern substitute. After the material has been loosened, it is transferred to 20-liter oil cans with an ordinary shovel. No pre-Columbian functional equivalents of this latter tool are known except among the Eskimo. Before oil cans were available, clay materials were carried in bags and baskets.

The dry materials of the clay body are prepared, either at the *mina* or at the potter's workshop, by beating them with a palo, or flail, until they are pulverized. Palos used by the Martínez family are made of wood, are 70 centimeters to a meter in length, and resemble a club (fig. 20). Preferred ones are branches with natural knots at the ends. An old baseball bat is sometimes used for this purpose. The Van de Veldes (1939:22) picture a similar implement, although this has an iron blade attached to one end for use in picking the clay from the ground.

A machete is the all-purpose cutting tool. It is used for gathering cactus and other woods, as well as to cut it into proper lengths for carrying and for burning. It is also used to cut up rubber tires, the alternate fuel, and as a wirecutter.

Very few tools are used in the actual manufacturing process. Some of these were pictured by Foster (1960:206); others have been added since. Mario, for example, no longer uses the reed knife pictured. Instead, he uses a *cuchillo*, a knife made of half a hacksaw blade, machine ground to a point by an automobile mechanic. It costs about 5 pesos to purchase a blade and to have it made into two *cuchillos*, but they are among the most used of Mario's tools. They are needed not only in a number of operations during the forming of the object, but also in decorating and finishing. Some cutting and piercing is done with a short piece of stiff wire, about 10 to 15 centimeters long. This wire is stuck into a lump of clay, which serves both as a handle and as an aid in finding it. Although not mentioned by Foster, the wire is probably a functional replacement for the cactus thorn listed as a tool by Hopkins (1974:68).

Each potter also has a collection of bits and pieces of wood, gourd, tin, or sherd, which he uses for thinning, smoothing, and shaping the work in progress. *Elote* is also used for these purposes, as well as for thinning and raising vessel walls. *Elote* are the rough corncobs pictured by Foster (1960:Fig. 6c). An object

called by Foster *elote liso*, smooth corncob, pictured in his figure 3a, is almost identical to some of Mario's tools. Mario says that these are *palo de sauce*, or willow wand. He cuts the willow growing by the river and carves several at a time. The four he is currently using were made five years ago, and he expects them to last another year or two before wearing too thin in the center to be usable. Used for shaping the rim of a vessel (fig. 25), they are 20 to 25 centimeters in length and 2 to 3 centimeters in diameter. These are also sometimes used as a measuring tool, as is any convenient stick or object that is the right length for the job at hand.

One of the most impermanent of the objects that must be considered under the heading of tools is a simple lump of clay. This is formed into a pestle shape as needed, used to tamp the paste until it conforms to the mold, and then returned to the common supply (fig. 26). Houston and Wainer (1971) describe a similar device from Oaxaca. These, called *azotadores*, are not only used in present-day Oaxaca, but have been found in Late Classic and Postclassic contexts (Houston and Wainer 1971:6). The major difference between these and the ones in use in Acatlán are that the Oaxacan versions have been fired and are a more permanent article in the tool inventory.

Tools used to decorate the wares in their plastic state include

Fig. 25. Shaping a toad's nose with the *palo de sauce*.

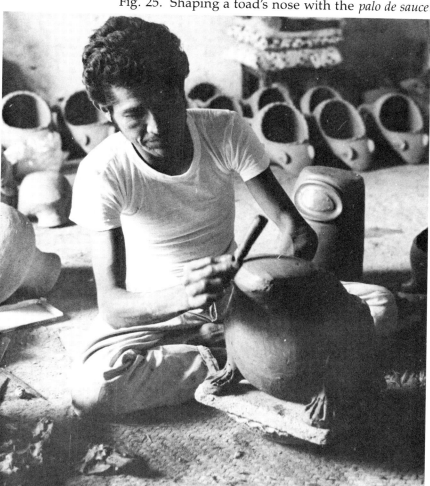

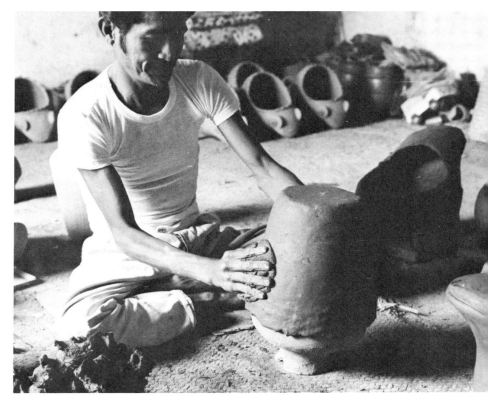

Fig. 26. Using a lump of clay as a tool.

the *cuchillo* and the short straight lengths of wire already mentioned, other pieces of wire bent into special shapes and used for stamps, pottery stamps, sticks, reeds, broken combs, hairpins, or any other object capable of leaving a mark on the clay while it is soft. Circles are now stamped with the mouth of a small glass pill bottle instead of the reeds used earlier, although a reed will sometimes be cut in half to achieve a semicircular pattern. Brushes are seldom purchased, but are made as needed with a few pig bristles lashed to a popsicle stick with sewing thread.

The only tools involved in finishing the wares are sandpaper and the useful *cuchillo*. Rags, both dry and wet, are used at every stage. Wet rags are used for the final forming of a lip, for adding a little water to a drying vessel being formed, and for coating the wares with *tinta*. Dry rags are used to blot up excess water in the bottom of an object, to "erase" mistakes in plastic decoration, and to polish the finished wares before they are fired.

Equipment

The equipment owned and used by Acatecan potters is extremely simple and is largely homemade. Two of the items, in fact, are so

simple that they have long gone unrecognized in archaeological contexts and are just now beginning to be understood. The first of these, the *parador*, was first described for Acatlán by Foster (1960: 207) who defined it as

> a flat-bottomed pottery saucer or casserole with flaring sides, averaging 17 cm. in diameter at the base, 42 cm. in diameter at the rim, and 10 cm. in height. The flat bottom of a used *parador* is much abraded from being rotated on the ground or on a reed mat. The *parador* is homologous to the Mama kabal.

Foster suggests that the use of these might date back to the occupancy of La Venta, basing this conclusion on artifacts found there that were almost identical to the *paradores* in use in Acatlán. Mario's are almost identical to those pictured by Foster except that the edges of Mario's are slightly more fluted to enable a better purchase (fig. 27). They are used to turn the work while it is being made or decorated (fig. 28). Although it has been suggested that they are the precursors, or primitive early forms, of the potter's wheel, a better comparison would be to the banding wheels used by many western potters for these same purposes.

As little understood as the *parador* was before Foster's pioneering work (1948, 1955), are *moldes*, probably the Acatecan potter's

Fig. 27. Setting a *ladrillo* on a *parador*.

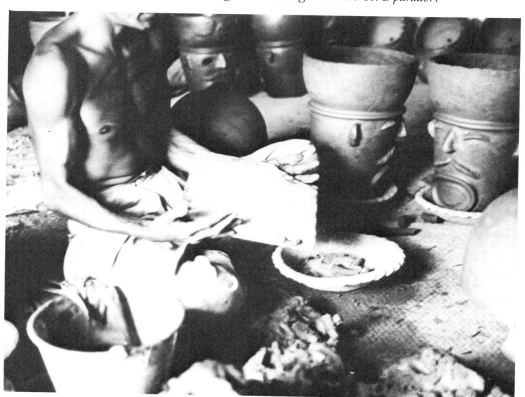

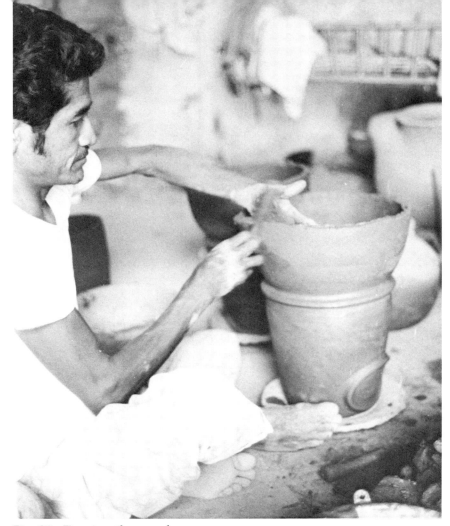

Fig. 28. Turning the *parador*.

most indispensable pieces of equipment. Three kinds are in use in
Acatlán: the press mold, the "mushroom" or convex mold, and
the vertical-halves mold. All three are now known to have been in
use in Mesoamerica before the conquest.

In Acatlán, press molds are used mostly for small details, such
as the leaves and flowers on trees of life (fig. 29). They are ex-
tremely useful for the rapid production of a large number of iden-
tical motifs. A potter finds it useful to have several press molds
with different designs. Mario uses press-molded details some-
times as decoration on a tinaja or *maceta*. The vertical-halves mold
is less popular, possibly because using it takes more time than
using the convex mold. Foster (1948:357) found that their use ap-
peared "to be limited to the state of Michoacán and immediately
adjacent areas." Mario, however, states firmly that they have "al-
ways" used them in Acatlán, although he uses them only for one
of the objects he manufactures.

The "mushroom" or convex mold is the most important of the

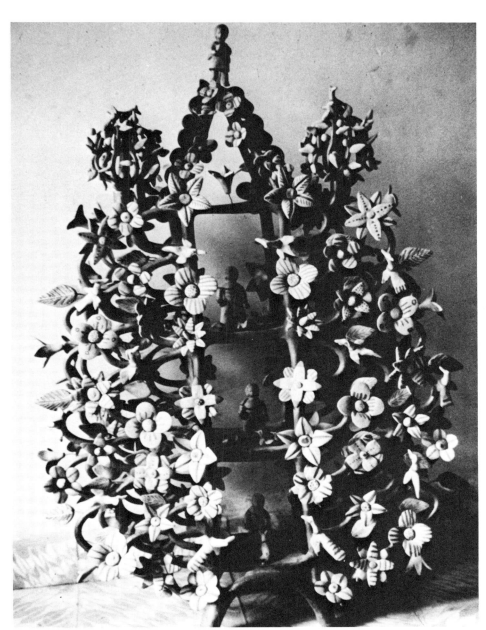

Fig. 29. A tree of life.

three, and is used for most of the work that is made in Acatlán, whether for the Sunday market or for the tourist trade. Mario has over fifty of these in his collection, in sizes and shapes suitable to any item he is likely to make (fig. 30). Some of them he very seldom uses now—for example, those for *molcajetes* (fig. 31) and other domestic wares. Some, including the very large molds he uses for *barriles*, are needed only occasionally. One of his molds

Fig. 30. Convex molds.

was made in 1932 and is among those he inherited from his father, who was also a potter; others are almost as old, including some that he purchased from a potter's widow. Most were made by Mario himself at various times when he needed a specific type of mold for a specific operation. Their origins can be told at a glance, as each was initialed and dated when it was made.

Moldes range in size from *molcajete* molds, about 10 centimeters in diameter and 7 or 8 centimeters high, to molds for *barriles* and *ánforas*, 80 centimeters to a meter high and 50 to 60 centimeters wide at the widest point. None has a "mushroom" handle, as pictured by Foster (1955:fig. 1). Some of the smaller molds, such as the *molcajete* and *cazuela* molds, are bowl-shaped or hemispherical, resting, in use, directly upon their rims if they are not small enough to hold in the hand. Others more closely resemble heavy jars and in use these, too, rest firmly on their sturdy rims. With the exception of the *molcajete* molds, which have a pattern incised, the molds have roughened exteriors, which serve to keep the paste from sticking to the surface. Walls are 1 to 2 centimeters thick, depending on the circumference and height of the mold. Broken, they are difficult to identify in an archaeological context, as there is nothing to distinguish them from "ordinary domestic wares."

After a work is removed from the molds, it is placed on one of three supports: a *parador* that is filled with pulverized *arena*, a *ladrillo* (fig. 27), or a *tabla*. This enables the piece to be moved about without damage between stages of the work. Alternatively,

the work can be turned in the *parador* alone, or supported by a *tabla* or *ladrillo* placed on the *parador*. *Ladrillos* are fired clay floor tiles 27 centimeters square that are purchased for a peso each from one of the three brick factories in town. These are not quite the functional equivalents of the *tabla* and have not, due to size, entirely replaced them. *Tablas* are fired clay discs made by the potter for his own use. They are smooth on the top, petate-marked on the bottom, and from 20 to 60 centimeters in diameter. Although *tablas* are used like *ladrillos* to support work in progress, larger *tablas* can be used as a clean work surface on which to roll out coils, make handles, and unmold a great number of press-molded details. *Tablas* are also sometimes used as wedging boards.

Most of the rest of Mario's equipment is purchased. Two pieces, the first quite ancient, the second relatively recent, are the petate (fig. 15) and sheet plastic. Petates date back in Mesoamerica at least seven to nine thousand years. Potters prepare their materials on them, do most of their work either sitting or kneeling on them, and occasionally use them to shade their wares from the sun to prevent too rapid drying. Petates are mats woven of tule or palm, come in a number of sizes, and are purchased either in the Sunday market or, if one is needed during the week, at Lupita's tienda on Avenida Reforma. The price varies according to quality and size, but a 1 by 2 meter petate from Amatitlán made of palm sells for about 35 or 40 pesos. New petates are not bought for pottery making, but for bedding, and the old ones "pass" into use in the workshop.

Fig. 31. *Molcajete* molds.

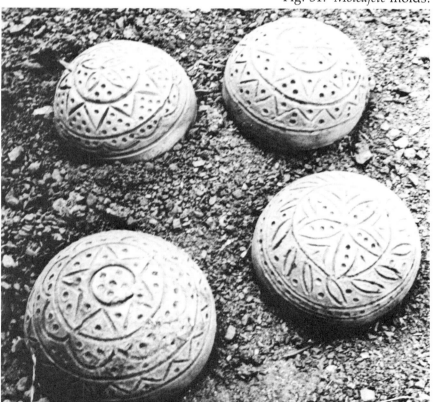

Sheet plastic is a recent innovation and has become so indispensable that no one can remember how he got along without it. It is sold for 2 to 3 pesos a square meter, the more expensive being twice as heavy a gauge. The plastic is used for a number of purposes—covering the prepared clay body until it is needed, keeping unfinished work in progress from becoming overdry should the potter have to leave it, and keeping the edges of an unfinished object moist enough to build on while the lower walls of a large vessel dry out enough to support additional weight.

Metal screening is also a relatively recent addition to the potter's inventory and is now used throughout Mexico to separate out roots, twigs, small stones, and other foreign matter from the clay. Presumably, this dross had to be removed manually before screen wire became available. The screening is nailed or stapled to a frame and the resulting construction resembles a window screen. This object is either supported above the ground on four stones or is propped up by a length of wood used as an easel (fig. 21). Sometimes it is leaned against a wall or tree while the dry material is shoveled through it. When *barro negro* is being mixed with the dry materials, however, the screen rests directly on these latter and the wet *barro negro* is poured, pushed, and rubbed through the mesh.

Containers of every size are used for everything from winning the raw materials to washing the sooty fired wares before they are sold. Empty jars and cans are saved for paint and water. Large 20-liter oil cans and canvas bags are bought secondhand. Other containers include whole and broken ceramic wares and plastic and galvanized pails, these last purchased for use in the pottery, but alternately serving the household.

Facilities

With the exception of their kilns, few Acatecan potters are fortunate enough to have facilities available that serve exclusively for pottery making. Space is at a premium in most of their crowded households and must be used as well for domestic activities. The yard behind the Martínez house and workshop is one example. It is partially divided into sections by the unfinished masonry walls that will someday add two rooms to the house. The second and smaller of the sections has become the home of a piglet, a recent capital investment. The first and larger of the future rooms is adjacent to the house and is the space most exclusively devoted to working purposes. This area is used for storage, both for molds that are not in use and for wares that are ready to be fired. Its major function, however, is that of a drying yard (plate 8). Both molds and greenware are dried here, the former before they can be reused, the latter at various stages of construction and after finishing. Although the sun cannot be considered a facility, it is certainly an ally of the Acatecan potter. The combination of the hot sun and the shadeless drying yard eliminates the need to

store drying greenware for days or even weeks before it can be fired.

On rare occasions, when their older siblings are in school and their mother must be absent as well, the smallest children might be put to play in the drying yard under the eye of their father. As a rule, however, most of the outside domestic activities are confined to the side yard closest to the water tap. Even here the space must be shared, as this is the area where the finishing touches are given the wares before they are fired and where any ashes or soot are cleaned off afterward. With the pig now occupying the space formerly used for drying laundry, Teresa has had to move her lines to the end of the lot outside of the house walls. This area used to be exclusively devoted to the kiln, wood storage, and storage of wares that are ready to fire. There is not much conflict, however, as the present scarcity of fuel precludes its storage, the finished wares are left in the drying yard, and on days when firing is to be done, Teresa is too busy to wash clothes.

Fig. 32. The kiln.

Mario's kiln is almost at the end of his lot and is separated by a narrow passage from his neighbor's wall (fig. 32). It is of the simple updraft type most common in Acatlán and found throughout Mexico where the indigenous kiln is still in use. It is an open cylinder, a little over 2 meters in diameter. The 30-centimeter-thick

adobe walls reduce the interior diameter to about 1½ meters. The outside height of these walls is about 1 meter. The inside depth varies, depending on the buildup of ashes, wasters, and mud. Usually, this buildup is shoveled out only once every three or four firings, this to level the floor with the outside ground (there is no grate to interfere with this operation). Three *hornillos*, or fire-mouths, are at ground level, spaced equidistant around the kiln walls. Mario's are shaped like equilateral triangles, 30 centimeters on a side. Some *hornillos* are square.

Mario built his kiln fifteen years ago with some help from his friends. He keeps it in good repair, mending cracks when they occur, and expects it to last indefinitely. If this is considered a "permanent" kiln, there is a second, less common type in use in Acatlán that can be called "temporary." These are built by Herón Martínez and his imitators to fire very large wares (such as the trees of life Herón has recently specialized in). Some of these extremely complex and fragile objects are up to 2 meters high, and they are extremely difficult to fire. They are set in place in the firing area, and a kiln of adobe blocks is built around them. *Hornillos* are included both at ground level and halfway up, although the kiln has been carefully fueled as it was built. These "temporary" kilns are similar in design, but not in proportion, to Mario's. They tend to be twice as high as they are wide, rather than the reverse. Temporary kilns are also used by the brickmakers. These hold 1,500 27-centimeter-square *ladrillos*, which have taken three men 5 days to make. They are fired on the sixth day in a temporary kiln similar to the other Acatecan kilns, though about twice the size of most of them. These *hornillos*, for example, are large enough to accept *órgano* as a fuel.

7

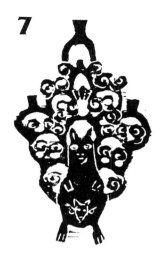

Making the Pottery

Almost all of the pottery made in Acatlán is formed on, or started on, the convex, or "mushroom," mold. Although Acatecan potters are familiar with most of the classic handbuilding techniques, any use of these is usually in combination with the convex mold. Concave molding, including the vertical-halves mold, is infrequently used. Press-molding, coiling, and slab-building are all techniques that in Acatlán are used in combination with convex molding. The "pinch-pot" technique, known to anthropologists as "lump-modeling," is used very seldom, as it is unsuited for most production work. The method used by most Acatecan potters is one that combines one or more of these basic hand-building techniques with that of convex molding. A simplified classification of Acatecan methods would include: simple one-step vessels using only the mold, molded and coiled wares, molded and modeled wares, compound molded wares done on two molds, and complex objects that employ more than two techniques.

The Basic Process

No matter how simple or complex the finished object is to be, the basic molding method is the same. The potter places the selected mold in front of him and, if it is still damp from previous use, he dusts it with pulverized *tierra colorada*, which serves as a mold release. He next takes from the mass at his side the right amount of clay for the object he is going to make and wedges the clay very briefly on the petate. The petate, too, has been dusted with *tierra colorada*, which is kept handy in a bowl at one side. After the brief wedging, the clay paste is flattened into a tortilla by slapping it with both hands (fig. 33). This action results in a round shape 2 or 3 centimeters thick, a little smaller in diameter than the mold that will be used. This tortilla is then picked up with both hands and placed on the mold (fig. 34). At this point, the paste neither covers the mold nor conforms to its shape; these changes are accom-

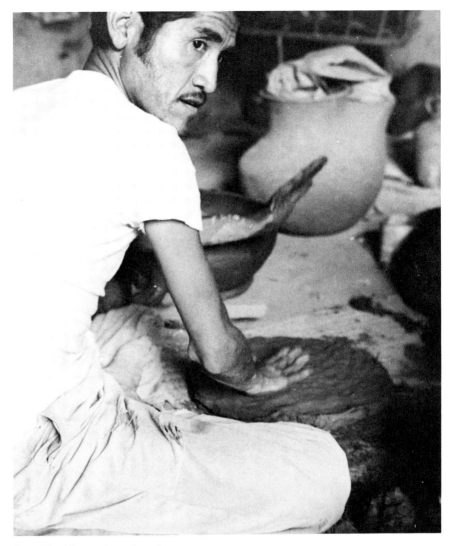

Fig. 33. Flattening the clay.

plished by the next steps. The tortilla of paste is, first, slapped with the palms of the hands and, second, tamped all over with a ball of clay until it assumes the shape of the mold (fig. 26). These actions are started at the top of the mold and worked downward and outward. Extending and thinning the paste is the next step, and this is also started at the center and worked outward and downward. If the tortilla has been made too thick, the excess is scraped off with a *cuchillo*; usually, however, rolling the paste with a piece of *elote* (fig. 35) until it extends beyond the edges of the mold is sufficient. The extra paste extending past the edges is next trimmed away with the *cuchillo*, and the piece is set aside until it dries enough to remove from the mold. The potter then repeats these steps with other molds until his first object is dry enough

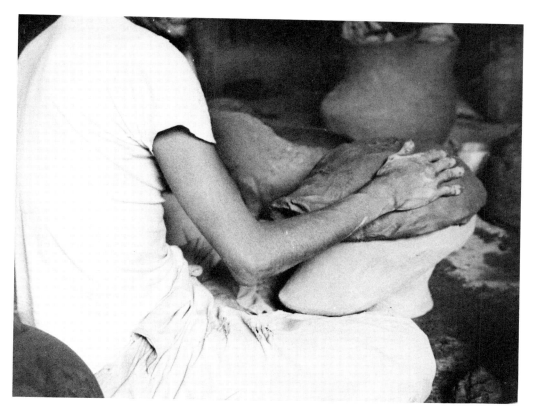

Fig. 34. Placing the paste on the mold.
Fig. 35. Thinning the walls with *elote*.

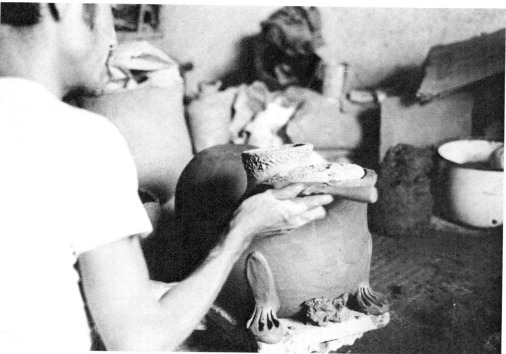

to return to. Mario and other master potters sit surrounded by works in various stages of completion, including up to a dozen starts still on their molds. This number, of course, varies with the skill and experience of the potter, the size and shape of the objects involved, and the thickness of their walls. The weather is also an important factor, inasmuch as drying times are doubled during the rainy season.

The next step, that of removing the started wares from their molds, is a crucial one (fig. 36). If the paste is still too moist, the object will collapse. If allowed to stay too long on the mold, the object will crack from drying shrinkage. The paste is removed by inverting the mold onto a *ladrillo* or *tabla* or directly into a *parador* filled with pulverized *arena*. The support selected depends both on the object's shape and on the way it is to be finished. As a general rule, those objects that have other than flat bottoms, and those that are finished by turning, are placed directly into *paradores* (fig. 28). From time to time, the paste sticks to the mold, a condition caused by using a damp mold or by using too little *tierra colorada*. Normally, the situation is quickly brought under control by tamping the resisting object with a ball of clay that has been flattened somewhat on the *tierra colorada* on the petate.

Up to this point, with a few minor exceptions, forming methods have been the same for all of the articles produced. These exceptions include ring-bases and tripodal supports that are added to some forms while still on the mold; most shapes, however, are flat-bottomed and need no other support. Simple one-step vessels require little more attention; after unmolding, the edges are finished and they are done. The *molcajete* is an example. Mario seldom makes these unless one is needed by Teresa or some

Fig. 36. Removing the mold.

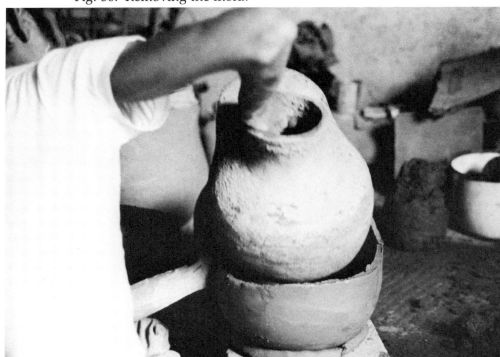

member of her family, and he has only a few *molcajete* molds (fig. 31) that had belonged to his father. Potters who specialize in domestic wares require three dozen or so, for the process is so simple and so rapid that an experienced worker can turn out a *molcajete* in less than a minute. In fact, it is so simple that this is one of the vessel forms chosen by the "amateurs" for specialization. The molds for these are deeply incised with the patterns and designs that will appear in relief on the interior of the finished *molcajete* and that function as the vessel's grinding surface. The molds are hemispherical, small enough to hold in the hand during use, with a size range of 10 to 15 centimeters in diameter and 7 to 10 centimeters depth. The tortilla of clay paste is quite firmly fitted to the mold to make sure that it is pressed into all of the incisions. The edge is next trimmed with the *cuchillo* flush with the edge of the mold, while the mold is still held in the hand. Before it is set aside to dry, three elongated lumps of clay are attached to the base. These are "pulled" to form feet by wetting the ends of the fingers of one hand and, grasping the lump firmly, at the same time drawing it away from the vessel to a point. The *molcajete* is then set aside to dry, still on its mold, and another is started. This sequence is repeated until the first to be started is dry enough to be unmolded—firm, but not yet leather-hard. *Molcajetes* are small enough to unmold onto the hand. Once in hand, the vessel is tapped on a *ladrillo* to blunt the feet, so that it will be wobblefree in use, and the rim is finished. For this, a coil of clay is added to the edge, firmed on with a rapid, circular, pinching motion, and then smoothed and thinned with a folded damp rag. Less than a minute is required for the entire finishing operation.

Other one-step vessels include cups, bowls, and casseroles. Bowl forms are the simplest, requiring little more work than a finished rim. Cups and casseroles have added handles. These are formed by rolling out coils on the *tabla*, cutting them to size, and curving them to the correct shape. They are then allowed to dry to leather-hardness before being attached to the leather-hard vessels for which they were made. Most single-step vessels are relatively small domestic wares intended for the Sunday market. Mario uses this system, however, to form flowerpots that range from 25 to 35 centimeters in height. Differences, other than their size, include a drainage hole at the bottom and a fluted edge. This type of edge is formed from a coil, added and thinned as was done with the *molcajetes*, and fluted immediately while it is still soft. Fluting methods differ among potters. Some hold two fingers on the interior of the rim and push the clay between them with the thumb. An alternative system used by many potters is simply to make successive depressions with the forefinger around the edge of the rim as the vessel is slowly rotated.

Molded and Coiled Vessels

The most common Acatecan pottery-making method, and possi-

bly the most ancient, is a combination of molding and coiling. With the exception of simple one-step cups, bowls, casseroles, and *molcajetes*, most domestic vessels are produced by this method, including those very large vessels of the sort usually made to order. These include, among others, vessels for water and grain storage, large planters, and *chimeneas* (figs. 10, 11), the space heaters mentioned earlier. *Pozoleros*, unusual vessels now little in demand, are also made in this fashion. *Pozoleros* are bottomless barrels used to line a spring or natural well to keep the sides from caving in.

The larger the vessel, the longer it takes to construct. When Mario makes any of these, it is usually done along with his regular work, for some of them require a day or more to construct. It took him, for example, three days to build three *cantimploras*, water storage vessels almost a meter high; these are sometimes also called *ánforas* (fig. 37). The first was started late on a Thursday afternoon, the second about 9:00 A.M. on Friday. Both of these were finished and a third started before work stopped Friday evening. These were built up gradually, as the vessel became firm enough to support the weight, of annular rings added to the mold-made base. These rings, one or two of which are added at a time, are 2 to 3 centimeters thick and 7 to 8 centimeters high. After they are added, they are scraped on both sides, first with a broken piece of gourd and then with a rough corncob, the *elote*. This scraping serves to weld the addition to the previous work and also to thin and raise the walls. During this sometimes vigorous procedure, a ball of clay is held behind the vessel wall that is being scraped to keep the wall from collapsing. While doing this, Mario sits on an unused, inverted mold and turns the *parador*, on which the work is resting, with the large toe of his right foot. The vessel is then set aside for an hour or so with sheet plastic covering only the edge. The covering prevents the edge from becoming too dry to accept the next addition, while the uncovered body of the vessel dries enough to support the added weight.

Cantimploras, *tinajas*, and *barriles* are all built in the same fashion—started on a mold and finished with coils. All three are used for water storage. *Tinajas* are the shortest, averaging 40 centimeters in height and 40 centimeters in width, those made by Raimundo Martínez (cited earlier) being exceptionally large. *Cantimploras*, or *ánforas*, are generally taller—80 centimeters to 1 meter in height and half that in diameter. Both *tinajas* and *cantimploras* have restricted necks, sometimes with the addition of a fluted edge. *Barriles* and *pozoleros* are about the same height and diameter as *cantimploras*, but taper to an open mouth about the same diameter as the base, roughly half that of their widest diameter. Mario finishes these with a folded-over lip to give an additional reinforcement to the rim.

Pozoleros are made with two horizontal handles. The other large vessels have vertical handles, two for the *tinajas* and *barriles*, and

three for the *cantimploras*. They are, of course, proportionately thicker and sturdier. The coils are usually flattened somewhat so that handles are oval in section. These handles function only for carrying the vessel empty, as they cannot support it filled with water. *Pozolero* handles are horizontal, as they are used to lower the vessel into the well or spring.

The *chimeneas* are among the largest vessels made by Acatecan potters and range in height from 1 to 1.5 meters (Mario's are almost exactly 1.2 meters). They are basically bottle-shaped, but under their long necks, which serve as chimneys, the shape varies somewhat from potter to potter. Some are quite globular; others have almost straight walls. Both painted and plastic decorations are used to make faces on the body of the *chimeneas*, the open mouth of the face serving as *hornillo*, or fire port. Some of these faces are human, others animal. Jaguars, called *tigres*, are popular, with painted whiskers and spots that give them the appearance of having measles. Some of the plastic ornament on these is done while the vessels are still on the molds—the mouth, for example, is outlined with a coil of clay. The opening is not cut, however, until the object is removed from the mold and is leatherhard. It would otherwise collapse.

Also made by molding and coiling is a vessel called an olla, which is the same shape, basically, as the ollas used as cooking vessels. It is, however, more than twice the size. Other differences include a fluted rim, a drainage hole, and often a band of

Fig. 37. Three *ánforas*.

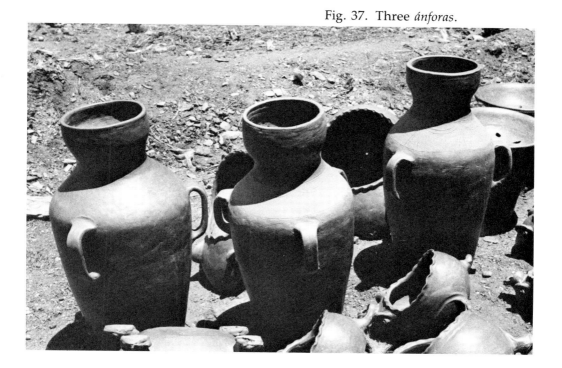

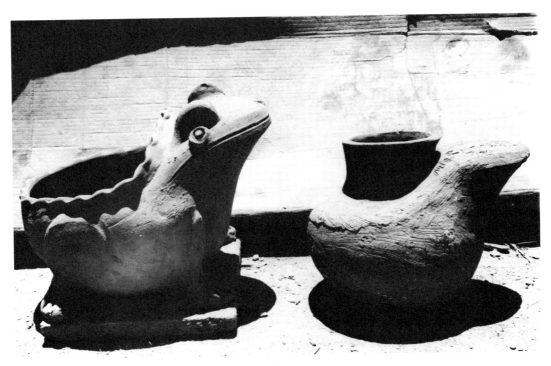

Fig. 38. A toad and its *molde*.

ornate plastic decoration. Both these, as well as the cooking ollas, have two vertical handles that connect the neck with the shoulder. Some fifteen, made by Mario all from the same mold for a special order, ranged from 55 to 60 centimeters in height and 46 centimeters in diameter at the widest part. According to Mario, these are usually bought by Mexican tourists to use as planters on their patios.

Molded and Modeled Vessels

Of the tourists passing through Acatlán, Mexicans buy more flowerpots than do Americans, who tend to prefer novelty items. One item that appeals to both nationalities are flowerpots in the shape of toads. The Mexicans purchase these because toads are good-luck symbols, the Americans because they are "cute." Acatecan toads are found in curio and handicraft shops in Mérida, Oaxaca, Puebla, Mexico City, and Júarez—probably representing an even wider Mexican distribution. They are also a popular item in import shops in the United States. Mario is but one of a number of Acatecan potters who make toads to fill this demand. He makes more toads than any other single item, from forty to ninety or one hundred in a week, depending upon their size (plate 8). Very often, weeks will pass before he receives an order for anything other than toads. He has molds for seven different sizes: the smallest, 14 centimeters long and 9 centimeters high; the largest,

or "*abuelos*," 57 centimeters long and 41 centimeters high. These are asymmetrical, appearing to be ovoid in shape when viewed from above. From the side, they bear a strong resemblance to the famous "shoe-pot," a vessel form that has had a long, unbroken sequence in the literature of American archaeology (fig. 38).

Initial steps in making toads are much the same as for other mold-made wares. The clay is wedged, a thick oval shape is patted out on the petate, and the paste is transferred to the mold. The paste is next slapped with both hands, scraped with a *cuchillo*, and rolled with an *elote* until it reaches beyond the edges of the mold. After the excess is trimmed away with a *cuchillo*, the object is set aside to dry until it can be unmolded safely. From this point on, however, construction techniques are unique to toad making.

Depending on the size of the toad being made, a *ladrillo* or *tabla* is dusted with *tierra colorada*. The mold with the body of the toad is then inverted upon this prepared support. Before the mold is removed, a lump of paste is placed in front of the body and a short coil in back of it to support it and keep it from wobbling while being worked on. Next, the front legs are made from a coil of clay of the appropriate length and breadth that is cut into two equal parts with the *cuchillo*. The cut end of each is bent at a right angle to form a foot; the other end is "pulled" to a taper with wet fingers. The tapered end is stuck to the toad's chest with a smearing motion, the foot is flattened onto the *ladrillo* with a thumb, and toes are cut with the *cuchillo* or a flat stick.

Mario's methods of joining two parts differ greatly from accepted practice among Anglo-European potters. The Anglo-European carefully crosshatches both surfaces to be joined, paints them with slip, and, after making the connection, further blends the parts together with his thumb or a modeling tool. Mario rather casually moistens the body with a damp hand and flicks a few drops of water on the leg before sticking the two parts together.

It takes Mario almost as little time to make the toes of the toad (plate 9). The thickest parts are now pierced in several places with the wire to prevent spalling during firing. Next, the body is thinned and smoothed with the *elote*, followed by the *palo de sauce*. Last, the body is trimmed with an elliptical cut around the mold with the *cuchillo*, the mold is lifted out with great care, and both the mold and the toad are put out to dry in the sun for about an hour. The time is almost doubled if the work stays inside.

When the body is dry enough for work to resume, the top of the head is added. This is formed of a half-moon shape cut from a slab of clay that has first been flattened on the petate. The piece is joined to the moistened edge of the head, trimmed, and smoothed on with the *elote*. The hind legs are now formed in a manner identical to the front legs. Before they are attached, however, a "hip" is made of a disc of clay moistened with water and put into place. The hind leg is attached to this "hip" and a curved

diagonal line is drawn across it with a finger to suggest a leg in sitting position. The toes are incised and the toad is again put aside to dry for an hour or so before the final touches are added. These touches include the drainage hole, if it has not yet been made; a fluted rim, done in the manner earlier described; and eyes and eyebrows. The eyes are made of two identically sized balls of clay stuck on and then flattened with a thumb. "Pupils" are then cut into the resulting eyeball with the mouth of a small glass pill bottle. Eyebrows are formed from a larger ball of clay, flattened, and cut into two half circles with the *cuchillo*. These half circles are each placed over an eye. Making a mouth, incised with the *cuchillo*, is the final step before the toad is put aside to dry to bone dryness. When bone dry, it can be removed from its *ladrillo* or *tabla*, and the support can be used for other work.

Other effigy flowerpots and planters are similarly made. After toads, the most popular are goats (plate 10), followed by bird forms, which include swans, ducks, chickens, and geese. The appropriate heads, tails, feet, wings, or other details are made by modeling and added to the basic shape. These wares are often made on a mold that had originally been made for domestic ware such as *cantimploras* or *barriles*. This is not a new practice; Foster (1960:208) notes that "a single mold sometimes serves as base for several different final products: for example, the same mold may be used for a bull, a duck, and the *chimbul*." This last named form, called the *chimbul* or *cántaro*, is made on a tall, narrow mold with outflaring walls, one of the most versatile molds in the potter's inventory.

Compound-Molded Objects

The reuse of molds for other objects (or possibly the manufacture of molds to serve more than one function) is quite common. Somewhat less common is the use of two different molds to form a single object. One example of this practice involves an object called a *maceta*, a flowerpot in the form of a head wearing a hat or crown, which is made in two parts (fig. 39). The crown, which is the actual flowerpot, is formed on a mold originally made for medium or large bowls. A *cántaro* or *cantimplora* mold is selected for the head. The parts are formed separately and, until joined, by the basic procedures followed for simple one-step vessels. A few extra precautions are taken while constructing the head, however, since it will have to support the weight of the crown both during construction and later, when filled with earth and used as a flowerpot. The first of these precautions occurs while patting out the tortilla of paste. An extra amount of paste is left in the center of the tortilla so that when it is placed on the mold there will be sufficient material to spread evenly over the entire surface of the mold and to hang down past the cut-off point on the mold. It is of utmost importance that both the base and the walls of the vessel be of even thickness; any thinner or thicker areas are po-

tential trouble spots. If the base is too thin, the object will collapse when the crown is added. If the walls are too thin, the weight of the paste will cause them to tear away from the base even before the mold is inverted and removed.

The crowns are formed on bowl molds that, lacking bases, rest directly on the petate. To use one, Mario pats out a large, flat tortilla of paste, scrapes it with the *cuchillo* to ensure its flatness, and, again with the *cuchillo*, cuts it into a perfect circle. After he transfers this disc to the mold, he thins it further by scraping and rolling. Both sections are then set aside to dry for an hour or more. Frequently, as many as a dozen heads will be made before the crowns are started, so important is it that they have sufficient time to dry enough to support the tops. Work on a head does not resume until this point is reached. Then, before unmolding, a mouth is formed with a coil of clay and annealed to the surface by wiping it around with a damp rag. The mold is then inverted directly into a *parador*, filled with *arena* or *tierra colorada*, and supported on this bed with a coil of clay. The mold is removed, and any interior cracks are repaired before the top is trimmed. To make sure that this trimming is done evenly, the potter marks a line all around with the *cuchillo*. The hand holding the knife is steadied by the measuring stick, which rests firmly on the ground

Fig. 39. Two *macetas*.

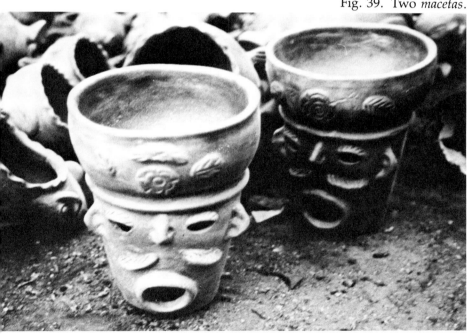

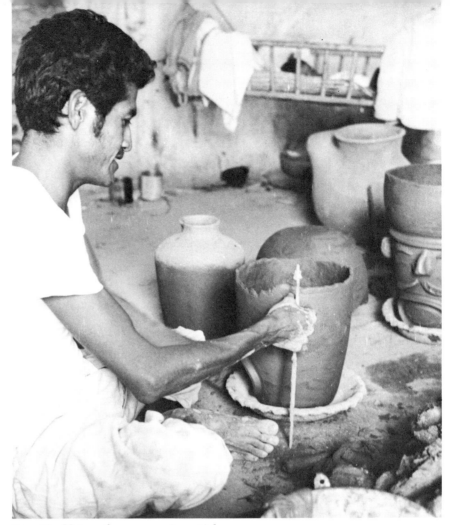

Fig. 40. Using the measuring stick.

(fig. 40). The excess clay is then cut away with one hand, while the other keeps trimmed clay from falling into the unfinished vessel. During both of these operations, the *parador* is turned steadily with the foot.

The vessel is again put aside to dry, this interval ending when the vessel is slightly less dry than leather-hard. Now, the outward flaring walls must be changed to a slightly carinated shoulder. To accomplish this, the *palo de sauce* is held at a 45-degree angle and rolled around the dampened edge, while the *parador* is kept revolving. The palo is kept damp, but not wet, and work continues until the vessel assumes the correct shape. If everything has been timed correctly, the crown is now dry enough to be attached and unmolded. It is tamped all over with a ball of clay to loosen it from the mold, the mold is inverted, and the *cuchillo* is inserted and run around the inside of the rim. The edge of the base is then dampened, and the crown, mold and all, is very gingerly rested

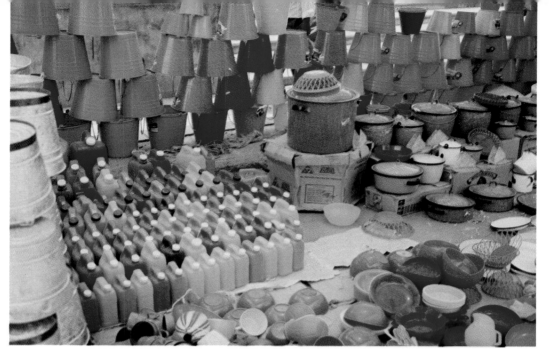

Plate 1. Plastic and metal wares.

Plate 2. Inside the Casa López.

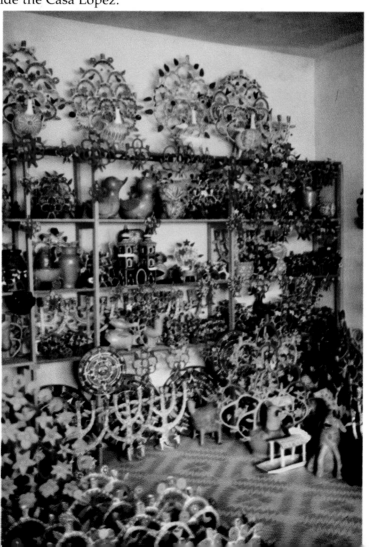

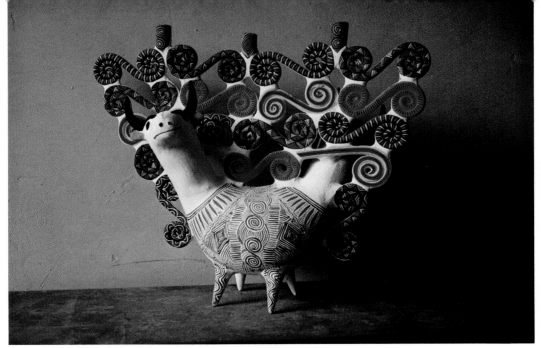

Plate 3. Candle holder painted with acrylic and painted with *grecas*.

Plate 4. Taking two trees of life to the dealer.

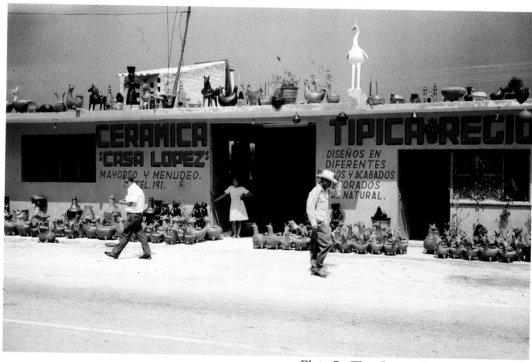

Plate 5. The Casa López.

Plate 6. A neighboring mining *tierra colorada*.

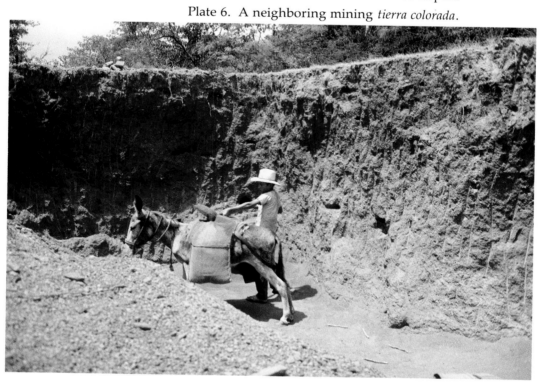

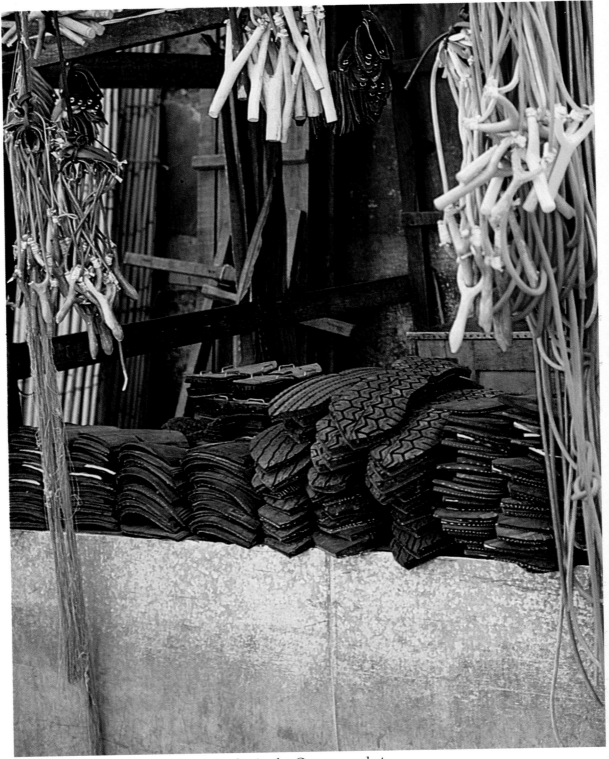

Plate 7. Sandal soles in the Oaxaca market.

Plate 8. The drying yard.

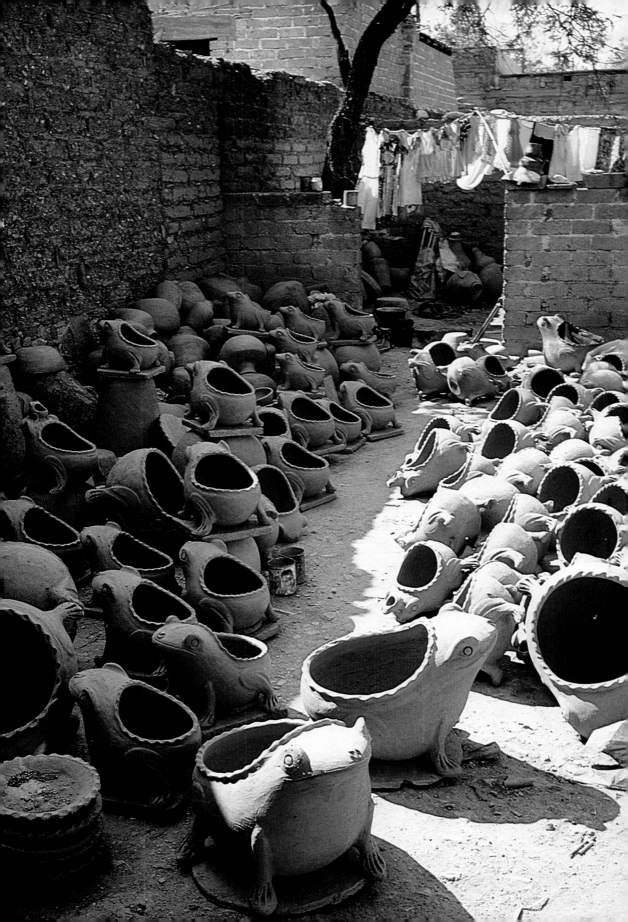

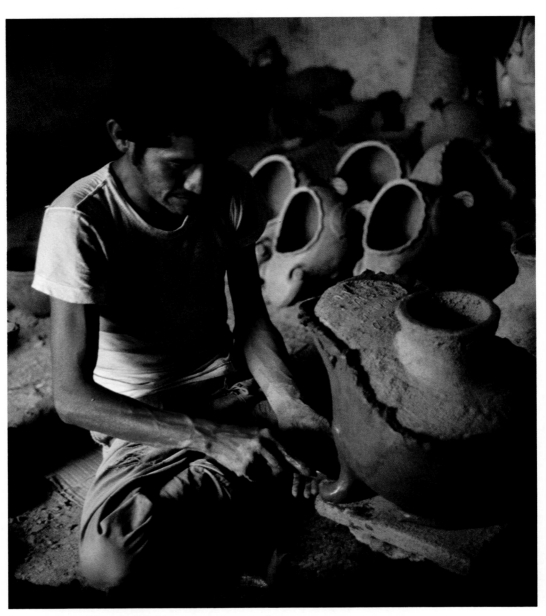

Plate 9. Making toes on a toad.

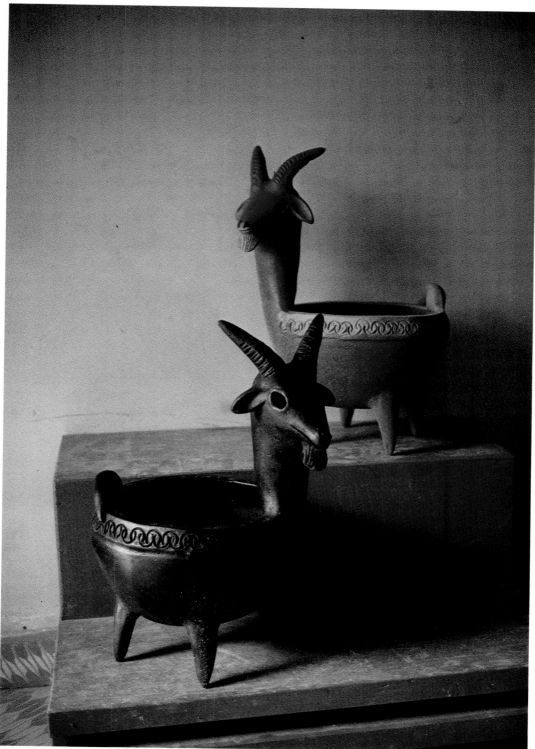

Plate 10. Two goats.

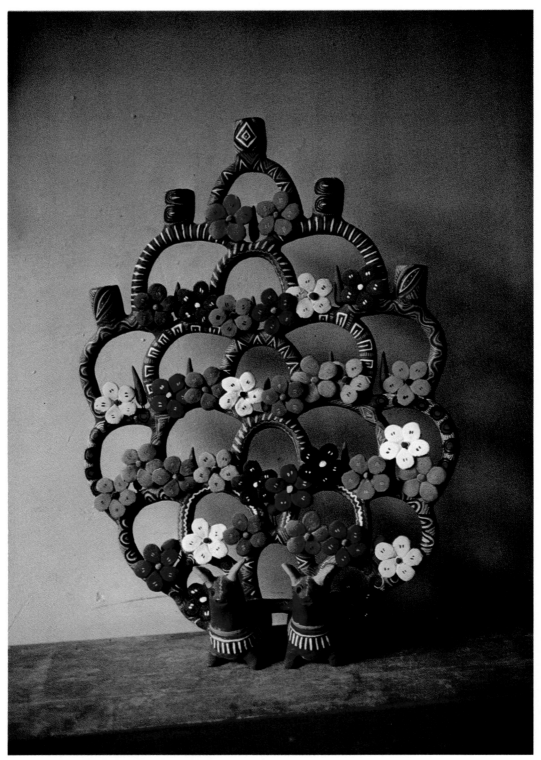

Plate 11. A tree of life.

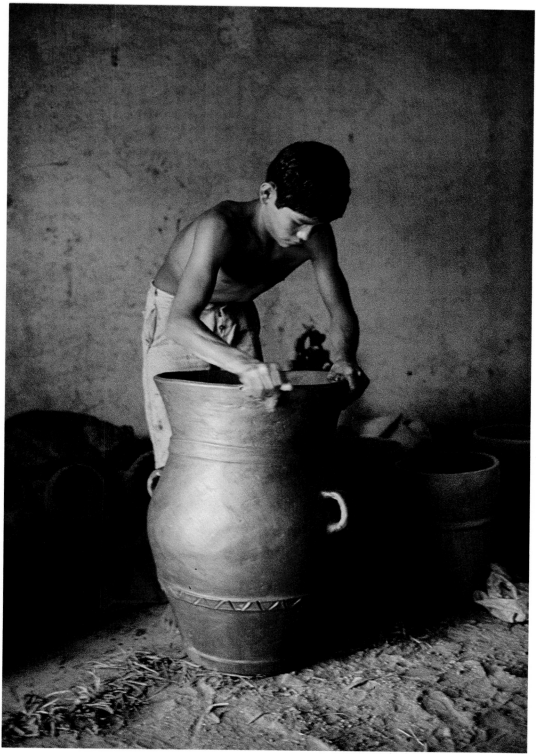

Plate 12. Salvador polishing an *urna*.

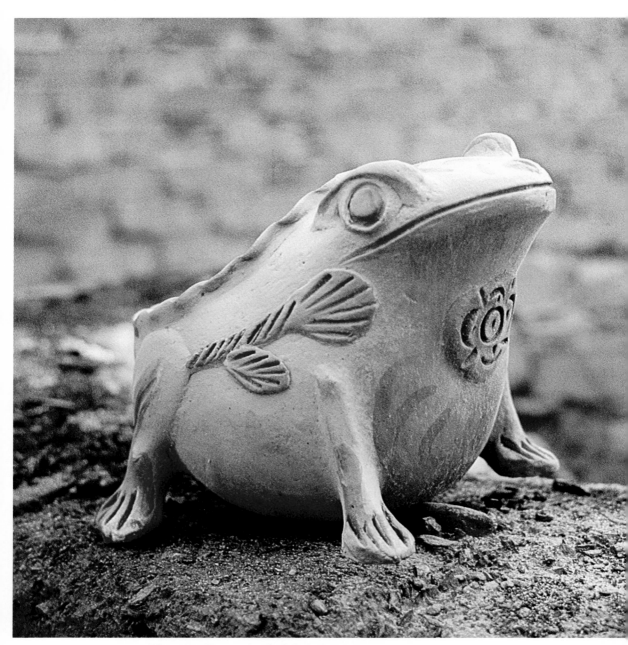

Plate 13. Painted relief decoration.

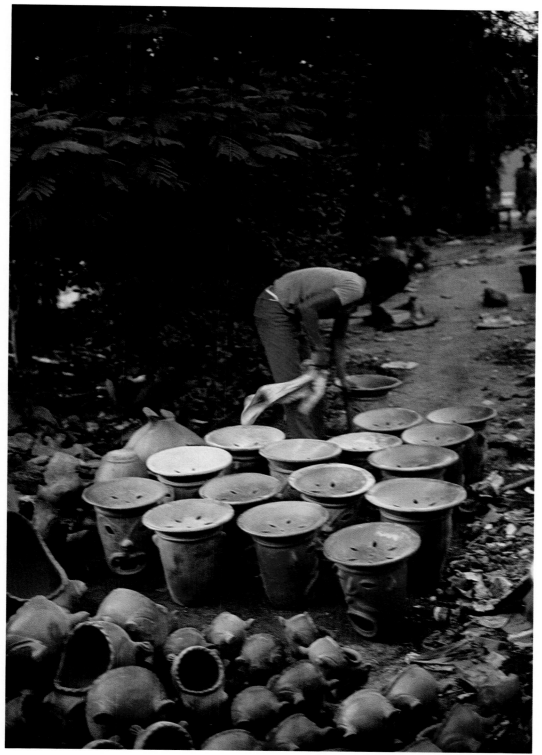

Plate 14. Unloading the kiln.

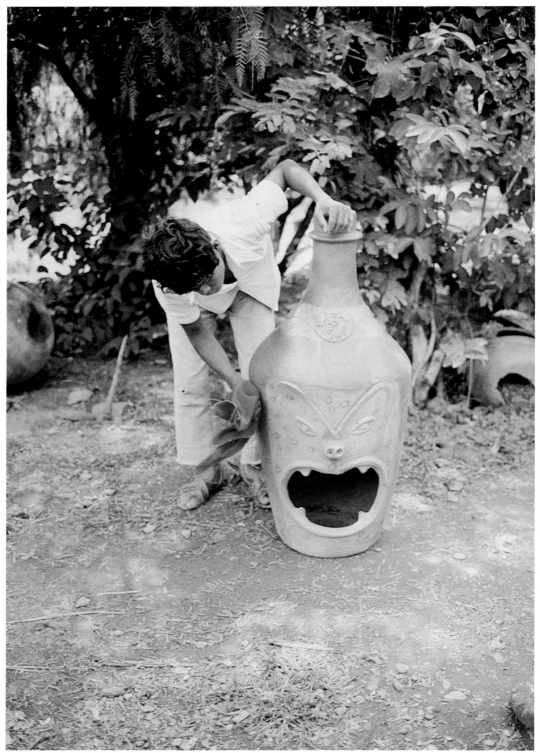

Plate 15. Dusting a *chimenea*.

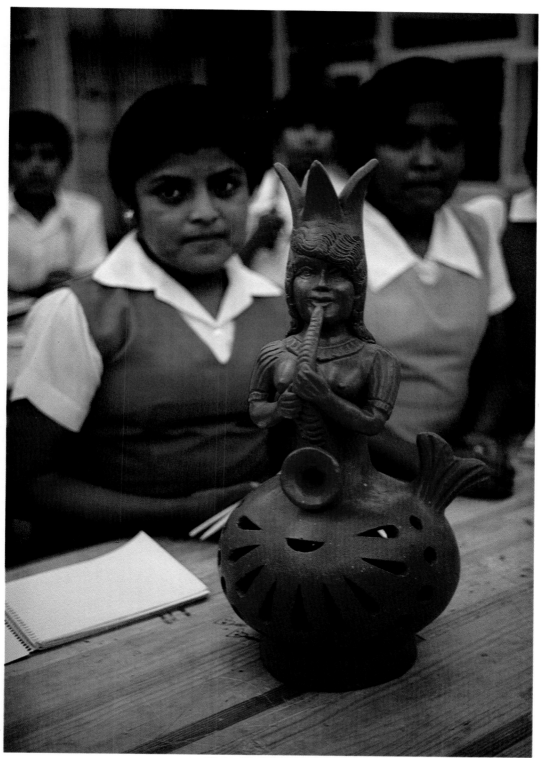

Plate 16. Mermaid by second-year student.

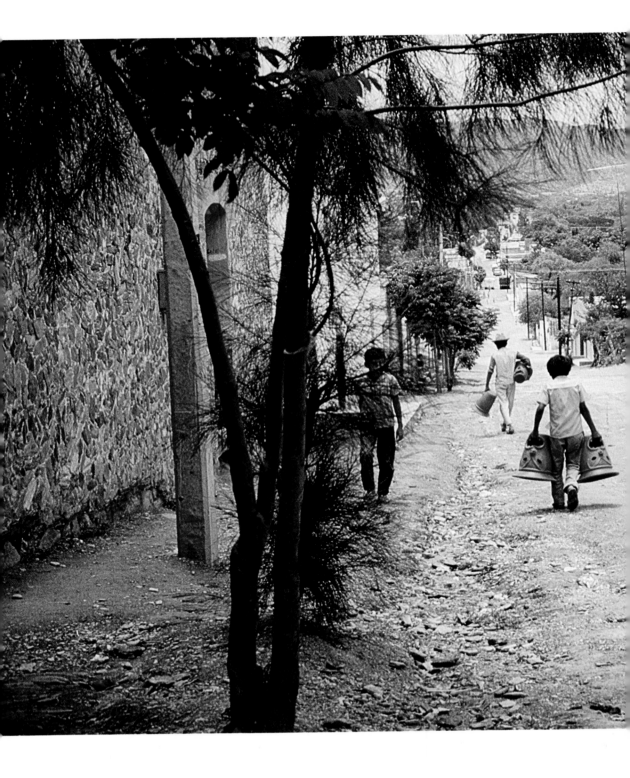

Plate 17.
Delivering the wares.

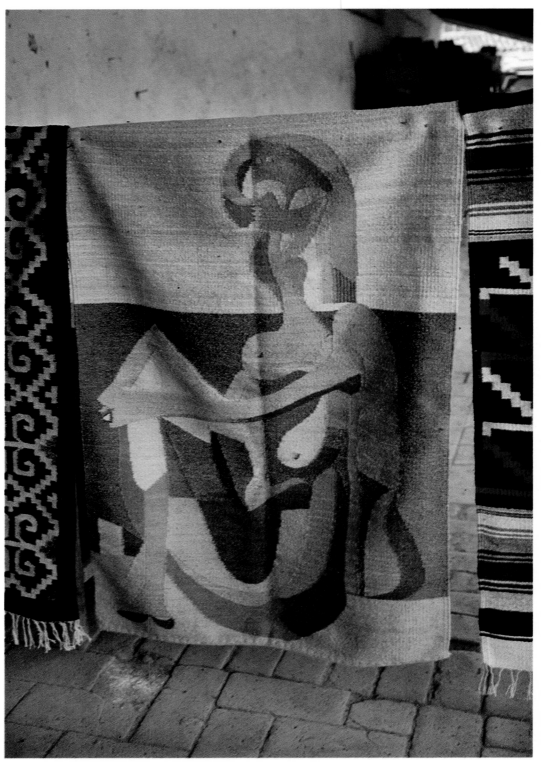

Plate 18. "Picasso" blanket.

upon it. The two parts must be thoroughly welded together before this upper mold is removed—a process that requires two steps. The first of these steps resembles the technique used to incline the shoulder of the lower vessel and involves the same tools and motions. While the object is revolved on the *parador*, the dampened *palo de sauce*, held at the same 45-degree angle, is rolled over the crack between upper and lower parts. To strengthen this joint further (a potentially weak one since it can be welded only from the outside), a coil is added and sealed on with a folded damp rag, while the *parador* is turned with the foot. Sometimes this coil is decorated with hatching while it is still plastic; just as frequently, it is left plain.

The upper mold is now removed with great care and the finishing touches are started. First, the inside of the bowl is scraped smooth, any developing cracks are filled in, and a drainage hole drilled with the point of the *cuchillo*. The features of the face are now added (eyebrows, eyes, nose, mustache, and ears seem to be Mario's preferred order). Holes are cut for eyes and mouth with the *cuchillo*, the hole for the mouth inside the previously applied lips (fig. 41). The eyebrows and mustache, made of small coils or strips of paste, are stamped (while still soft) with the end of a flat stick to form a series of short, straight, vertical lines representing hairs. After the ears are incised with an S curve, the face is done. The crown is finished last. Its edge is trimmed, if necessary; incurved with the *palo de sauce*; and smoothed and thinned with a damp rag. These last three operations are performed while the vessel is turning. The front of the crown is trimmed with plastic decoration—applied flowers made by hand or press-molded, with a spray of leaves, are favored.

The brasero (fig. 42), a form very similar to the *maceta*, is constructed in an almost identical manner. The major difference between the two forms is function. The brasero is a small cookstove, used for cooking an olla of beans over a charcoal fire. Because of this use, the mouths on braseros must be large enough for a hand to reach in with charcoal lumps or matches. The brasero's crown is shallow, almost flat in some cases, having been made on a *cazuela* mold. Instead of a tiny drainage hole, it is pierced with a star-shaped or flower-shaped pattern of cutouts to allow the heat from the charcoal fire in the bottom vessel to cook the contents of the olla.

Mario makes a third compound-molded object called a *lámpara* (fig. 43). This is a candle shield, set down over a candle to keep it from being extinguished by the wind. *Lámparas* are more decorative than useful, as very little light can filter through their pierced openings. Mario's *lámparas* are pear-shaped, the bottom made on a bowl mold, the top on a mold particularly made for the purpose. Both sections are made in the same fashion earlier described. Differences are found, however, in the joining-together process. Top and bottom sections of the *lámparas* must be welded together flush, rather than with the ball-and-cup fit of the upper

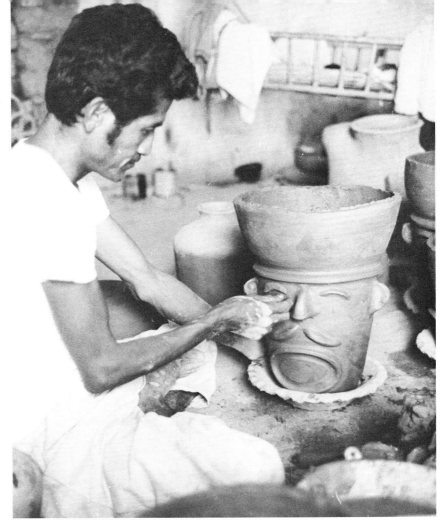

Fig. 41. Cutting the openings in a *maceta*.
Fig. 42. *Braseros*.

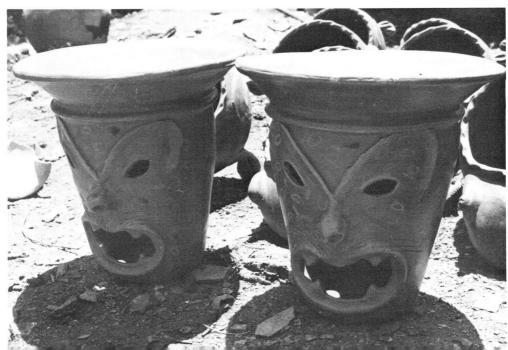

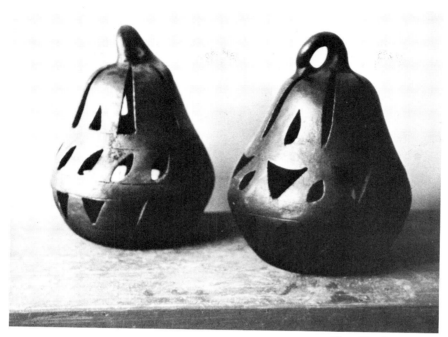

Fig. 43. *Lamparas.*

and lower vessels of *macetas* and braseros. The bottom section is
unmolded onto a *ladrillo* and trimmed, but its edge is not canted
inward. The top section is unmolded, and both parts are allowed
to dry until firm, but not yet leather-hard. The edges of both are
then moistened and the two parts fitted together, with any chinks
or gaps between the two being filled with plastic clay forced in
with the end of a finger. The object on its *ladrillo* is then turned on
the *parador*, while first the *elote*, next the willow, is rolled over the
weld to seal it. A stem is added to the top, and it is set aside to dry
until leather-hard. When this stage is reached, Mario divides the
lamps into horizontal zones for the cutouts. To make these, he
holds a short, pointed stick horizontally in his right hand, sup-
ported by the measuring stick. As his left hand turns the *parador*,
the pointed stick incises faint lines on the lamp. Teresa then uses
these guidelines to cut bands of openings around the body of the
lamp with the *cuchillo*. Crescents, diamonds, triangles, stars, and
circles are among the motifs selected. Last, a circle is removed
from the bottom and the ware is put aside for its final drying.

The Vertical-Halves Mold

Mario uses the vertical-halves mold for only one of the objects
that he manufactures, a *rana*, or frog, 25 centimeters high (fig.
44). Those that Mario makes are purely decorative, though some
potters make frogs with a flowerpot on their backs. Acatecan pot-
ters make frogs in a variety of sizes, ranging from 10 to 50 cen-

timeters in height, which are bought primarily by American, rather than Mexican, tourists. The frogs are basically ovoid; vertically oriented in a sitting position; and have cutout, inverted, crescent-shaped mouths and added legs.

To make these, the potter slaps out the clay paste into an oval shape several centimeters larger than needed, scrapes it flat, and fits it into the half-mold, where it is further scraped and thinned. Next, the edges and mouth are trimmed flush with the mold half with the *cuchillo*. He then puts it aside to dry, while repeating these actions with the second half-mold. When firm, but not yet leather-hard, the edges of the paste in both halves of the mold are moistened, and the two parts are joined. The join is further strengthened by reaching into the open mouth and working the two parts together with a finger. One-half of the mold is now removed and the object rests, lying on its side in the other half. After twenty or thirty minutes, the frog is carefully unmolded by inverting it either onto the hand or onto the petate, depending on size. After it is unmolded, it is set upright on a *ladrillo*, supported by a coil of clay, and the weld is sealed from the outside. Next, the legs are modeled by "pulling," are affixed to the body, and the "toes" and "fingers" are incised with a flat stick. Techniques of making the eyes vary from potter to potter; some simply stamp a circle directly onto the body, others use flattened balls of clay, and some combine the two by stamping a circle onto the flattened ball of clay, a system Mario uses for toad's eyes.

Complex Constructions

The techniques of convex molding, press-molding, coiling, modeling, and even the pinch-pot are combined to manufacture some of Acatlán's largest wares, the tree of life (plates 4, 11; figs. 29, 45). Although they do serve to hold candles, these complex constructions are more decorative than functional. Most recently inspired by the work of Aurelio Flores in Izúcar de Matamoros, 87 kilometers north on route 190, their ultimate roots go back to the Old World. They are, according to Harvey (1973:151), one of the earliest symbols of fertility and rebirth. Originating in the Middle East and taken to Spain by the Moors, the form must have been brought by the Spanish to the New World since

> the clay tree of life did not appear until after the Conquest. Its original motifs were religious. Leaf-clad Adams and Eves are still used most often. Other trees have moon crescents with angel faces, hot pink apples suspended on wires, and serpents lurking in jungle-like trees. It may be filled with fantastically hued birds and butterflies or crowned lions leering from the branches. On top, a superb angel may hold the world. Still others depict the Flight to Egypt or the story of the Nativity. Medallions, swags, garlands, and even columns straight out of the European renaissance and the baroque era are used.

Unlike some of the other wares produced by Acatecan potters,

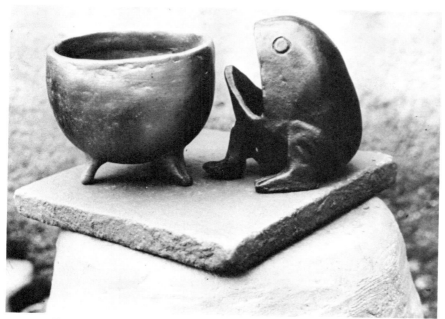

Fig. 44. Frog and bowl with tripodal support made by children.
Fig. 45. Two small trees of life.

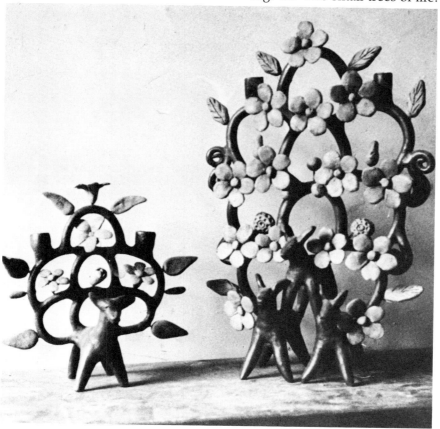

no two trees of life are alike. Individual styles are recognizable in these, however, as they are in the other wares. Trees of life vary in size, complexity, decoration, and merit; their prices reflect all of these factors, with a range in American dollars from one to a thousand. Some are as small as 25 centimeters in height and width; some made by Herón Martínez exceed 2 meters in both dimensions. Some have only one or two motifs, others a bewildering multiplicity. Herón builds his trees of life on a particular theme that is consistent throughout the work. One of his recent trees, for example, featured a number of mermaids playing musical instruments, while fish and other marine creatures sported about the edges of the piece.

Whether simple or complex, large or small, the form requires a sturdy base. Styles in these vary. Some trees are built directly on a central figure, or figures, whether human or animal, as was the case with Herón's mermaids. Others are based on a round or oval flat platform, or on a hemisphere built on a bowl mold. A trunk, or central figure or figures, will be attached to this base. The tree is built upwards and outwards from this central core, and is assembled of a number of elements made by various techniques. Often underlying these diverse motifs is a framework made of "branches" of coils of clay. Coils are rolled out on the *tabla*, and curved into arcs of varying lengths and diameters. Other coiled forms include tendrils, stems, spirals, decorative volutes, and *grecas*, reversed spiral motifs (plate 3). Small motifs that will be wanted in great number, such as flowers, fruit, and leaves, are usually made in a press-mold. Many potters, particularly those who specialize in trees of life, have three or four dozen press-molds among their possessions. Before a press-mold is used, it is dusted with *tierra colorada*. The paste is slapped into the mold with force and scraped flush with the surface with the *cuchillo*. The motif is then turned out to dry on a *ladrillo*, which also has had *tierra colorada* sifted onto it. Some of these press-molded motifs are altered slightly by hand-modeling after they have dried slightly. A leaf, for example, might be curved over a finger. Hand-modeling is also used for small birds, animals, and people. These have added details, such as wings or clothing or "pulled" arms, legs, and tails. Forms that are too large to be modeled solid and fired safely are started on a convex mold of the approximate size and shape desired, and have coiled and modeled additions. Lump-modeling, one of the few uses of this technique in Acatlán, is used for the candlecups.

It is convenient to describe the construction of a tree of life as proceeding in stages. In the initial stage, the base, or central figure unit, is made. While this is drying, the other elements needed in the first stage of construction are made; since these are smaller than the basic unit, they will take less time to dry and, ideally, will reach the desired level of firmness at the same time. "Branches" are added to the trunk; flowers, leaves, and fruit are added to the

branches; and birds and butterflies, people and animals, and an-
gels and devils further burden the form. These are added upward
and outward from the central base when the stage preceding the
addition has dried enough to support the added weight. Some of
the largest of these constructions require as long as a month to
build, and even the average 75-centimeter to one-meter size will
require more than a week.

An unusual feature of the tree of life is the technique used to
join the parts. They are connected with short lengths of 14-gauge
galvanized wire. These pieces of wire, 4 to 5 centimeters long, are
thrust into a branch or figure, and the succeeding branch or ele-
ment is impaled on it. Wires are also bent into U shapes that are
pushed into the underside of a branch, and a bird or butterfly at-
tached to it with another U. This practice gives some degree of
movement to the tree. Other motifs occasionally used for this rea-
son are children or girls on swings and the Angel Gabriel with his
trumpet. These are suspended with nylon or cotton cord added
after firing.

Trees of life are the most difficult articles to make in the Acate-
can potters' repertoire, yet there are no secrets to their con-
struction. None of the separate components is difficult to make.
Some, for example, press-molded leaves, are so simple that they
are made by the children in some households. The real secret of
success in making these wares is time and patience. Everyone
wants to emulate Herón's example, but few can afford the invest-
ment of time involved. Of these few, fewer still have the patience
and skill to duplicate his achievements.

8

Finishing the Pottery

Drying the Wares

Before the wares can be fired, they must be air-dried to reach a state called, by Anglo-European potters, "bone dry." In higher latitudes of the northern Temperate Zone (e.g., the northeastern United States), it sometimes takes as much as a month for very large, thick wares to reach this condition. Such a time schedule, and the need to protect the drying wares from precipitation, creates a considerable storage problem as production continues. Acatecan potters are fortunate in this regard, for most of them, like Mario, have a section of their patios or yards set aside for the purpose of drying both greenware and equipment (plate 8). An even more important advantage enjoyed by the Acatecan potter is his climate. Climatic conditions in Acatlán approach those considered by Hamer (1975:104) as almost ideal for the purpose of drying pottery. He states that

> warm, dry and breezy weather is more effective than cool, damp and still weather. The most effective conditions could cause unequal drying out at rims and handles. This results in warpage and cracking and must be avoided by sheltering the pots or slowing down the drying rate. Pots will need to be turned around and over to even out the effects of sun and wind.

Warpage is seldom a problem in Acatlán owing to the nature of the clay body used. Drying cracks occur, but with constant attention, the danger from these is minimized. Whenever someone moves a piece of work or a mold into or out of the house, he checks the condition of the other drying wares. Frequently, Mario will send a child to check the progress of a specific piece with instructions to turn it over or to move it into the shade if it has reached a certain level of dryness. Wares are sometimes brought into the house and covered either partially or entirely with sheet plastic to prevent too rapid drying. With the amount of care and

attention given the drying process, cracking is not a common occurrence. Breakage poses a greater problem and happens more frequently than cracking. Bone-dry greenware is extremely fragile and subject to damage. Parts that protrude are particularly vulnerable. These include such easily broken parts as the ears and noses on *macetas* and braseros, ducks' bills, goats' horns, and fluted edges. Broken toads' feet are the most common accident in the Martínez household, reflecting the fact that more toads are made than any other single item. During the rainy season, accidents are much more numerous. Greenware must be stacked two, three, or four deep inside the house in an already overcrowded space waiting sometimes for two to three weeks to be fired.

Unless a drying object is completely beyond repair, an effort is made to salvage it. The more moisture the object contains when it is repaired, the more effective and successful the mend is likely to be. Drying cracks are easily and quickly filled with paste, either with the *cuchillo* or with the finger, depending on the size of the crack. The new paste is then scraped level with the surface of the object and observed closely until the ware is dry to make sure that the defect does not reopen.

Bone-dry wares that have broken are likely to need more drastic action, such as reattachment of broken parts or, if these have shattered, replacement with new ones. When a toad leg or other piece breaks off a vessel, it is placed inside the vessel and the object is set aside for later repairs, usually done when several accumulate. Both the part and the section of the vessel to which it is to be attached are moistened with water, and a small amount of paste is smeared on the two surfaces to be joined. The part is then pushed firmly into place on the vessel and held until it sticks. The excess paste that oozes out of the repair is then scraped off with the *cuchillo*. If the broken part is too fragmented for such treatment, a replacement part must be made of plastic clay body and attached, a much more difficult task. First, the body of the vessel is moistened with as much water as it will absorb, the new part is made, and it is allowed to stiffen somewhat. The body is again moistened and the two parts are joined; adhesion is more likely if both body and part are equal in water content. Drying cracks are expected between new and old work. These are filled as they occur.

Not all of these repairs are immediately successful. Some must be done in stages. Some of them never work. Unfortunately, some mends that appear to have been quite successful fail only while they are being fired. The object then is usually a total loss, the paste cannot be reused, and it "took the space for nothing" in the kiln. Frequently, desperation measures are used on these, such as re-repairing the break with plastic paste and refiring. Although this should not, in theory, be possible, Acatecan potters succeed in such repairs. Trees of life, which frequently crack around the wires when drying, are repaired with paste before firing. These same cracks often open again in the kiln, but are re-

paired after firing with plaster of Paris. Since most trees of life are painted with acrylic paints, the mends become invisible. All mended items are all too prone to break again in the same place. For this reason, such wares are handled with extreme caution until turned over to the trader.

Painting and Polishing the Wares

Domestic wares, and ware such as trees of life that will be painted with acrylic paints, are ready to be fired as soon as they are bone dry. The highly polished red or black finish used on much of the tourist-trade pottery must be done before firing; the firing determines the final color of the wares, red or black. The wares are ready for this finish as soon as they are bone dry, but, in practice, this is not done until there are enough for a kiln load, the entire load being done the same day that they are to be fired.

In the Martínez household, Teresa usually takes charge of this operation, helped by her older sons. Mario continues his own work in the workshop while this is being done, waiting until almost all of the wares are ready to fire before he goes out to prepare the kiln. Finishing a kiln load of pottery can require most of a day's time and is sometimes, but not often, started the day before. More frequently, firing must be postponed until the work is finished.

With the exception of the rainy season, Teresa prefers to paint and polish the wares outside in the patio. There are a number of reasons for her preference, least of which is the fact that the work is so messy. From the patio she can watch her dinner cooking and keep an eye on the children. The drying yard is convenient, as is the water supply. It is also more pleasant to work in the shade of the trees than in the house, work seems to go faster, and neighbors seeing her at work will stop for a chat. Before she can start, a number of preparations must be made. The *tinta* from the week before is brought out and stirred up, and a new batch is started. An old petate or two is laid down, the portable radio, if it is working, is turned on and put up in one of the trees, and the necessary tools and rags are found. When all of the necessaries are gathered around her, including four to six vessels within arm's reach, Teresa starts to work sitting cross-legged in her oldest clothes, with an old sheet across her lap.

Finishing a kiln load of wares by painting and polishing them is a long, tedious day's work for one person and, if she knows that she must do it by herself, Teresa tries to do some of it the day before. Mario usually fires on Saturday, however, and even during the school year there is a son or two to help her on Saturday morning. There are a number of steps involved in the process, and when there is more than one person working, the operation can be set up almost like an assembly line. With three persons working at the task, the entire kiln load can be done in about five hours.

Each vessel is first inspected carefully; should it need any repairs that have so far escaped notice, it is set aside. (Previously repaired vessels are particularly carefully scrutinized.) The vessel is now carefully scraped all over the surface with the side of the *cuchillo* and then sanded with sandpaper. The purpose of the scraping and sanding is to eliminate any of the coarser particles of *arena* that might be protruding from the surface; the operations leave the surface pitted and pockmarked instead. The surface is then evened by filling the pits and any hairline cracks left from earlier repairs with the thickened deposit from the bottom of the previous week's *tinta* (fig. 46).

After sanding, scraping, and filling, the wares are ready for their first coat of *tinta*. Once all of the work has been filled in, the old *tinta* is stirred up and used for the first coat. The vessel, if small enough, is held firmly in the lap with one hand. With the other hand, a rag is dipped in the old *tinta*, squeezed as dry as possible, and wiped over the surface of the object. This is repeated until the vessel is covered. It is then set aside to dry. The second coat is done with fresh *tinta* and is applied in the same manner. This second coat must be quickly polished with a dry rag while it is still damp—probably the most difficult step in the process (plate 12). If done correctly, the entire surface of the vessel is given a smooth, highly polished reddish-brown finish, which it retains through firing when fired in an oxidizing atmosphere. When fired in a reducing atmosphere, this same finish turns a glossy black.

Finishing the wares in such fashion has been variously described by the Martínez boys as "boring," "dirty," and "a nuisance." It can also be described as dangerous, at least as far as the wares are concerned. It is very easy to snap off a part or to punch a hole in the wall of the fragile greenware while scraping or sanding it. Applying the *tinta* is also hazardous; if too much liquid soaks into the bone-dry vessel's walls, they are likely to collapse. If the final coat of *tinta* is applied too wet, it washes the first coat off, giving streaky results. One or two grains of *arena* that are overlooked can scratch great gouges in a vessel wall while it is being polished.

The entire vessel is not coated with *tinta*. The insides of toads and other vessels intended for flowerpots are not painted, nor are other parts that will remain unseen in use, such as bases. There are more functional reasons for this omission than merely saving a little of the difficult-to-obtain *tinta* or an hour or two of labor for painting and polishing a kiln load of wares. Burnishing, as Hamer (1975:314) points out, seals the surface pores of the clay. If the vessel were to be completely burnished, the steam, unable to escape in firing, would build up pressure until it blew itself free, resulting in the loss of the vessel. Unpainted sections fire to a pale, almost pink, terra-cotta color in an oxidizing atmosphere and to a dull gray in a reducing atmosphere. Frequently, objects that are to

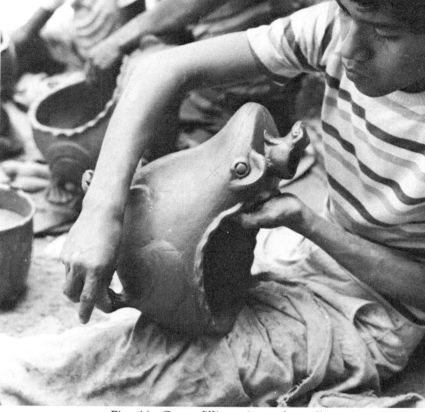

Fig. 46. Oscar filling pits and small cracks with *tinta*.

be fired in an oxidizing atmosphere are made to take advantage of this contrast in color. Mario will sometimes receive an order for toads or other forms with molded and modeled leaves and flowers. These relief decorations, painted with *tinta*, stand out in strong contrast to their very much lighter backgrounds (plate 13). Another example of the use of this decorative technique was found one year when it became fashionable to make *chimeneas* with feline faces, called *tigres*. These had faces covered with painted *tinta* spots, and a row of them in the López warehouse suggested an epidemic of a childhood disease rather than the ferocity intended.

Firing the Wares

Anglo-European potters might agree with Cardew's (1969:170) statement that "clayware, however much skill and knowledge has gone into its making, has no commercial value until it has been fired." In many potters' households in Acatlán, including Mario's, as much as half of this "commercial value" has already been realized in advance payments from the trader. The fact that this payment has been long spent and that the rest of the money from the

kiln load is desperately needed makes the successful firing of the week's works one of the most crucial stages in the entire pottery-making operation.

In the Martínez household, firing usually occurs once a week, seldom oftener, more likely on Saturday than any other day, and usually late in the afternoon, when all of the wares have been painted and polished. If it is too dark before the wares are ready to fire, firing is deferred until the next day. Mario never fires at night and does not know anyone in Acatlán who follows that practice.

When almost all of the wares have been second-coated and polished, firing preparations are begun. It is usually Juan who carries the finished pieces back toward the kiln, one or two at a time, depending on their size. By this time, Mario has stopped working in the house and gone back to get the kiln ready. He climbs inside and shovels out the accumulation of ash and, if it is the rainy season, mud until the floor of the kiln is level and dry. Next, he prepares a bed of fuel and large wasters, in lieu of a grate, on which the wares will rest while they are being fired. When he is satisfied that this is ready, he starts stacking the wares. He remains inside loading the pieces handed him by Juan and Salvador (fig. 47) until there is no more room and he must climb out to finish the job.

The largest wares are loaded first, the really large ones, such as *chimeneas* or *barriles* in the center, other large wares surrounding them. Every piece must be securely placed to prevent its moving or shifting during the firing, but not so tightly packed as to be smashed as the pieces expand or contract at different stages. To prevent this, some wares are braced against each other, others kept from touching by waster sherds inserted between them.

Fig. 47. Loading the kiln.

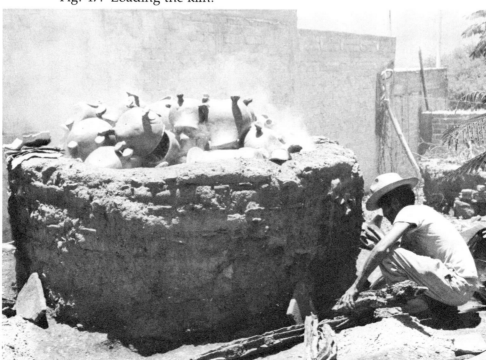

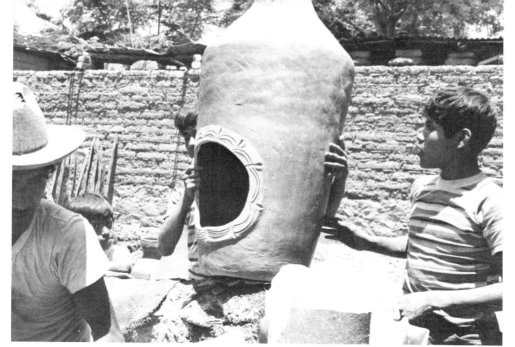

Fig. 48. Starting the fire.

After the first layer is completely set with the largest pieces, Mario climbs out and finishes loading by leaning over the wall. As he stacks upward, the size of the wares diminishes—first large, then two or three layers of medium-sized wares. The small wares go on the very top, with quite tiny objects fitted inside the larger ones. These might include objects the size of a *molcajete*, or some of the wares Mario might fire as a favor for one of the old women he helps. Such objects as motifs to be added to trees of life, pipes, beads, and pendants are placed inside larger objects more to prevent their loss or breakage than to conserve space. Practice pieces made by the children in a family are usually also placed inside other wares. If these "blow up" because of some flaw, damage to other wares is minimized. Some typical kiln loads included: six *braseros*, four *macetas*, ten large toads, and twenty medium toads; three *chimeneas*, two *braseros*, three large toads, and twenty-four medium toads; two *barriles*, ten *macetas*, and fifty medium toads; ten large toads, forty medium toads, ten *macetas*, and ten small toads; and three *cantimploras* and fifty *lámparas*.

The kiln is stacked above the level of its walls (fig. 48), piled sometimes as high as 50 to 75 centimeters, before the wares are covered with one or two layers of large waster sherds. It is probably this loosely arranged covering that makes this type of kiln burn with such a successful updraft. Another factor contributing to this strong updraft is the fact that ignition is started even before the sherd covering is added. This is accomplished by wrapping a strip of kerosene-soaked rag around the end of a sick, lighting it with a match, and using it as a torch to light the ends of long pieces of cactus that extend from the *hornillos*. Almost the

full lengths of these pieces extend outward from the kiln, resting on the ground, and are pushed in as they burn, the flames drawn inward and upward in the kiln by the strong updraft. Great care is exercised in pushing the fuel into the kiln, both to avoid breaking the wares and to avoid personal injury from burns and cactus thorns. Another danger is posed by the ever-present scorpions that live in the cactus. Organ cactus is particularly infested with them, adding to the reasons for its lack of favor as a fuel. Scorpion bites are seldom fatal to adults, but are painful and slow to heal. An infected scorpion bite on one potter's hand kept him from working for over a month.

Once the fire is lit and beginning to climb, Mario starts to cover the wares, a procedure that takes ten to twelve minutes (fig. 49). He walks around the kiln, reaching through the mounting flames to place large waster sherds on the stack of greenware (fig. 50). Fueling, neglected while the wares are being covered, is resumed when the task is completed, and continues through the remainder of the firing cycle. At least one other member of the family remains in the immediate vicinity of the kiln during the firing, ready to help Mario in any way he requires. If it is a school day and Juan and Salvador are gone, Teresa will stand by. The main responsibility for successfully firing the week's work is Mario's, and he does not leave the kiln until the job is done.

No two firings are identical, either in kiln load or in firing schedule. Enough similarities exist, however, so that certain patterns emerge. Several firings in the summer of 1975 were measured with a chromel/alumel type K kiln pyrometer (fig. 51), and time-temperature curves were graphed (figs. 52–57). From the time that the fire is first lighted until about twenty minutes after the wares are covered, Mario adds fuel slowly. This period, known to Anglo-American potters as "water smoking," ends when the temperature has reached about 225°C. At this point, Mario increases his rate of fueling so that the temperature climbs about 25° C a minute until it peaks. With the increasing shortage of fuel, Mario fires for only eighty or ninety minutes, instead of the two hours or more that he prefers. He stops fueling now when he runs out of fuel rather than at the end of a particular length of time. Even with this attenuated schedule, he is able to achieve temperatures of between 750° and 790° C, although on at least one occasion he has run out of fuel even before 700° C was reached.

Mario judges temperature by eye, a common practice among potters. A chart by Fournier (1973:83) illustrates the correspondence of color to temperature: 400° C, black heat; 500° C, dull red heat; 700° C, red heat; 850° C, orange-red heat; 1100° C, yellow heat; and 1350° C, white heat. Hamer (1975:125) uses the term "first red" to describe

the incandescent glow of the pots in a kiln. The temperature is about 600°C (1112°F) and is an indication that dunting point 573° (1063°F) has been passed and that ceramic change is almost com-

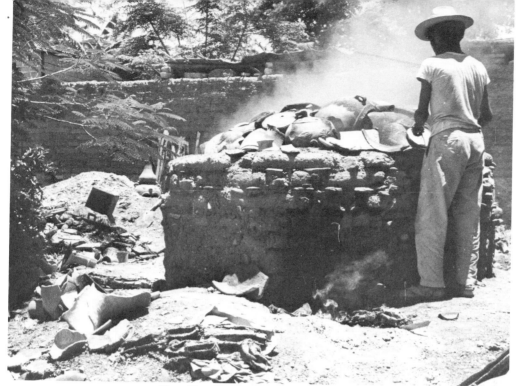

Fig. 49. Covering the kiln with wasted sherds.
Fig. 50. Adjusting the sherd covering.

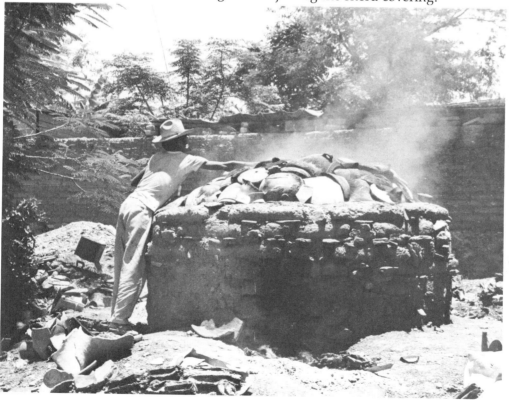

plete. Where open flames are concerned or electric elements may be glowing, the first red is about 500°C (932°F).

This correspondence of color to temperature was confirmed with the kiln pyrometer. Mario says that he used to fire until the wares turned orange, but that one more *cargita* of wood is required to achieve this. One of the firings during the summer of 1975 had to be halted at only 670° C as there was no more wood and Mario did not want to risk using tires alone (fig. 56).

Tires are not added at the beginning of the firing cycle unless wood is in really short supply. Mario prefers to wait until the fire is burning well, the kiln is covered, and the "water-smoking" period has ended. From this point until firing is complete, he is "the servant of the fire" (fig. 58), constantly circling the kiln, now adding wood, now a few tire scraps, now adjusting a waster as flames burst through the top, now withdrawing a few brands to keep the heat from increasing too rapidly. Over the roaring of the flames an occasional snapping sound can be heard, usually only the steam escaping from a damp piece of wood. There is worry, however, until the kiln is opened and the wares are drawn, as the same sound might signal such firing accidents as the explosion of a too wet object, or spalling caused by the inadvertent inclusion of some foreign matter, a pebble or a bit of plaster.

As the end of the firing nears, a thin layer of white ash begins

Fig. 51. The completed sherd covering. The pyrometer is resting on a cement block.

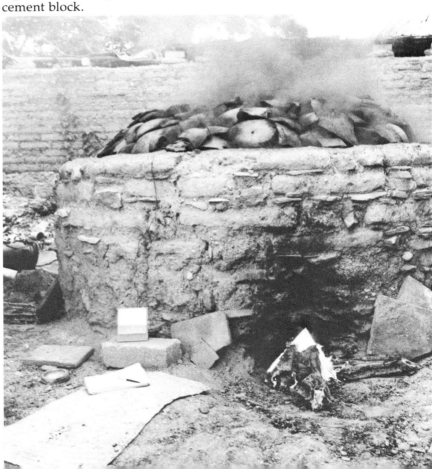

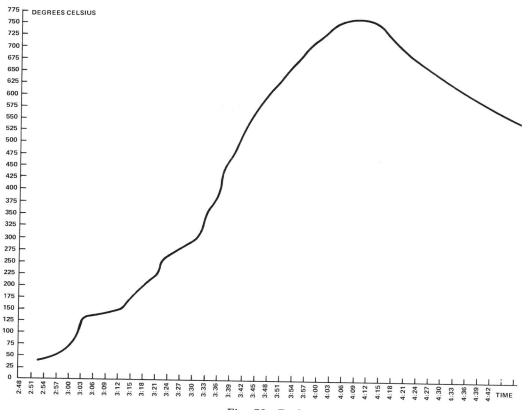

Fig. 52. Reduction firing, July 3, 1975.
Fig. 53. Reduction firing, July 12, 1975.

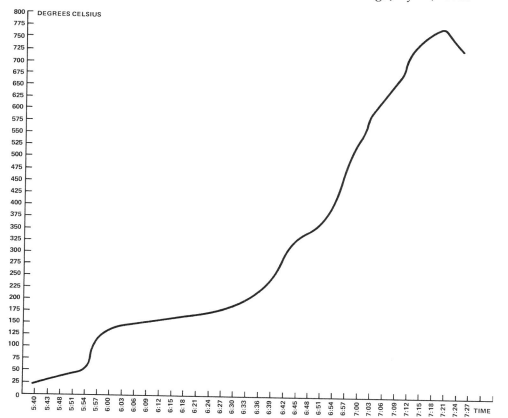

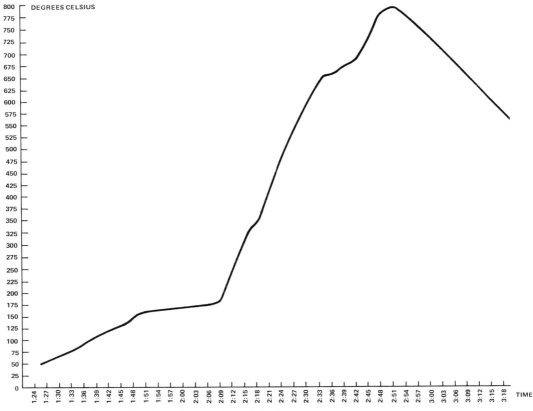

Fig. 54. Oxidation firing, July 19, 1975.

Fig. 55. Oxidation firing, July 23, 1975.

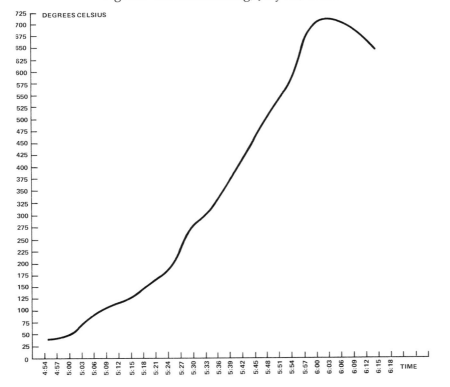

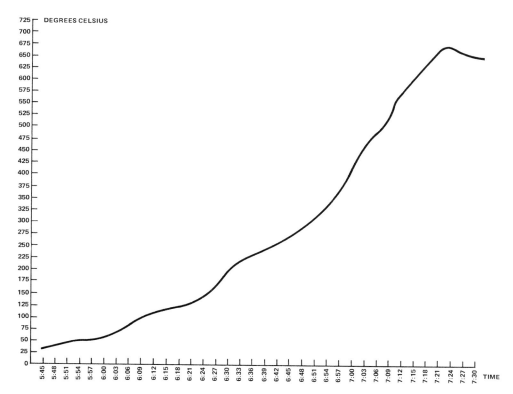

Fig. 56. Reduction firing, August 2, 1975.

Fig. 57. Reduction firing, August 13, 1975.

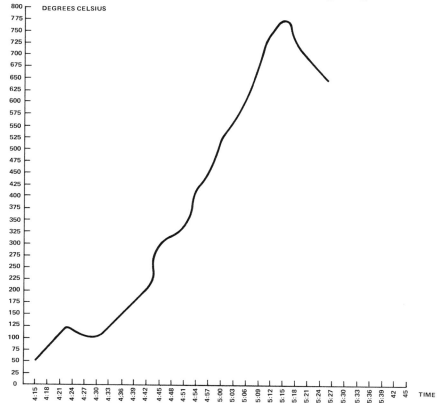

to accumulate on the sherds covering the top of the kiln. Through these sherds can be seen the luminous glow of the wares within. Unless the wood is gone sooner, firing ends when Mario is satisfied with the color, sometimes prying loose a waster with his poker to inspect the wares more closely. Any last bit of fuel is now shoved into the kiln and the *hornillos* are covered with their "doors." These "doors," *ladrillos* with one corner removed the better to fit the triangular shape of the *hornillos*, are pushed against the openings and held firmly in place with heavy stones. If the trader has ordered redwares, Mario is finished with the firing once the *hornillos* are closed. The fire is left to die down and the kiln is allowed to cool until the next morning, when it will be unloaded.

Several further steps are needed for a reduction firing, if the trader has specified blackware. Shortly before the fire reaches its maximum temperature, Juan brings several buckets of water, which he pours into a hole he has dug in the dirt near the kiln. As he pours the water, he uses a stick to mix it with the loosened dirt. When enough of this resulting mud has been formed, Mario begins to shovel it onto the wasters on top of the kiln. He works as rapidly as possible and is assisted by everyone present—Teresa, Salvador, and Juan—who apply the mud with both hands. The scene, for the next few minutes, is one of feverish activity. Loud hissing sounds are heard as each shovelful of mud hits the hot wasters. The steam from the drying mud mixes with the smoke from the fire and rises in a dense cloud. As soon as the top of the kiln is covered with a layer of mud 10 to 15 centimeters thick, Mario turns his attention to the *hornillos*. He adds a little more fuel to each one before he closes them with the *ladrillos*, which he then seals with mud. Meanwhile, the others in the family have been watching the top of the kiln. As the mud covering dries, it cracks. These cracks, signaled by bursts of smoke, must be sealed with fresh mud. This is plastered on with the hands, "buttered" into the crack until the smoke stops. The internal temperature of the kiln has peaked with the covering of the top, and, when Mario is satisfied that it is completely sealed and in no danger of further leaks, it is left to cool gradually, not to be unloaded until the next day.

Unloading the Kiln

The kiln is unloaded the first thing in the morning, often as early as 5:30 or 6:00, of the day after the wares are fired. If the firing was a reduction one, the dried mud must first be carefully chipped and peeled from the waster sherds and replaced in the hole from which it was dug. Next, the waster sherds are removed and stacked in neat piles, near the kiln, but out of everyone's way. Finally, the still warm wares are carefully unloaded. Each of these objects is tested as it is drawn from the kiln by tapping it with a

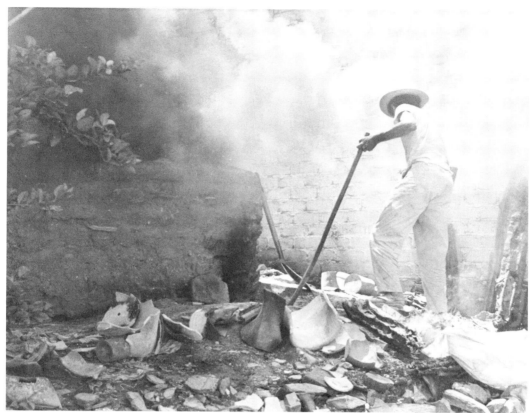

Fig. 58. Circling the kiln.

fingernail. If it "doesn't sound right," it is set aside. If it does not ring clearly, it has been incompletely fired and will be refired with the next load. Broken wares are also set aside. Some can be mended; others are fit for nothing but kiln furniture.

Acceptable wares are sorted into rows according to type and size as they are unloaded (plate 14). When unloading is complete, they are counted. Those "owned" by the trader are prepared for delivery. This may mean only dusting off the ash with a dry rag (plate 15), but, on some occasions, entire kiln loads have been left so greasy and sooty from firing with tires that the wares had to be scrubbed in a bath of soapy water (fig. 59). When they are clean, they are taken down the hill (plate 17) and delivered to López or to another pottery trader's shop or warehouse, one or two at a time until the trader's order is filled and Mario receives the balance of the money due him. Mario tries to make and fire a few extra wares each week, both to allow for the inevitable accidents and to have a few on hand, if possible, when the occasional itinerant trader stops by. If the firing has been a success, the local trader's order will be filled and three to five pieces can be stockpiled against this visit.

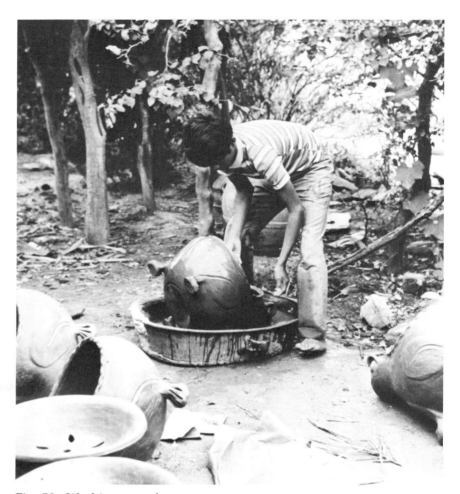

Fig. 59. Washing a toad.

9

Learning to Be a Potter

When Mario and his family deliver the week's work to López or some other trader, they are participating in a marketing procedure that has emerged only within the last generation. While in López's warehouse or shop, they are able to see some of the wide range of wares now being produced in Acatlán. Despite their diversity, all of these have been made using the same basic method as that described in Chapter 7—convex-molding, used either alone or combined with one or another of the basic handbuilding techniques. This method of pottery making, widespread throughout Mexico, is of considerable antiquity; it might be posited that the methods used to teach these skills are equally ancient. With one or two exceptions of obviously recent origin, traditional teaching and learning patterns seem relatively undisturbed.

Traditional Ways

Traditionally, in Acatlán as in other pottery-making towns, the craft is taught by parent to child, generation after generation. The strength of the continuing tradition, however, probably owes as much to the economics of the craft as it does to the fact that child-rearing practices are conservative and slow to change. Pottery making has always been such a poorly paid, low-status occupation that few potters have been able to maintain a separate workshop or studio away from home. This is the case in Acatlán where, like Mario, most potters and their families can afford to live and work in houses no larger than one or two rooms. In these, and spilling out onto the patio, all activities both domestic and occupational must take place. Potters' children are seldom, therefore, far from the sight and sound of work in progress. The clutter of the activity surrounds them. There are materials, tools, and wares in every stage of manufacture, as well as broken pieces waiting for repair, and wasters from various firing accidents. From the time he is born, the potter's child observes all of this, as

well as the sight of both parents and older siblings working. Since, typically, the nuclear family constitutes a pottery-making work group, the child gradually assumes a greater share of the work as he grows older, learning the craft as he does so.

Mario and Teresa's nine children are at various stages in this learning process. María Cecilia, their youngest child, is not yet a year old, but she has already unconsciously learned a great deal about ceramics. As a newborn infant, she was carried slung in her mother's rebozo while her mother worked. Her cradle hangs in a corner of the room; from it, she can see everything that goes on (figs. 60, 61). At the age of four or five months, she was sometimes placed in a cardboard carton to sit and watch her parents and older siblings at work. The carton outgrown, she now observes the work in progress from the vantage point of a wheelless walker. This is sometimes placed inside as materials are prepared or wares are formed. Later in the week she sits outside under the trees watching the work as it is painted and polished and loaded into the kiln and fired. Soon she will learn to walk; as she does so she will be attended constantly by her mother or an older sister until she learns to avoid the tools and supplies, the fragile greenware, and the finished work.

The most important thing Mario's oldest son, Oscar, seems to have learned about pottery making is that he dislikes it. Now 20, he should have mastered the craft and left home to start his own establishment, instead of joining the ranks of the defectors. Before he left home, his share of the work included taking the burro to the hills to look for fuel or to mine clay minerals. He had also helped to prepare these materials for use, mixed the clay body, painted and polished the finished wares (fig. 46), helped to load and unload the kiln, and carried the finished wares downhill to be sold. He had, in fact, participated in every stage of pottery making except for the actual manufacture of the wares. Actually, although he had assumed the responsibility for these tasks, they had fallen to him by default because, after several years of unsuccessful attempts, Oscar had failed to master even the most elementary steps in forming the wares. Possibly, his attitude toward the craft contributed to his ineptitude. His departure to work for his aunt and to live in her pharmacy was a relief to the rest of the family.

The next seven Martínez children are involved in pottery to varying degrees. Even at the age of 3, children are capable of bringing tools (thus learning them by name), bringing water, doing other short errands, and helping to clean up. Martín is so pleased to be asked to help that he must, at times, be diverted into some other activity. He will fill the water can cupful by cupful until it is in danger of overflowing. Though no longer constrained by his cradle or the walker, Martín still sits for long periods watching his father work. When Veronica was 3, she was assigned the task of picking up cutout clay scraps from the *lámparas*

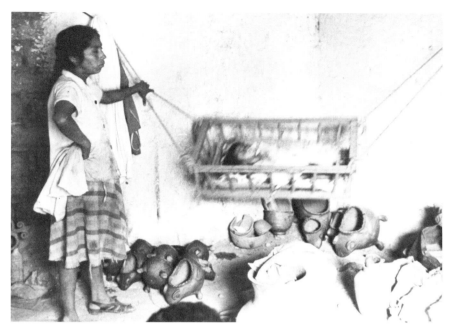

Fig. 60. Rocking the baby.

Fig. 61. Work resumed.

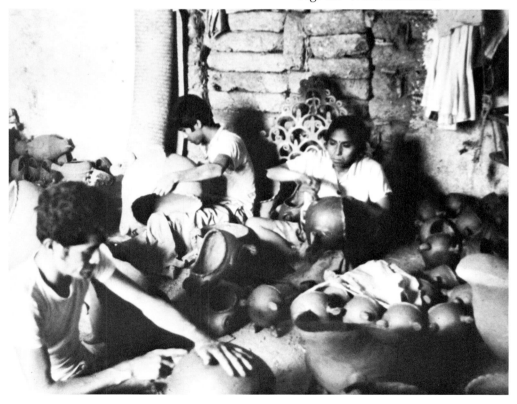

and returning them to the clay barrel. Two years later, she was carrying molds into the house from the yard while her sister, Alejandra, a year older, was entrusted with carrying actual wares. They are still, at 7 and 8, the primary performers of these tasks, as Martín is as yet too young to trust with anything very fragile. He sometimes joins his sisters as they play house under the lemon tree, making their own dishes out of the family clay. Hopkins (1974:64) found children as young as 6 in Acatlán making simple press-molded details such as leaves, as well as shaping handles. That the younger Martínez children escape this drudgery more likely indicates that Mario has little occasion to use such details rather than a preference for doing it himself.

Teresa and María Luisa, at 10 and 12, are given much more responsibility than their younger sisters. They can be entrusted with relatively large sums of money, sent on errands to the center of town, or given complex messages to deliver to the doctor or the pottery trader. At home, they clean, wash dishes, and take care of their younger siblings, leaving their mother free to work on pottery. When she was 11, María Luisa began to learn pottery making from her father. There is no particular right age for this, according to Mario; children are ready when they have developed the necessary strength and patience and when they really want to learn. Usually this point is reached at about the age of 9 or 10, sometimes earlier and sometimes, as was the case with Oscar, never.

Mario acknowledges that, by the time a potter's child is ready to sit down and learn to make pottery, he already knows a great deal, but "it is in the head, not in the hands." He says that, although times have changed and people are now making many new and different things, he tries to teach his children in the same way that he learned from his father, the same way that everyone he knows was taught. Usually, the first vessel that a child is taught to make is a hemispherical bowl with tripodal support, 10 to 12 centimeters in diameter and 6 to 8 centimeters in height (fig. 44).

Several critical techniques must be mastered with this first project, the simplest of one-step vessels. First, of course, he must learn to wedge the paste until all of the air bubbles are removed, without folding in any new ones in the process. Next, he must learn to sift the *tierra colorada* evenly over mat and mold—the paste will of course stick to any place not covered. On the other hand, if the child becomes overenthusiastic or overcautious and uses too much *tierra colorada*, the excess will cause the paste to dry too quickly, possibly cracking before it is even removed from the mold. Work proceeds as earlier described for one-step vessels. Simple as the process appears to be, there are many hurdles to overcome; at any stage along the way, failure can occur. Frequently, this failure is a result of unfamiliarity with the degree of moisture required at different steps in the manufacturing process.

Too little moisture results in cracks, too much collapses the vessel. After a great deal of practice making bowls, the child goes on to the next project. This, called an "ollita," is nothing more than the bowl form built up with coils to form a neckless spherical jar.

These two vessel shapes are among the oldest found in Mesoamerica. The *tecomate*, or neckless seed storage jar, was found both at Puerto Marqués (Brush 1965) and at Purrón Cave (MacNeish, Peterson, and Flannery 1970). In both phases, *tecomates* are the dominant form, although convex-walled bowls similar to María Luisa's are also found. The great antiquity of these two shapes suggests a similar age for the manufacturing method. Molds are said by MacNeish, Peterson, and Flannery (1970:237) to be a hallmark of the Late Postclassic; certainly, they are little recognized before that period in the literature. The mold used by María Luisa for both bowls and "ollitas" would hardly be recognized as such by the archaeologist. Nothing more than a roughened ceramic hemisphere with no support, it might well be dismissed as a "common, coarse-paste, domestic vessel."

Once he masters the first two forms, the potter's child is advanced to the next project—a small *cántaro*. This is somewhat more difficult than the "ollita" or *tecomate*, as it has added handles, a neck and rim, and a flat bottom rather than a tripodal support. María Luisa will probably not learn to make these. Successful manufacture of this form requires mastery of the *parador*, an artifact used only by men (and boys). As Foster (1960:210) discovered, women do not turn the *parador* with the foot because of the immodest position they would be forced to assume. A final technique, though of minor importance, is the vertical-halves mold. Although Mario seldom has occasion to use this, he feels that its mastery is a necessary step in the learning process.

Once a child can produce simple bowls, "ollitas," *cántaros*, and the frogs (fig. 44), which utilize his vertical-halves mold, Mario is satisfied that there is a solid foundation on which to build. The child has now learned all of the techniques needed to make the entire spectrum of traditional and nontraditional Acatecan wares. Ahead of him, after school and during summer vacations, are years of practice as he works on larger and larger molds, adds new vessel forms, picks up speed, and perfects his technique. Now a member of the family work group, he joins in obtaining materials, preparing the paste, and finishing and firing the wares.

Juan is 15 and has been making pottery since he was 9. By the time he was 11 or 12, he was able to produce the smallest sizes of *lámparas*, *macetas*, toads (fig. 62), and other items of the trader's weekly order. The smallest toad, for example, is 9 centimeters high and 13.5 centimeters long. Now he is capable of making the largest of the seven sizes made by the family—41 centimeters high and 57 centimeters long, although this largest mold is usually reserved for use by his father or by Salvador.

Salvador, at 18, is almost as accomplished a potter as his father and should, by now, have left home to start his own establishment or, alternatively, brought home a bride to help with the work. Instead, like Oscar, his behavior reflects many of the changes affecting Acatecan ceramics. Rather than planning to leave home after his graduation from *secundaria*, he opted to remain at home and enroll in *preparatoria*, for which he must pay 100 pesos a month tuition, as well as the cost of books and supplies. After he graduates, he expects to attend the state university in Puebla. Salvador considered attending the Normal School in Acatlán but the program, four years after *secundaria*, would prepare him only for teaching in elementary school, and he would like to teach at least at the high school level. In order to implement these ambitions,

Fig. 62. Juan, at twelve, making a toad.

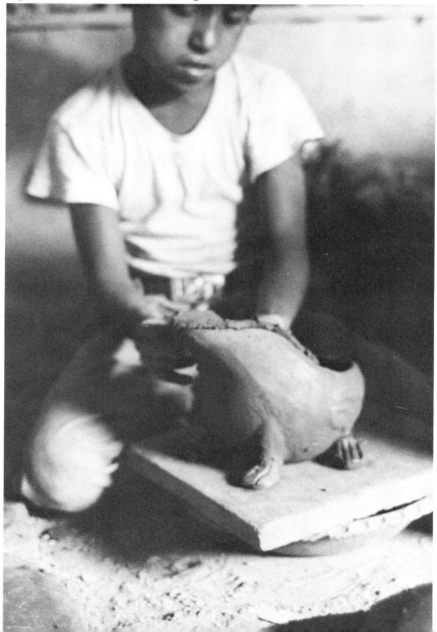

he spends his spare time experimenting with new designs, hoping to perfect a marketable line of his own. He has tried turtles, goats, and ducks, but his greatest success so far has been a series of trees of life inspired by a picture in his sixth-grade geography text (López 1968:118) (figs. 63, 64). The style of these trees of life is reminiscent of that of Herón; a central figure, or figures, sup-

Fig. 63. A kangaroo tree of life.

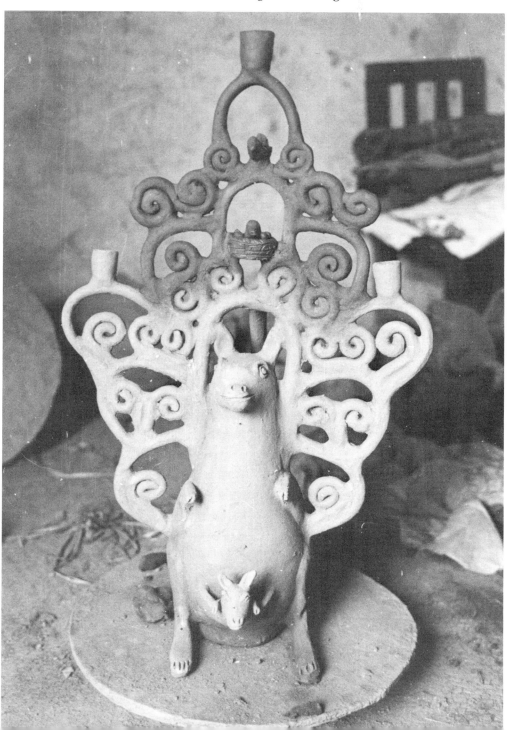

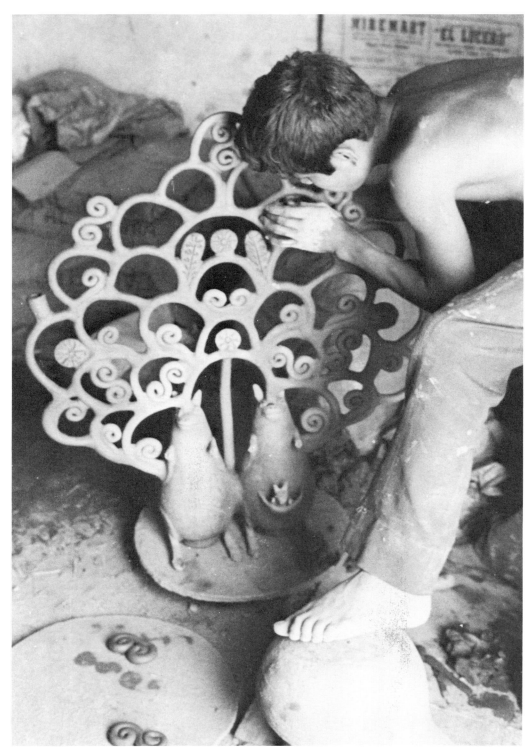

Fig. 64. Salvador working on a double-kangaroo tree of life.

ports an elaborate "tree," a framework of branches with leaves and flowers, as well as smaller figures. The central motif, one or two kangaroos, is taken from a lesson on Australia—certainly a departure from Acatlán's long ceramic tradition. Some of Juan's creations are just as far removed; these include "King-Kong, "smiley-faces," and peace symbols.

Mario helps his sons with these, both with suggestions and with actual "hands on" assistance (fig. 65). Mario is an excellent teacher: patient, kind, and encouraging. His comments and suggestions are always positive rather than critical, and he always seems to know when these are needed, as well as which moment to step in with physical help. Here he contributes no more than the exact touch needed to prevent a child's piece from becoming a discouraging failure; he never takes over the work. There are several boys in the neighborhood, friends of his sons, who come to him for help and advice with their work. One of these, José, the son of a pig butcher, is more attracted to pottery making than he is to his father's occupation. He spends all the time he can watching Mario, Salvador, and Juan at work and sometimes attempts a piece of his own. Mario neither encourages nor discourages him from his interest. Mario is glad to help the boy and, of course, any diversion is welcome to relieve the day-to-day monotony, but he does not want to appear "to take the boy away from his father," who is neither a relative nor a compadre.

Fig. 65. Mario helping Salvador.

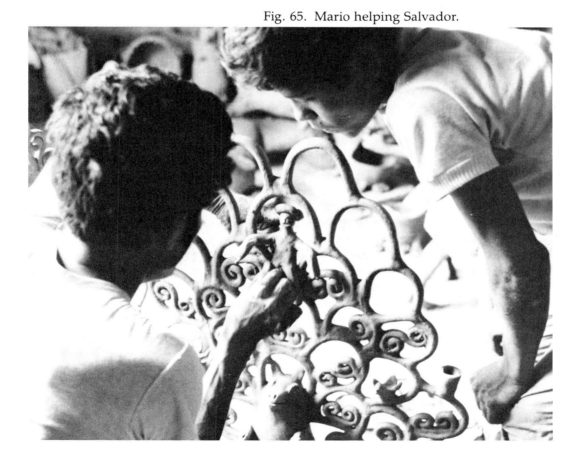

Fortunately for José, he no longer must rely on a parent or close relative to teach him pottery making, as it is now an elective minor subject taught at Fray Bartolomé de las Casas, the junior high school he will attend. Other choices include carpentry, electricity, and plumbing for boys, as well as cooking and sewing for girls. Both sexes can select typing or ceramics. Ceramics is not a very popular course among potters' children. Oscar chose carpentry instead, and Salvador transferred to typing after a single semester. Salvador dropped the course because he felt that he was learning very little and that that little was not going to be very useful to him. At the time that he took the course, the students were being taught slip-casting procedures almost exclusively. Salvador spent almost the entire semester attempting a bust of Emiliano Zapata; he would have preferred Benito Juárez, but never had an opportunity to use that mold. Finally achieving an unbroken casting, he spent the rest of the semester painting it before transferring to the typing class for his remaining five semesters at *secundaria*.

There have been a number of changes since Salvador took the ceramics course in the fall of 1972, but it is still not all that it might be. The new teacher is a native Acatecan who attempts to teach more traditional methods of pottery making to his students. His is an uphill struggle for a number of reasons. The students must work standing at long tables, a position foreign to pottery making anywhere (fig. 66). There were supposed to be stools, some say, that were never sent by the government; others say that the science department took them. Certainly, the traditional use of the *parador* cannot be taught at tables, yet no one thinks of sitting on the floor at school.

There are other difficulties. The clay, for which the students must pay a peso a kilo, is the standard Acatecan clay body. The formula for this mixture was developed empirically by generations of Acatecan potters and is ideally suited to the many handbuilding techniques that are used by them. It is not at all suitable, however, for wheel throwing, which, fortunately, is not yet offered. The clay body is even less suited to the technique of slipcasting. The new teacher cannot eliminate this technique from his curriculum because the molds are there and the students demand to use them (fig. 67). No matter how much the clay body is thinned, however, it does not become a suitable casting slip—it is too coarse and no deflocculant is added to prevent settling. The results are unsatisfactory. There are voids, the clay body sticks to the molds and tears when attempts are made to unmold the piece, and frequently a successfully unmolded piece will collapse because its walls are too thin or it was unmolded prematurely. If the piece survives to be fired, it is in danger of being crushed by heavier handbuilt pieces, as the kiln and the method of loading

and firing used are typically Acatecan, identical to that used by Mario.

There are also some discipline problems in the ceramics classes. The teacher must teach thirty to thirty-six students at a time, not all of whom can be said to be seriously interested in the subject matter. Elective classes at Fray Bartolomé de las Casas meet twice a week for a three-hour period. In contrast, similar classes in the Baltimore and Frederick, Maryland, junior high schools meet for fifty minutes a day, five days a week. Although the rather high teacher-student ratio is similar in all cases, one teacher for between thirty and thirty-six students, the shorter time period seems better suited to the interest span of the age level.

As in any classroom situation anywhere, students vary widely in interest and motivation, and, as in any art class, they vary widely in talent. There are some whose most creative endeavors include throwing pellets of clay at the ceiling and timing how long it takes them to fall. At the other end of the spectrum (or

Fig. 66. A ceramics class.

curve), there are students who are not only highly motivated and talented, but who are also willing to work at learning the craft of pottery making. The considerable effort that they must expend to overcome the many obstacles that confront them in the ceramics class is, however, often rewarded with pieces that are good enough to sell to a trader. An example of work of this caliber is a mermaid playing a saxophone made by a second-year student (plate 16). Although an almost direct copy of a design originated by Herón Martínez (and copied by him from Doña Rosa of Coyotepec), it is the very sort of work encouraged by the traders. Most of the students, however, fall into a middle group between the delinquent and the inspired. They plod along, doing work that is good enough to get by. Most of their work is small, some traditional, such as bowls (fig. 67) and *molcajetes*, other pieces more derivative of the new tourist-oriented market (fig. 68). On the whole, it is not felt that the school ceramics classes pose much of a threat, either to traditional family-oriented pottery-learning patterns or to the competition in the marketplace.

Although not open to José, there is still another major innovation in pottery-teaching methods in Acatlán, and this, too, shows little likelihood of threatening traditional pottery-learning patterns or of becoming established as a system. To the surprise of everyone in Acatlán, Herón has taken on three apprentices. These are not children, or even teenagers. They are adult men, are from *por allá* (elsewhere than Acatlán), and, most amazing of all, they are said actually to pay Herón to learn his methods. As in

Fig. 67. A slip cast head with three bowls.

most of Herón's actions, this has engendered widespread discussion and envy. Everyone would like to have apprentices who would not only pay to learn, but also do all of the dirty work. No one knows how to find these "crazy ones" who want to become apprentices and, again, Herón's good fortune is attributed to his publicity.

The Trader as Teacher

Among Acatecan potters who think about it, few would fail to acknowledge the debt they owe Herón. Although much of their weekly output includes copies of wares from all over Mexico and, indeed, now other parts of Latin America, much is copied from the one-of-a-kind pieces made by Herón Martínez and a handful of other innovators. The average Acatecan potter is not an innovator. He is an artisan rather than an artist, and, as Foster (1965: 52) explains, "artisans are not artists almost by definition." Foster further states that

> in spite of the presence of an occasional potter-artist in peasant societies, the evidence suggests that market demand rather than artistic urge is the primary cause of change. . . . In contemporary Mexico the tourist trade beyond question is the active force that is producing a florescence in pottery forms and designs.

In Acatlán, it is the traders who are primarily responsible, not only for the "florescence in pottery form and design," but also

Fig. 68. Other students' work.

for the diffusion (now greatly accelerated) that troubled Foster (1960:212) earlier. It is the traders who have both introduced new materials, such as the acrylic paints, and new techniques, such as reduction firing, but also taught the potters how to use these new materials and techniques. The traders have not, as yet, attempted to introduce the use of glaze, the potter's wheel, or the technique of high-fired stoneware. Alfonso López says that these will come, but "no one in Acatlán is ready yet," and predicts that "within 10 years Acatlán will be just like Tonalá." (See Diaz 1966.)

It is the incredible variety of pottery form and design that makes the greatest visual impact on a visitor to one of the pottery shops on the highway. Encouraging the development of this multiplicity is the area in which the traders have had the greatest impact. They have purchased examples of wares they want to carry in their stocks from potters in distant pottery-making towns, often watching the potter as he made the object. Upon his return to Acatlán, the trader has then been able, with the help of one or more examples, to instruct the Acatecan potter in the proper reproduction of the design. The pear-shaped candle shields, called *lámparas* (see fig. 43), made by Mario and family illustrate this form of diffusion. Originally from San Bartolo Coyotepec, Oaxaca, the *lámpara* is one of the forms developed by the famous Doña Rosa. López explains that it is much more convenient for him to buy copies of these as well as of other popular wares in Acatlán. It saves breakage in shipping, and he need not overstock items that might not sell well. He has Herón's work copied because Herón cannot meet the demand for his work by himself.

Besides providing examples of actual wares to copy, the trader also provides pictures. These pictures range from indistinct black-and-white newspaper photographs to the full-color covers of *Artesanos y Proveedores*. Picture postcards of wares in the National Museum of Anthropology in Mexico City are also used, providing the inspiration for some of the "empty revivals" mentioned earlier. Some of the three-dimensional copies of these two-dimensional prototypes lose much in the translation. Unseen or unclear details are omitted or changed to something better understood, and the resulting "copy" is so far from the original version as to be almost itself an original. Some of these are successful enough to become part of a particular potter's repertoire; some simply do not sell and are discontinued.

In the desperate search for new ideas by trader and potter alike, inspiration is being sought in a number of ways unheard of (and, of course, unneeded) a generation ago. Besides newspaper, magazine, and book designs, ideas have been taken from television and motion picture heroes and comic-strip characters. With roads better than a generation ago and with rapid, cheap bus transportation readily available, people are traveling more often and farther, and are bringing back ideas and examples from the museums and markets of Oaxaca and Puebla, as well as Mexico City.

Regional and nationwide competitions and exhibitions have offered Acatecans other than Herón Martínez the opportunity to show their work, as well as to see the best examples of work from other parts of the country.

10

The Past and the Future of Ceramics in Acatlán

Present-day Acatlán is still an important pottery-making center. How long it will remain one in today's rapidly changing Mexico is to be seen. How long it has been a pottery-making center is another question and one that can be answered only by some serious and intensive archaeological work. Despite the belief of Mario and his colleagues that Acatlán has "always" been a pottery town, there is little evidence to substantiate such a claim, for there has been very little archaeological investigation of the area. That is unfortunate, since such investigations might help solve a number of problems. Some of these problems specifically involve ceramics, e.g., the origin of such wares as Aztec I and Thin Orange, and the antiquity of the convex mold. Other questions and problems are more basic to Mesoamerican archaeology as a whole.

Acatlán was at the midpoint of one of the two main routes that connected Teotihuacán and Cholula with Monte Albán; presumably, it was equally subject to influences from both directions, as well as from Tehuacán and Veracruz. According to Peterson (1962:80), Acatlán is in an area that is a key to understanding not only the Mixteca Alta, the Mixtequilla, and surrounding territory, but the rest of Mexico as well. Peterson emphasized the urgent need for archaeological work at such sites as Tlilantongo, Coixtlahuaca, Coxcatlán, Tututepec, Suchixtepec, Quiotepec, Huajuapan, Cuicatlán, and Teotitlán in addition to Acatlán. In this area, the Mixteca Baja, and its towns of Acatlán, Puebla, and Huajuapan, Oaxaca, Paddock (1966:176) has found evidence of a "pre-Mixteca–Puebla" style. Paddock termed this region the Nuiñe (literally, "Hot Land"), from the Alvarado dictionary of 1593. Paddock later reported on a brief salvage project he completed in a tomb in Huajuapan de León, Oaxaca, about 62 kilometers south of Acatlán and also on the Pan American Highway. This project apparently confirmed Paddock's hypothesis that the Nuiñe, which had long been considered by archaeologists to have

been "too poor to have been of importance in ancient times," was the home of a distinctive regional art style previously unknown. In addition, Paddock (1970:2) states, it "seems to have been a meeting ground for the major early traditions whose capitols were at Teotihuacán, in the Valley of Mexico, and Monte Albán, in the Valley of Oaxaca."

According to Paddock (1966:178), one ancient trait unique to the Ñuiñe style was centered at Acatlán. This is an artifact complex known as *cabecitas colosales*, or colossal headlets, small pottery heads similar in conception to the Olmec colossal stone sculptures. Their similarity lies in the fact that the Acatecan pottery heads, although much smaller and much later (Paddock does not say how much smaller or how much later), are also bodiless, naturalistic, and almost spherical. A number of these "headlets" are stored in the Museo Nacional in Mexico City and Paddock has examined others of Acatecan provenience, which he pictures in his figures 199–207.

No one has found the "headlet" problem fascinating enough to warrant further investigation, and the situation has not changed since Moser (1969:483) complained that

> though A. Espejo has made some explorations at Acatlán Viejo, the report remains unpublished. To my knowledge, no other excavations of a scientific nature have been conducted in this region. This is especially unfortunate since Espejo believes that she has found the antecedents of the Aztec I ceramic tradition at Acatlán.

Moser cites Jiménez Moreno (1966:62), who apparently had access to Espejo's mimeographed report, although Jiménez Moreno himself does not cite it.

More important to Mesoamerican archaeology in general, and to the ceramics specialist in particular, than the origin of Aztec I ware is the origin of Thin Orange ware. Thin Orange was an important and widely distributed tradeware that was made from the end of the Preclassic through Early and Late Classic. Its center of origin must have been in the region of southern Puebla, according to Sotomayer and Castillo Tejero (1963:18), but the exact location of its manufacture has yet to be determined. Sherds of Thin Orange, as well as whole vessels, have been found throughout Mesoamerica. Kidder, Jennings, and Shook (1946:197) traced its distribution from northern Puebla to Copán, Honduras, and illustrated some of known Acatlán provenience (1946:fig. 196a,b,c). The range of Thin Orange has since been extended as far west as Colima and as far north as Tula (Tolstoy 1958:20).

Shepard (1946:201) characterizes the style of Thin Orange as one of simplicity and restraint, with a delicacy and an appearance of fine workmanship that is exceptional. The thinness of the vessel walls is the most important and unusual attribute of the ware. Shepard feels that

> an unusually strong, plastic clay would have been required to ob-

tain the thinness of wall which characterizes the ware, and for this reason it could not successfully be imitated by people possessing only ordinary clays. It is therefore certain that thin orange was made in a locality where high grade clay occurred, and what is essentially a technical feature was probably an important factor in its wide distribution.

Most scholars will agree with Kidder, Jennings, and Shook (1946:198), who were sure that Thin Orange was made in a single locality; it is the particular locality that is still in question. Leonard (1953:443) is certain that she has narrowed the search to a pottery-manufacturing site just north of the modern town of San Juan Ixcaquixtla. She bases her belief that the potters who lived here were responsible for Thin Orange ware on the following: "(1) The finding of this ceramic ware exclusively in the tombs and cellars of the area north of San Juan Ixcaquixtla. (2) The existence of pieces that were unmarketable due to firing defects. (3) The existence of coarse pieces possibly made for domestic use." [My translation]

Paddock (1966:177) seems to accept Leonard's findings but reminds us that (1966:178) "in most of the Ñuiñe region many local imitations of it, all failing to achieve the quality of the original, were made. Acatlán, also in southern Puebla, is the important modern pottery center where a ware very similar to ancient Thin Orange is produced today."

It is not inconceivable that the reason that the manufacturing site of Thin Orange has not been discovered is that it is still in use for pottery manufacturing and that that site is Acatlán. Mario and his colleagues might very well be working on a ceramic tell with the long sought Thin Orange center many meters beneath them. The wares produced in Acatlán today are certainly very similar in appearance to Thin Orange ware, both in color and in paste. Thinness of body wall is thought to be a desirable characteristic as well. Modern Acatecan ceramics are probably made in much the same way as was Thin Orange, and it is entirely possible that Leonard's (1953:443) third point could prove to be her most convincing argument in favor of an Ixcaquixtlan origin for Thin Orange. The "coarse pieces possibly made for daily use" could well have been molds, although she later posits that the "crude vessels of thin orange paste that were found" were made in the period of decadence following the fall of Teotihuacán.

That Leonard did not recognize the coarse pieces as molds is not surprising, even though Foster (1948:362) had earlier explained that

> most archeologists are not well acquainted with modern techniques, and have not been trained to recognize molds, and partially to the usual fate of molds. With one exception (perhaps two) no molds, except those for figurines have been reported archeologically. This is less significant than appears at first thought. Unlike finished pottery, and perhaps ritual ware, a mold is the lowliest

of household artifacts. Never would it be placed in a grave with a deceased person, and other chances of survival are slight. If broken once or twice, a mold is patched together and reused. Not until it is completely shattered is it discarded, and then its component parts are scattered at random. Moreover, when reduced to sherds a plain mold without effigy characteristics is practically indistinguishable from coarse utilitarian ware. Distinctive as they are, and with archeologists on the lookout for them, only a handful of Mochica molds have been discovered. With no distinctive marks, and with no one looking for them, it is not surprising that molds are unreported from Mexico.

Archaeologists are now more aware than was Leonard of molds, their appearance, and the appearance of the finished wares. The work of MacNeish, Peterson, and Flannery (1970:237), who found the use of molds widespread in the Late Postclassic, is an example cited earlier. Archaeologists seem not to be aware of a second possible use for such wares as Leonard's "crude vessels of thin orange paste"—i.e., saggars. Saggars have been defined by Fournier (1973:196) as clay boxes in which pottery is fired to protect the ware from flame and ash. They may be oval or circular; if square or oblong, they have rounded corners. The wall thickness averages 20 millimeters. As Fournier explains, their use has declined with the coming of cleaner fuels and smaller kilns. The extremely low percentage of fire clouding and other firing related defects found on Thin Orange ware may be because the wares were fired in a protective outer vessel, a vessel primarily intended to prevent the eggshell-thin walls of the Thin Orange from breaking as wares shifted during the firing. Although they do not make vessels expressly to serve as saggars, modern Acatecan potters place their more delicate wares in another sheltering vessel before firing them.

Saggars, or their equivalent, could have been used to protect Thin Orange wares in an open or pit firing, and it is entirely possible that they were fired in this fashion, as Sotomayor and Castillo Tejero (1963:19) found a firing temperature range of only 500° to 600°C. It is more likely, however, that Thin Orange wares, as well as many other preconquest Mesoamerican ceramics, were fired in kilns that were very similar to those in use in present-day Acatlán. Long thought to have been a Spanish introduction, kilns from pre-Columbian times were only recently discovered. Two were found during 1972 and 1973 in a residential zone at Monte Albán, and have been assigned to Monte Albán IIIB-IV, the Late Classic. Winter and Payne (1976:37) find them of interest for three reasons:

> First, because of their similarity to the ceramic kilns used today in the Valley of Oaxaca, those of Monte Albán suggest a pre-Hispanic origin for an element of contemporary pottery techniques in Oaxaca; second, the kilns of Monte Albán provide us with data about the production of pottery in pre-Hispanic times, and third, the

kilns provide us with relative data, as to domestic specialization in
Monte Albán [my translation].

145
The Past and
the Future

Winter and Payne (1976:37) compare the two kilns found with
those in use in Santa María Atzompa and San Bartolo Coyotepec,
two pottery-making towns in the Valley of Oaxaca. The larger of
the two kilns found was 1.4 meters in diameter, an open cylinder
with walls made of stones mixed with clay. The second was some-
what smaller, 1 to 1.1 meters in diameter. In this were found a
group of large sherds with indications that they had been used to
cover the kiln during firing (Winter and Payne 1976:39).

Both of the Monte Albán kilns, as well as the habit of covering
the wares with large wasters during firing, are very similar to
those described earlier for modern Acatlán. There are other sim-
ilarities between Monte Albán and Acatlán; some wares described
by Caso and Bernal (1965:875) are an example. "Very coarse
brown clay was used in the manufacture of ordinary pieces, such
as great conical vases in the shape of flowerpots, comals, ollas,
and also large boot-shaped vessels." Two of these wares, the
"flowerpot" and the "boot-shaped" vessel, pictured in their figure
7, bear a strong resemblance to the molds used daily by Mario
Martínez and other Acatecan potters. Some Gray wares, illus-
trated in their figure 4, could also have been made in Acatlán.
They are animal-effigy vessels—a frog, a duck, and two snails.
The four, also shown, were probably formed on a mold similar
in shape to those used by Mario to make toads ("boot-shaped"
vessels).

Both the "ordinary pieces" and the effigy vessels date from
Monte Albán I, the upper Preclassic horizon as defined by Caso
and Bernal (1965:871). Their dates, which average 650 B.C., corre-
spond to the Mesoamerican Middle Preclassic as defined by other
writers, according to an editor's footnote. If indeed they are found
upon reexamination to be mold-made, it would push the use of
this method of pottery making back 2,000 years earlier than Mac-
Neish, Peterson, and Flannery's (1970:237) Late Postclassic. In
light of Acatecan pottery-teaching procedures earlier described, it
can be posited that the use of molds goes back to the beginnings
of pottery making in Mexico. Only more archaeological work
done by archaeologists aware of molds and their use can con-
fidently extend the spatial and temporal limits of this method, but
such extension is likely.

Acatlán's ceramic tradition cannot be dated with any degree of
certainty, but since at least the Late Postclassic, Acatecan pottery
making has been (to apply the terminology of General System
Theory) a system in a state of relative equilibrium. Recent changes
in some subsystems of the craft, primarily the economic and en-
culturation subsystems, as well as changes in the Mexican eco-
nomic system, have altered this state. These changes have placed
pottery making in a state of disequilibrium, a state from which it

must either move up to a higher state of equilibrium or fail to survive. What further changes must take place to decide the fate of the pottery-making system one way or another? At this point, it seems likely that Acatecan pottery making, by selecting certain changes and innovations and rejecting others, will survive.

Meggers (1975:19) asks "what circumstances encourage acceptance of innovations, whether generated locally or obtained from elsewhere." In Acatlán, as well as in many other Mexican craft centers, these circumstances have been primarily economic. With the decline in demand for traditional wares, craftsmen have accepted design innovations where they would not have accepted a change in manufacturing method. Díaz (1966:183) found this to be the case in Tonalá, where a

> Tonaltecan potter will make any clay object which can be made by the molding method he is accustomed to and by using his kind of kiln. These latter two limitations are more important than the aesthetic one. What changes is the shape of the object or the kind of decoration used; what remains the same is the technique of manufacture, the division of labor, and the organization of work.

Similar problems were faced by Zapotecan weavers in Teotitlán del Valle, Oaxaca, and similar solutions were found. As increasing industrialization of Mexico's textile industry has brought inexpensive, factory-woven, synthetic yard goods to the most remote village markets, there has been a concomitant lessening of demand for the relatively expensive, handwoven, woolen blankets and sarapes of Teotitlán. As Teotitleco weavers increasingly turned to the tourist markets in Mitla and Oaxaca City, they must have become as desperate for new marketable ideas as Acatecan potters. Teotitleco weavers also relied heavily at first on stepped-fret designs in "empty revival" in a production called the "Mitla blanket." By 1970, they were more than ready to accept some fairly drastic stylistic innovations, which were set in motion by an outside source. This took the form, according to Miller (1975:7), of an unknown woman who arrived in the village with a collection of contemporary art books and magazines. Weavers now include designs by Miró, Picasso (plate 18), Vasarely, Matisse, Calder, and Klee, among others, in their repertoires. Yet, as Miller is careful to point out, both pre-Columbian dyes and rudimentary looms are still in use.

In discussing innovation among Papago Indian potters, Fontana et al. (1962:82) also stress that

> potters who have been "trained" in traditional Papago pottery techniques adhere to those techniques even when shown others. . . . nontraditional forms are made in traditional ways. The gathering and preparation of clay is the same; the modeling or molding with paddle-and-anvil and coiling are the same; the slipping is the same; and the firing is the same.

In describing the work of one particular Papago potter, Laura Kerman, Fontana et al. (1962:115) stress her role as an "innova-

tor." Although other Papago potters have been slow to follow her example, the authors suggest that she may not be "atypical of 'aberrant' potters in other cultures and at other times." Acatecan potters, on the contrary, have been more than anxious to follow the lead of their resident "aberrant," Herón Martínez. What was lacking, perhaps, among the Papago was economic motivation.

Earlier cited was Foster's (1960:212) statement that "diffusion is rapidly wiping out many regional distinctions in Mexican ceramics." Just as regional styles have blended or are blending into a national style, national styles are merging into a contemporary international style. "Aberrant innovators," such as Herón Martínez, Jorge Wilmot, Aurelio Flores, and other prominent Mexican potters, are becoming as well known for their work as Peter Voulkos, the late María Martínez of San Ildefonso, the late Bernard Leach, or the late Hamada. Teotitlecan weavers—Isaac Vásquez García and Alberto Vásquez—have shown their work in Paris, New York, and California, as well as in Mexico City. Part of a worldwide revival of interest, this renaissance in Mexican handicrafts has attracted the Seventh Assembly of the World Crafts Council and the Second International Exposition of World Crafts, which met simultaneously in Mexico. The point has been reached, according to Nelson (1971:70), at which "a modern ceramist may have more in common with a craftsman in another country than with the potter down the street."

The impact of these trends is just beginning to be felt at the village level. Although it is perhaps premature to predict the end result, an analogue can be found in the southwestern United States. In a discussion of similar trends, Spicer (1962:559) draws parallels between Navajo weaving and Pueblo pottery making, in that both groups have developed into distinct artistic traditions. The first tradition, that of cheap and rapid production to meet the demands of the tourist trade, is still typical of the great mass of the Navajo blanket trade. The second tradition is that of production for an upper-income clientele of sophisticated and esthetically conscious buyers. Certainly there is nothing new about the latter; people who can afford it have always wanted nothing but the best in the material culture with which they surround themselves. In discussing the three types of pottery most widely distributed in Mesoamerica, Thin Orange, Fine Orange, and Plumbate, Shepard (1968:355) posited that the "wide distribution of these three types points to the possibility of a general preference for pottery that is technically superior." Minton and Wedgewood could be substituted in a discussion of present-day ceramic preference among the well-to-do.

Spicer's first tradition, that of "cheap and rapid production to meet the demands of the tourist trade," is not limited to Navajo weaving. In a discussion of "commercial" and "souvenir" arts, Graburn (1970:196) finds that

> this market has been growing in recent decades with the increasing affluence of the white populations and the "proletarianization" of

art itself. Art is no longer purchased by the rich few. The turmoil in our own artistic productions, combined with ever increasing travel and the lure of exotica and non-machine age crafts, have elevated minority ethnic arts from curiosities to much desired arts, with a market of hundreds of thousands or millions.

To Nelson (1971:70), this increased market represents "the desire to possess and to use an object bearing the imaginative touch of the human hand represents a natural reaction against the sterility of industrially produced products, and this is responsible for the recent widespread interest in all the crafts."

In light of the present heavy demand for craft wares, including Mexican pottery, Acatecan pottery making seems to be in no danger of disappearing. And, despite the many changes in marketing procedures and pottery design, manufacturing methods are most likely to remain unchanged. In many ways, the convex mold is superior to the potter's wheel for production work. Larger pieces can be made by this process than on the wheel, and more rapidly, a form can be reproduced an infinite number of times, and while the potter is able to produce radially symmetrical forms on a convex mold, he is not limited to these as he would be on the potter's wheel. For these reasons rather than tradition, Acatecan potters, like other Mexican potters accustomed to convex molding, will continue to do so. In the past, anthropologists have spoken of one group or another "rejecting" or "failing to accept" the potter's wheel even after it had been "introduced." As can be seen, the reasons for "rejecting" the wheel are valid, and a method of pottery making, possibly 7,000 years old, is likely to continue.

From its recent state of disequilibrium, Acatecan pottery making seems to be in the process of reintegrating on two separate levels of equilibrium. These two levels can be equated with Spicer's two traditions in Navajo weaving and Pueblo pottery making, with the work of Herón and Mario typical of the work of both levels. With increased demand for pottery, the gap between the two levels will continue to widen. The better craftsmen, such as Mario, will more than likely move up to the upper level of production, while others are doubling and even tripling their turnout of ever smaller and more badly made pieces.

A tourist in the Casa López was heard to remark upon viewing the plethora of wares that "these people are being ruined; their traditions are gone." After Miller's (1975:7) article about Teotitlán weavers appeared in *Crafts Horizons*, the prestigious journal of the American Crafts Council, a number of members wrote to the editor complaining that Teotitleco weavers were being "ruined." Yet, as Graburn (1976:13) reminds us:

> The persistence of traditional arts and crafts depends on: (1) continued demand for the items, (2) availability of the traditional raw materials, (3) time to work and lack of competing attractions, (4) knowledge of the skills and the aesthetics of the arts, (5) rewards and prestige from peer-group members, (6) the role of the items in

supporting the belief systems and ritual or gift-exchange systems. Much as we are nostalgic about these loved arts, people do not go on making them for our pleasure if our society and technology have destroyed the incentive to do so. They go off and become bus-drivers or betel-nut sellers.

Graburn later states that "European and Western society in general, while promoting and rewarding changes in its own arts and sciences, bemoans the same in others." The "ruined" weavers in Teotitlán are not bemoaning the rewards brought to them by the changes in their weaving patterns. They have rebuilt their houses with plastered walls, tiled floors, and fluorescent shop lights over their looms. Their increased prosperity is beginning to be reflected in the better health and nutrition of their families, the better education of their children, and greater hopes for the future. As Acatecan pottery making stabilizes at a higher level, perhaps the "ruined" potters will be able to emulate the prosperity of the weavers and thus escape the "miserably low incomes" Foster (1967:61) mentioned.

Archaeologists have increasingly turned to ethnographic research as an aid in the interpretation of archaeological data. The necessity for this was explained by Deetz (1970:123): "Material culture of living societies has traditionally been the domain of the ethnographers and they have not been as concerned with this aspect as with other more exciting subjects." Earlier cited was Leone's (1972:26) similar complaint about the long neglect by ethnographers of studies of material culture. In the climate of the "New Archaeology" of the 1960s, such dissatisfaction with the work of ethnographers led to the emergence of a new field of inquiry, within the subdiscipline of archaeology. Termed "ethnoarchaeology," early examples were Oswalt and Van Stone's (1967) study of innovation in Eskimo artifacts, Gould's (1968) study of stone toolmaking in western Australia, and Stanislawski's (1969) work with Hopi pottery makers.

By the 1970s, ethnoarchaeologists were investigating a broad spectrum of problems. Three collections of papers (Donnan and Clewlow, Jr., eds.:1974; Gould, ed.:1978; and Kramer, ed.:1979) reflect the widely varying cultural and ecological settings chosen by the investigators and their common interest in the study of material culture. Gould (1978:4) defines ethnoarchaeology as "the study of present day material behavior. . . . a peculiar kind of ethnography, one with an unabashed materialist bias. The ethnoarcheologist looks *first* at the ways in which material items are made, used, and discarded (or collected, processed, and disposed of), and he tries to make these observations as empirical as possible."

The methodology of ethnoarchaeology includes a concern with fact gathering that could almost be called neo-Boasian. The Boasian ethnographer was concerned, as is the ethnoarchaeologist,

with the collection of a body of data about a culture before that culture disappeared. The ethnoarchaeologist, working against even greater time pressures, must do remedial ethnography to discover those aspects of material culture that have failed to interest the ethnographers and that are necessary to his archaeological investigations. The present study falls within this category. Intended as a contribution to Mesoamerican archaeology in general, and the region of southern Puebla in particular, its purpose has been to shed some light on pre-Columbian pottery-making methods. Much more work of this nature is needed before we can reach a clear understanding of the role of the craftsman and his craft in Mexico before the conquest. As an integral part of man's culture, his material technology is the means man uses to control or change his environment.

As in any problem-oriented research, the quest for answers to one question exposes other questions to view. Changing styles in ceramics have always been indicative of changes in the cultures of the potters who made them. The rapidly changing ceramics of Acatlán are a reflection of the rapidly changing culture and technology of modern Mexico. How have these changes affected the lives of Acatecan potters? As Leone (1972:26) states: "We know almost nothing about the effects of technology and material culture on other cultural subsystems and vice versa." Future research should concentrate on some of these subsystems; the economics of pottery making, the seemingly high incidence of drinking among potters, and the effects of the changing technology on the social structure of the potters are some examples. One of the most frequent final statements found in scholarly writing is a plea for more work to be done in the area. In the case of Acatlán, this is sound advice.

Appendix: Technological Analysis

The mineral composition of the components of the clay body used by Mario Martínez were measured on a North American Philips Electronics X-ray generator and diffractometer. Earlier petrographic examination of these materials under a polarizing microscope had shown only quartz as a component of the clay body. Both oriented and unoriented samples were studied. Glycolation and heat treatment were used to confirm the identification of the clay minerals.

tierra colorada: Used for 50 percent of the clay body. Kaolinite, illite, very fine grained quartz colored by hematite. Contains no montmorillonite.

arena: Used for 25 percent of the clay body. Talc with minor admixture of "illite" (a partially degraded muscovite).

barro negro: Used for 25 percent of the clay body. Predominantly montmorillonite, with less than 10 percent "illite." (This is not an interlayered clay, but a physical mixture.)

tinta: Used as a paint applied before firing. Illite and kaolnite colored with hematite.

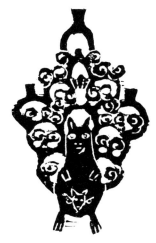

Glossary

Definitions reflect usage local to Acatlán, Puebla, which differs in some instances from that current in other areas of México.

adobe: Sun-dried building blocks made of clay or mud.

aguardiente: An untaxed liquor, similar to rum, made of sugarcane. Found in South and Central America and the southwestern United States.

alma: Literally, soul. A base or core made of crumpled or rolled-up newspaper used in place of a **molde** to support some clay objects as they are made.

anafre: A small metal charcoal-burning stove.

ánfora: Amphora, an alternative term for *cantimplora*, a three-handled water storage jar 0.8 to 1.0 meter high (fig. 37).

arena: Literally, sand. One of the components of the clay body. See Appendix.

azotador: A lump of clay formed into the shape of a pestle, fired, and used as a pottery-making tool in the state of Oaxaca.

barril: A pottery water-storage container 0.75 to 1.0 meter high (fig. 8).

barrio: A neighborhood or section of a town, often corresponding to a ward in a United States city.

barro negro: Literally, black clay. One of the components of the clay body. See Appendix.

brasero: A ceramic brazier usually used to cook an olla of beans (fig. 42).

cabecitas colosales: Literally, large little heads. Pre-Columbian pottery artifacts of Acatecan provenience.

cacicazgo: A chieftainship.

cacique: A native leader, or chief. Local political boss.

campesino: A person from the country. A peasant.

cántaro: A pottery water bottle 45 to 50 centimeters high, with either 3 or 4 vertical handles (figs. 3, 12).

cantimplora: A pottery water storage vessel with a restricted neck and 3 vertical handles from 0.8 to 1.0 meter high; *ánfora* is an alternative term (fig. 37).

cargita: The amount of fuel or other load that can be carried by one burro (fig. 23).

cazuela: A shallow casserole used for cooking and serving. Usually has two loop handles (fig. 4).

centavo: One-hundredth of a *peso*, an amount so small in value that it is no longer coined.

coda: Literally, elbow. In southern Puebla, the gesture of clapping the left elbow with the right hand, meaning "cheap" or "stingy."

comal: A metal, stone, or pottery griddle on which tortillas are baked over an open flame.

compadre: The parent of one's godchild, or the godparent of one's own child.

compadrazgo: Literally, co-parent-

hood. An institution of fictive kinship.

consola: A piece of furniture usually containing a radio and phonograph and, often, a television set.

cuchillo: A small knife, with no handle, made of half of hacksaw blade, used as a pottery-making tool. Also, dinner knife.

chimbul: An alternative term for *cántaro*, a pottery water bottle (figs. 3, 12).

chimenea: A pottery space heater (figs. 10, 11, plate 15).

chorreada: A multicolored effect achieved with glaze, common to some Oaxacan wares.

distrito: The largest political division of a Mexican state, similar to a United States county.

elote: A corncob used as a pottery-making tool (fig. 35)

fiesta: Almost any kind of preplanned social activity, with the exception of funerals.

greca: Reversed spiral or stepped-fret motif, either painted or modeled (plate 3).

Gringo: Anyone from the United States, Canada, or Europe.

guayabera: A pleated, open-collared shirt worn without a tie. Originally from Cuba, now manufactured in Yucatán.

hornillo: Firemouth of a kiln (fig. 32).

horno: A kiln (fig. 32).

huaraches: Sandals woven of narrow strips of leather, often with soles made of automobile tires (plate 7).

indigenismo: The current vogue for reviving Mexico's Indian past.

jiotilla: A species of cactus, *Escontria chiltilla*, used for kiln fuel.

jip: A Mexicanization of the English slang term "hip."

ladrillo: Fired clay tile or brick (fig. 27).

lámpara: Pottery candle shield (fig. 43).

liquado: Iced, noncarbonated drink made with fruit juice and water. Now often made in a blender.

maceta: A head or flowerpot; flowerpots in the shape of heads are,

therefore, visual puns (fig. 39).

machete: A large, broad, heavy, all-purpose knife.

maestro: Literally, master. A term of respect accorded to teachers and master craftsmen.

mano: A handstone or pestle, rolled across a metate to grind corn.

masa: Dough made of corn and used for tortillas.

mestizo: A person of mixed Spanish and Indian descent.

metate: A concave grinding stone or mortar used with a mano.

mina: Mine (figs. 18, 19, plate 6).

Mixteca: Indigenous inhabitants of the states of Puebla, Oaxaca, and Guerrero, Mexico.

molcajete: A tripodal pottery grinding bowl with a raised design on the interior.

molde: A mold (figs. 30, 31, 38).

molina nixtamel: A town or neighborhood mill where cooked corn is ground into *masa* or dough for the individual customer.

municipio: A political entity roughly equivalent to a township in the United States.

norteamericano: Anything, or anyone, from the United States.

olla: A ceramic vessel in which beans are cooked (fig. 4).

ollita: Any small vessel; more locally, a neckless spherical jar resembling a *tecomate*.

órgano: The popular name for two large species of cactus, *Cereus marginatus* and *Cereus gemmatus*. The name is taken from their resemblance to a pipe organ.

palo: A wooden stick or club (fig. 20).

palo de sauce: A small willow stick or wand, used as a ceramic tool (fig. 25).

parador: A flat-bottomed, cylindrical turntable or support used while making pottery. They vary in diameter from 40 to 50 centimeters (figs. 27, 28).

paseo: A twilight or evening walk around the park.

pepino: The fruit of any of a number of species of cucurbit. Usually a wild cucumber.

petate: A woven mat made of palm or tule used for sleeping or as a work

surface for pottery making (figs. 1, 15).

peso: A Mexican coin formerly worth 8 cents in United States currency, now worth 4 cents.

pica: A straight-shafted, pointed steel tool used to prize loose clay body materials at the mine.

pila: A metal or concrete water storage tank.

pistolero: A bandit or gangster.

plato: A plate.

por allá: Literally, over yonder. Anywhere else than one's present location.

posada: an inn or boarding house.

pozolero: A barrel-shaped pottery liner for a spring or natural well.

preparatoria: A senior high school.

primaria: Elementary school, grades 1 to 6.

quinceaños: The fifteenth birthday, an important rite of passage for Mexican girls that is usually marked with a fiesta.

rana: Frog (fig. 44).

rebozo: A long rectangular shawl.

refresco: A carbonated soft drink.

refresquería: A stand or small shop where *refrescos* are sold.

sarape: A blanket or poncho.

secundaria: A junior high school.

significado: Significance or meaning.

sombrero: Hat.

tabla: A fired clay disc used to provide a clean, smooth work surface for pottery making or as a support for work in progress.

taco: A crisp fried *tortilla* filled with meat or other filling.

taza: A handled coffee cup.

tecomate: A neckless, spherical seed storage jar.

Tesáha: An alternate spelling of *Tizaá*.

tienda: A small neighborhood general store.

Tierra Caliente: Literally, hot land. Veracruz.

tierra colorada: Literally, colored earth. One of the components of the clay body. See Appendix.

tigre: A jaguar or any other large cat.

tinaja: A water storage jar almost as wide as high, the dimensions of which range from 50 centimeters to 1 meter.

tinta: A mixture used to paint greenware before firing. See Appendix.

Tizaá: The local name for the Acatlán River. Also applied to the immediate region of the town.

tortilla: A flat, thin cake of corn dough baked on a *comal*, by extension, a flat thin disc of clay.

urna: The generic term now applied to any large vessel. More properly, one with a narrow footed base (plate 12).

zócalo: The central square, or park, in a town.

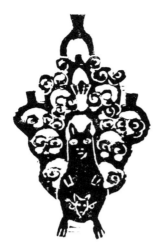

References Cited

Ascher, Robert
 1961a Analogy in Archeological Interpretation. Southwestern Journal of Anthropology 17:317–25.
 1961b Experimental Archaeology. American Anthropologist 63:793–816.

Brush, Charles F.
 1965 Pox Pottery: Earliest Identified Mexican Ceramic. Science 149:194–95.

Cardew, Michael
 1969 Pioneer Pottery. London: Longman.
Caso, Alfonso, and Ignacio Bernal.
 1965 Ceramics of Oaxaca. In Archaeology of Southern Mesoamerica, Part 2. Gordon R. Willey, ed. Pp. 871–95. Handbook of Middle American Indians, Vol. 3. Robert Wauchope, gen. ed. Austin: University of Texas Press.
Chang, K. C.
 1967 Major Aspects of the Interrelationship of Archeology and Ethnology. Current Anthropology 8:227–43.
Charleston, Robert J., ed.
 1968 World Ceramics: An Illustrated History. New York: McGraw-Hill.

Deetz, James
 1965 The Dynamics of Stylistic Change in Arikara Ceramics. Illinois Studies in Anthropology 4.
 1970 Archaeology as a Social Science. In Current Directions in Anthropology. Ann Fischer, ed. Bulletins of the American Anthropological Association, Vol. 3, No. 3, part 2:115–25.
Diaz, May N.
 1966 Tonalá: Conservatism, Responsibility and Authority in a Mexican Town. Berkeley: University of California Press.
Donnan, Christopher B., and C. William Clewlow, Jr., eds.
 1974 Ethnoarchaeology. Institute of Archaeology Monograph 4. Los Angeles: University of California.

Espejel, Carlos
 1972 Las artesanías tradicionales en México. México: Sep/Setentas.
 1975 Cerámica popular mexicana. Barcelona: Editorial Blume.

Fodor, Eugene, ed.
 1972 Fodor's Mexico 1972. New York: David McKay Company, Inc.
Fontana, Bernard L., et al.
 1962 Papago Indian Pottery. Seattle: University of Washington Press.
Foster, George M.
 1948 Some Implications of Modern Mexican Mold-Made Pottery. South-

western Journal of Anthropology 4:356–70.

1955 Contemporary Pottery Techniques in Southern and Central Mexico. Middle American Research Records 22:1–48.

1960 Archaeological Implications of the Modern Pottery of Acatlán, Puebla, Mexico. American Antiquity 26:205–14.

1964 Treasure Tales and the Image of the Static Economy in a Mexican Peasant Community. Journal of American Folklore 77:39–44.

1965 The Sociology of Pottery: Questions and Hypotheses Arising from Contemporary Mexican Work. In Ceramics and Man. Frederick R. Matson, ed. Pp. 43–61. New York: Aldine.

1967a Contemporary Pottery and Basketry. In Social Anthropology. Manning Nash, ed. Pp. 103–24. Handbook of Middle American Indians, Vol. 6, Robert Wauchope, gen. ed. Austin: University of Texas Press.

1967b Tzintzuntzan: Mexican Peasants in a Changing World. Boston: Little, Brown and Company.

Fournier, Robert

1973 Illustrated Dictionary of Practical Pottery. New York: Van Nostrand Reinhold Company.

Freeman, Leslie G., Jr., and James A. Brown

1964 Statistical Analysis of Carter Ranch Pottery. Chapters in the Prehistory of Arizona II. Paul S. Martin, ed. Fieldiana: Anthropology, Vol. 55, 126–54.

Fuentes Aguilar, Luis

1972 Regiones naturales del estado de Puebla. México: UNAM.

Gould, Richard A.

1968 Living Archaeology: The Ngatatjara of Western Australia. Southwestern Journal of Anthropology 24:101–22.

1978 From Tasmania to Tucson: New Directions in Ethnoarchaeology. In Explorations in Ethnoarchaeology. Richard A. Gould, ed. Pp. 1–10. Albuquerque: University of New Mexico Press.

Gould, Richard A., ed.

1978 Explorations in Ethnoarchaeology. Albuquerque: University of New Mexico Press.

Graburn, Nelson H. H.

1970 Art and Pluralism in the Americas. Anuario Indigenista 30:191–204.

1976 Introduction. In Ethnic and Tourist Arts: Cultural Expressions from the Fourth World. Nelson H. H. Graburn, ed. Pp. 1–32. Berkeley: University of California Press.

Grange, Roger T., Jr.

1968 Pawnee and Lower Loup Pottery. Lincoln: Nebraska State Historical Society Publications in Anthropology 3.

Griffin, James W., and Carleton W. Angell

1935 An Experimental Study of the Techniques of Pottery Making. Papers of the Michigan Academy of Science. Arts and Letters 20:1–6.

Gutiérrez, Elektra, and Tonatiúh Gutiérrez

1970–71 El arte popular de México. Artes de México: Número Extraordinario. Extraordinario.

Hamer, Frank

1975 The Potter's Dictionary of Materials and Techniques. London: Pitman Publishing.

Harvey, Marian

1973 Crafts of Mexico. New York: Macmillan.

Hendry, J. C.

1957 Atzompa: a Pottery Producing Village of Southern Mexico. Ph.D. dissertation, Cornell University. Ann Arbor: University Microfilms, Publication No. 22, 199.

Hodges, H. W. M.

1965 Aspects of Pottery in Temperate Europe Before the Roman Empire. In Ceramics and Man. Frederick R. Matson, ed. Pp. 114–23. Chicago: Aldine.

Hodin, J. P.
1967 Biographical Note. *In* A Potter's Work, by Bernard Leach. Tokyo: Kodansha International Ltd.
Hole, Frank, and Robert F. Heizer
1969 An Introduction to Prehistoric Archeology. New York: Holt, Rinehart and Winston, Inc.
Hopkins, Barbara
1974 Mexican Ceramics Today. *In* A Guide to Mexican Ceramics, by Florencia Muller and Barbara Hopkins. Pp. 61–127. México: Minutiae Mexicana.
Houston, Margaret, and Judith Carson Wainer
1971 Pottery-Making Tools from the Valley and Coast of Oaxaca. Boletín de Estudios Oaxaqueños 36.

Jiménez Moreno, Wigberto
1966 Mesoamerica Before the Toltecs. *In* Ancient Oaxaca: Discoveries in Mexican Archeology and History. John Paddock, ed. Pp. 3–82. Stanford: Stanford University Press.

Kidder, A. V., S. J. Jennings, and E. M. Shook
1946 Excavations at Kaminaljuyu. Carnegie Institution of Washington Publication 561.
Kramer, Carol, ed.
1979 Ethnoarchaeology: Implications of Ethnography for Archaeology. New York: Columbia University Press.
Kubler, George
1971 On the Colonial Extinction of the Motifs of Pre-Columbian Art. *In* Anthropology and Art. Charlotte M. Otten, ed. Pp. 212–26. Garden City: The Natural History Press.

La Farge, Oliver
1959 Foreword. *In* Five Families, by Oscar Lewis. Pp. vii–x. New York: New American Library.
Lawrence, W. G.
1972 Ceramic Science for the Potter. Philadelphia: Chilton Book Company.
Leach, Bernard
1973 A Potter's Book. Levittown: Transatlantic Arts, Inc.
Leonard, Carmen Cook de
1953 Los Popolocas de Puebla. Revista Mexicana de Estudios Antropológicos 13:423–25.
Leone, Mark P.
1972 Issues in Anthropological Archaeology. *In* Contemporary Archaeology: A Guide to Theory and Contributions. Mark P. Leone, ed. Pp. 14–27. Carbondale: Southern Illinois University Press.
Longacre, William A.
1970 Archaeology as Anthropology: A Case Study. Anthropological Papers of the University of Arizona 17.
López Llergo, Rita
1968 Mi cuaderno de trabajo de sexto año: geografía. México: Comisión Nacional de los Libros de Texto Gratuitos. Dependiente de la Secretaría de Educación Pública.

MacNeish, Richard S., Frederick A. Peterson, and Kent V. Flannery
1970 Ceramics. The Prehistory of the Tehuacán Valley, Vol. 3. Richard S. Mac-Neish, gen. ed. Austin: University of Texas Press.
Matson, Frederick R.
1960 The Quantitative Study of Ceramic Materials. *In* The Application of Quantitative Methods in Archaeology. R. F. Heizer and S. F. Cook, eds. Pp. 34–59. Viking Fund Publications in Anthropology 28.
1963 Some Aspects of Ceramic Technology. *In* Science in Archaeology: A Survey of Progress and Research. Don Brothwell and Eric Higgs, eds. Pp. 489–98. London: Thames and Hudson.

1965 Ceramic Ecology: An Approach to the Study of the Early Cultures of the Near East. *In* Ceramics and Man. Frederick R. Matson, ed. Pp. 202–17. Chicago: Aldine.
1971 A Study of Temperatures Used in Firing Ancient Mesopotamian Pottery. *In* Science and Archaeology, Robert H. Brill, ed. Pp. 65–79. Cambridge: The M.I.T. Press.

Meggers, Betty J.
1975 The Transpacific Origin of Mesoamerican Civilization: A Preliminary Review of the Evidence and its Theoretical Implications. American Anthropologist 77:1–27.

Mejic, Senén
1974 Con el presidente municipal de Huajuapan de León. La Mixteca: Voz del Tizaá 1(4):1, 4.
1977 El incendio en el Calvario fue una perdida invalorable. La Mixteca: Voz del Tesáha 4(27):1, 6.

Michaels, Alan S.
1958 Rheological Properties of Aqueous Clay Systems. *In* Ceramic Fabrication Processes. W. D. Kingery, ed. Pp. 23–31. Cambridge: The M.I.T. Press.

Miller, Carol
1975 Village Weaves Anew. Craft Horizons 36(6):7.

Moser, Chris L.
1969 Matching Polychrome Sets from Acatlán, Puebla. American Antiquity 34:480–83.

Munsterberg, Hugo
1964 The Ceramic Art of Japan: A Handbook for Collectors. Rutland, Vermont: Charles E. Tuttle Company.

Nelson, Glenn C.
1971 Ceramics: A Potter's Handbook. New York: Holt, Rinehart and Winston, Inc.

Noble, Joseph V.
1960 The Techniques of Attic Vase-Painting. American Journal of Archaeology 64:307–18.

Norman, James, and Margaret Fox Schmidt
1973 A Shopper's Guide to Mexico: Where, What, and How to Buy. Garden City: Dolphin Books.

Novelo, Victoria
1976 Artesanías y capitalismo en México. México: Instituto National de Antropología e Historia.

Ortíz de Montellano, Guillermo
1975 Significado de. La Mixteca: Voz del Tesáha 2(14):4.

Oswalt, Wendell H., and James W. Van Stone
1967 The Ethnoarchaeology of Crow Village Alaska. Bureau of American Ethnology Bulletin 199.

Paddock, John
1966 Oaxaca in Ancient Mesoamerica. *In* Ancient Oaxaca: Discoveries in Mexican Archeology and History. John Paddock, ed. Pp. 83–242. Stanford: Stanford University Press.
1970 A Beginning in the Ñuiñe: Salvage Excavations at Ñuyoo, Huajuapan. Boletín de Estudios Oaxaqueños 26.

Payne, William O.
1970 A Potter's Analysis of the Pottery from Lambityeco Tomb 2. Boletín de Estudios Oaxaqueños 29.

Peacock, D. P. S.
1970 The Scientific Analysis of Ancient Ceramics: a Review. World Archaeology 1:375–89.

Peterson, Frederick A.
1962 Ancient Mexico: An Introduction to the Pre-Hispanic Cultures. New York: Capricorn Books.

Quimby, George I.
 1949 A Hopewell Tool for Decorating Pottery. American Antiquity 4:344.

Reina, Ruben E.
 1963 The Potter and the Farmer: The Fate of Two Innovators in a Maya Village. Expedition 5(4):18–30.
Richter, Gisela M. A.
 1923 The Craft of Athenian Pottery. New Haven: Yale University Press.

Shepard, Anna O.
 1946 Technological Features of Thin Orange Ware. *In* Excavations at Kaminaljuyu, by A. V. Kidder, S. J. Jennings, and E. M. Shook. Carnegie Institution of Washington Publication 561.
 1968 Ceramics for the Archaeologist. Washington: Carnegie Institution of Washington.
Simpson, Lesley Byrd
 1971 Many Mexicos. Berkeley: University of California Press.
Sotomayor, Alfredo, and Noemí Castillo Tejero
 1963 Estudio petrográfico de la cerámica "Anaranjado Delgado." México: Instituto Nacional de Antropología e Historia.
Spicer, Edward H.
 1962 Cycles of Conquest. Tucson: The University of Arizona Press.
Stanislawski, Michael B.
 1969 The Ethno-Archaeology of Hopi Pottery Making. Plateau 42(1):27–33.

Tamayo, Jorge L.
 1962 Geografía general de México. Tomo III: Geografía biológica y humana. México: Instituto Mexicana de Investigaciones Económicas.
Tapia, Miguel Y., and Simitrio Márquez Herrera
 n.d. Diario de un pueblo: Acatlán de Osorio, Pue. Miguel Salmorán Marín, ed. Mexico City: privately printed.
Thompson, Raymond H.
 1958 Modern Yucatecan Maya Pottery Making. Memoirs of the Society for American Archeology 15.
Tolstoy, Paul
 1958 Surface Survey of the Northern Valley of Mexico: The Classic and Post-Classic Periods. Transactions of the American Philosophical Society 48(5).

Van de Velde, Paul, and Henriette Romeike Van de Velde
 1939 The Black Pottery of Coyotepec, Oaxaca, Mexico. Southwest Museum Papers 13.
de Vera, Juan
 1907 Relación de los pueblos de Acatlán, Chila, Petlaltzingo, Icxitlan y Piaztla. México: Anales del Museo Nacional de México. Segunda Epoca, Tomo IV, número 3.

Wagner, Philip L.
 1964 Natural Vegetation of Middle America. *In* Natural Environment and Early Cultures. Robert C. West, ed. Pp. 216–64. Handbook of Middle American Indians, Vol. 1. Robert Wauchope, gen. ed. Austin: University of Texas Press.
Webb, Malcolm C.
 1972 *Review of* Monographs and Papers in Maya Archaeology, William R. Bullard, Jr., ed. American Anthropologist 74:124–26.
Willey, Gordon R.
 1961 Volume in Pottery and the Selection of Samples. American Antiquity 27:230–31.
Winter, Marcus C., and William O. Payne
 1976 Hornos para cerámica hallados en Monte Albán. Boletín del INAH 16:37–40.

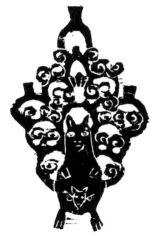

Index

DATE DUE

PRINTED IN U.S.A.